pain don't hurt

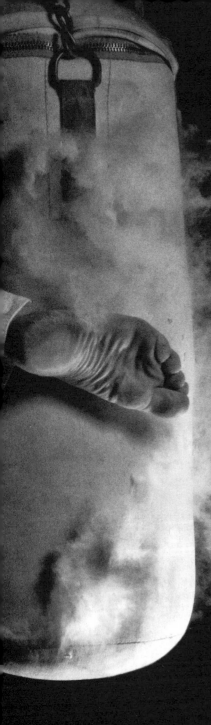

AN
ANTHONY
BOURDAIN
BOOK
ecco

AN IMPRINT OF HARPERCOLLINS PUBLISHERS

PAIN DON'T HURT

FIGHTING INSIDE AND OUTSIDE THE RING

MARK "FIGHTSHARK" MILLER

with SHELBY JONES

HarperCollins books may be purchased for educational, business, or sales promotional use. For information please e-mail the Special Markets Department at SPsales@harpercollins.com.

FIRST EDITION

Designed by Suet Yee Chong

Library of Congress Cataloging-in-Publication Data has been applied for.

ISBN 978-0-06-222234-3

14 15 16 17 18 OV/RRD 10 9 8 7 6 5 4 3 2 1

to benjamin, ronan, patrick, justin, amy, chad, mikee, matty, rakaa, cory, and everyone else who makes up my very large and beautiful family

acknowledgments

Tony B., for the opportunity to tell my story and for being a friend and mentor through this, I thank you.

Dan Halpern, for all of the advice and encouragement, much love.

Kim Witherspoon, William Callahan, and the rest of the team at Inkwell, thank you for everything.

Libby Edelson, without you this wouldn't be. I can't thank you enough.

Ottavia, for being awesome, that's all.

Bebe, for helping me remember and for being an anchor.

Justin, for all the love and support and for the reminiscing.

Matty, for guiding me to the shore.

I thank you all and give my love.

pain don't hurt

prologue

Mom, Dad, there's someone alive over there.

—ME

I am five years old, standing a few hundred feet from the devastated wreckage of a helicopter. Strewn around that wreckage are bloodied body parts, and people screaming. I wish I could tell you this is all fake, that I've stumbled onto the set of a horror movie. But it isn't. I'm out in front of St. Joseph's Catholic church, and the body parts belong to people who had been alive only minutes ago.

The church had chartered the helicopter to drop a bunch of Ping-Pong balls onto the crowd as part of a big festival. The Ping-Pong balls were marked with numbers that matched prizes being raffled off. The church custodian had brought his twelve-year-old daughter, Mary-Beth Allison, with him up in the helicopter, as she had never even been inside so much as an airplane—he wanted her to see what it was like, to be up in the air, like a noisy, awkward bird. The two of them were to be the official Ping-Pong ball droppers.

I had been watching the copter as it flew into view and came closer and closer to the crowd. Mary-Beth Allison, whom I knew only in passing, was leaning out of the side, happily dropping the tiny

white balls onto the laughing crowd. Mary-Beth's mother stood in the throng by the concession stand, watching her daughter giggling above her. Everyone was running to grab the Ping-Pong balls, and the crowd was getting thicker right below the hovering aircraft. Suddenly, the helicopter did this odd pitch forward and dove directly into the concession stand.

Mary-Beth's mother is one of the first crushed. Screaming fills the air. Everyone starts running every which way as the twitching blades of the helicopter twist around and around. My parents pull me farther from the wreckage, as bodies seem to be tossed into the air. My parents are desperate to prevent me from seeing what I am seeing. At least, this is what I want to believe. More likely, my father senses the impending traffic jam as people flee the scene and wants to leave before it starts, with no real consideration for the horror that I'm seeing. The small bodies of children lie in pieces like shattered dolls. There are bodies that have been dismembered by the helicopter's blades. Arms, legs, and heads are torn from bodies; blood is everywhere, sloshing in the grass, turning the church lawn into a gory Pollock painting. I think about how Mary-Beth Allison must have been watching as her own mother was struck by the helicopter. Later I hear that the final body count is eight—but the number of people injured is much higher. . . .

Up until now, I liked coming to this place. Big festivals are exciting to me. There's always food and toys, and these outings are pretty much the only times my parents are nice to me, and to each other, mostly because they know others are watching. I like this aspect of being in crowds. I had hoped to catch a Ping-Pong ball; I had hoped to win a prize, something I could take home and play with for a long time, something special I wouldn't get any other way, so I had been wandering closer to the crowd when the impact happened.

"Oh, Harry, we should get out of here, this is horrible." My mother only partially shields her eyes from the carnage. The parking

lot is coming into view, and we see immediately where we won't be walking. The parking lot looks like a battlefield, the asphalt coated with blood and bits of person. Later we learn that this is where emergency workers have temporarily moved both the dead and the injured. Both of my parents stand stock-still, and no one speaks as they mull over where to go next. Police and firemen begin showing up. Ambulances empty hordes of broad-shouldered men running in formation into the field, carrying large stretchers. People groan and scream, but all I can see is Mary-Beth and her father, writhing on the ground next to the helicopter. I'm sure it's them.

"Mom, Dad, there's someone alive over there. . . . In the helicopter, or next to it." I point at the wilted-looking bodies I see moving. Mary-Beth Allison is alive; so are her dad and the pilot. The throng of paramedics descends upon them and blocks them from view.

"Mom, that is Mary-Beth Allison! She didn't die!" In such an unbearably grim and horrible moment, I am amazed and moved that this girl is alive, and I try in my childish way to bring light into the darkness. Something had allowed her to survive. The world passes in a frenzy of uniforms, sirens, and screams, but all I can see is that little girl: confused, scared, but most definitely alive.

"We have to go, Harry, seriously." My mother quickens her step, dragging me along, past families and other kids who look as frightened as I feel. Mom is sweating, panicked, and I smell the familiar mix of perfume and alcohol coming through her pores.

"Well Jesus, Helen, the parking lot looks like a morgue, where would you suggest we go?" My father is less horrified by it all and more irritated by what he perceives as *an inconvenience*. It's possible he has seen worse. He was in World War II, and he was wounded there, though he never speaks in detail about what he experienced. He takes deep, annoyed breaths. We can't cross to get to our car the usual way without having to walk through gore. Instead of serving as a comfort to me, my father's towering countenance reminds

me now to watch how I speak. I was well aware that as his lack of patience grew, so did the probability I would get my ass kicked before bedtime.

"Dad, did you see? That little girl—"

He cuts me off. "Mark, there is no way she survived that crash, kid, no way." He is clearly irritated with me. He believes I've conjured this image of a living and uninjured Mary-Beth Allison just for fun, to tell a story, to garner attention, and he hates children who demand attention. He casts me a vexed look and points to a path that will loop us around to our car while enabling us to avoid the parking lot.

We walk for what seems like a long time. By the time we get to the car there are men with plastic bags walking around the parking lot, bending and gathering . . . things. I ask what they are doing, but I ask quietly and without conviction. I'm not sure I want to know. By now my father is thoroughly rankled and my mother upset. They will go home and drink, their favorite hobby. I will go to my room and attempt to be absolutely silent, praying my father will forget I'm even there. Sooner or later there will be food placed on the table and we will eat in silence, if I'm lucky. I know I shouldn't ask any more questions. I should stay quiet now.

Once we get home, my mother turns on the TV to hear the news. Every channel, it seems, is reporting on the crash. The fourteen-year-old daughter of a family we know has been killed, her head cut clean off by the circling blades. Reporters talk about why it happened. Some say the helicopter may have struck a utility pole; others say the crash was a result of engine failure. Suddenly I hear it: Mary-Beth Allison and her father, along with the pilot, are survivors. I was right, and I had to stifle shouting out. Not only did they survive, but the news is saying that they are virtually unharmed.

Much later and after dinner, my father falls asleep in front of the TV. My mother tidies up in the kitchen. I hear her calling my

name in a whisper, calling me into the kitchen. I peek in and there she is, clutching a small plate with a slab of her German chocolate cake on it. I crack a smile and take a seat at the kitchen table as she places the cake in front of me. My mom makes the *best* German chocolate cake. She puts one hand on my back, and I smell her perfume on her wrist as I fork small pieces off the sharp corner of the sweet confection. I'm not usually allowed to have sweets, being a recently diagnosed diabetic. But once in a while my mother allows me to have them, at birthday parties and on Halloween, and sometimes when she feels some sort of apology is in order. But this isn't a birthday party, and it isn't Halloween.

"Mark, you know all of those people that died today have gone to heaven, right? They are all in heaven, and there's no pain in heaven, and they get to be with God."

I pause. Then I ask the one question I know I shouldn't.

"Why wasn't God there today? I mean, why did he let that happen at his house? Why did he let those people die?"

My mother looks shaky; my challenging her faith makes her uncomfortable. She reaches for her half-empty glass of vodka, amaretto, and orange juice, her signature drink, and tips it toward her small bow-shaped mouth before answering. The dimples in her face crinkle as she purses her lips around an ice cube.

"God sometimes can't help. God wishes he could, but he can't. Now finish your cake." She tries to put a definitive end to the conversation. But here I am, five years old, eating cake, having just witnessed a bunch of people get hacked up, so I have questions. Up until now I have believed that God is good, that good people who love God will be cared for, and that children especially will never be harmed while God is watching. I have believed God is always there, protecting people, at least keeping them from dying. But seeing a fourteen-year-old girl lose her head, literally, on the lawn of a church has immediately altered my perspective.

"Mom, if he can't help with something at his house, then when can he? I thought God could do anything." I ask these questions less to get answers but more to solidify what is already dawning on me. I'm realizing that these are stories. The kinds of stories your parents tell you to comfort you, to keep you in line, etc., etc. This blunt realization doesn't make me feel bad, though. I mean, I've already figured out that Santa Claus is actually my father. I appreciate the effort adults make to ensure I feel safe and cared for. I also know that there are good things in the world and that there are bad things. Colin, my older brother, is already educating me on these matters. He wasn't there this morning (he had been with his biological mother), but we told him about it when he came home after his visit. His response had been to say, "Wow, that's gross! Did you see it all happen?" To which I told him that I had seen some.

My mother blinks very fast and finally says, "Well, I don't know, Mark, I just don't. Sometimes bad things happen to good people. Life is very cruel and you just have to survive it any way possible." With that, she yanks my plate away and places it in the dishwasher. She has failed. Her effort at covering the cracks of my already challenging existence with a polished religious veneer has not worked, and the veneer has crinkled and flaked away. I'm not sure that I *don't* believe in God. . . . But I do know that everything I've been told about him up until now is a lie.

The next day I'm playing in my front yard when a neighbor coasts down the street in his car and comes to a stop in front of our house, rolling down his window as he does so. He smiles at me and asks if I'm okay. He heard what happened at St. Joseph's the day before. He is a nice man, a good man. I often wish he was my father.

"Yes, sir. Do you know that Mary-Beth Allison survived?" I share my one nugget of sunshine with him.

He smiles very wide and says, "Yes, and that's very good news.

Sometimes the people closest to a crash like that are spared. It's very good news that she is all right." Then he drives off.

I keep thinking about Mary-Beth Allison. How her mother was killed, but she and her dad were spared. I decide it wasn't God who saved them, but that because they had known before anyone that the helicopter was going to crash, they had had time to act in a way that would help them survive. They were able to "wish" that they would live. To will themselves to live. You can't will yourself to survive if you don't know you are about to die. But if you see the danger coming, you can close your eyes and pray, or wish, or demand of the world that it not let you leave, and then you have the ability to take action. I know that it's a flawed idea, but it seems to make the most sense, and it gives credit to the survivors, which makes it seem less arbitrary that they survived.

After I deduce this, every night before bed I wish with all my might that I will one day be a great athlete. That my heart will somehow mend itself. That I won't need surgery. That my diabetes will go away. I do this every night for years.

Something begins to bloom inside of me then, some comfort in a dark place that says survival is possible even when things seem most bleak. And with that, I find new faith, in the power of a strong will. I have no idea how important this will be for me.

I know now that the universe hears everything you ask of it. And oftentimes what you will is what you manifest. But it only takes requests in the order they are received, and it doesn't always give you what you want, though you do get a version of exactly what you ask for.

chapter one

And we shall draw from the heart of suffering itself
the means of inspiration and survival.
—WINSTON CHURCHILL

A t this moment, right now, all I knew was I was just trying to survive. I had already bitten through my lip, and the salty iron taste of blood was coating my dry tongue, wreathing it in some sort of gore sweater. It was making me feel sick. It was 95 degrees outside, hot even for a Pennsylvania summer, and the air felt like the unclean and speckled inside of a skinned animal steaming across my shoulders. The crappy rotating fan was doing nothing but moving the heat around the room in sticky waves. The sweat collecting around my hairline was starting to run into my eyes. I was just a few minutes away from getting my first belt beating. I was six years old.

"Don't cry, oh for God's sake. You look like a stupid baby when you cry, and you aren't a baby, are you? You're a man." The heavy New York accent came volleying out of my father, propelled on a cumulus puff of twenty-four-hour-a-day whiskey/beer breath. His black eyes burned with a sickening mix of compulsion and fury. I flinched against the inevitable. Time for the nightly rampage . . .

His gargantuan hands rose above my cringing head. Years

later *Sporting News* would run a story on legendary wide receiver Jerry Rice. In the center of the paper they included a life-size outline of Jerry's famed enormous hands. As men at the local bar sat marveling, placing their own hands over the outline and laughing at how dwarfed theirs looked by comparison, my father leaned over their shoulders and slapped his hand down over the outline, utterly eclipsing it. I remember feeling a sick sort of pride, the old "My dad really could beat up your dad." Those mitts were his moneymakers. Their massive size is what made it possible for him to grip a basketball in his palm with the effortlessness with which most children can palm a yo-yo and garnered him a spot as the poster boy for the first-ever NBA game. He only played pro for a few years, but his image is still used today. His hands earned him a level of uneasy respect from neighbors and the other men who would spend time frequenting the same local bars, tolerating his raucous and often caustic storytelling, watching him boss me around, forcing me to entertain the other drunks by recalling baseball or basketball player statistics, or to recite Lou Gehrig's retirement speech from memory with faultless accuracy. "You know, I was there when he gave that speech," he would say, over and over again. No one ever dared to tell him that they'd heard it before. No one ever dared to tell him much. When "Moose" spoke, it was listening time. That's what they called him, "Moose," because he was just so fucking imposing. . . . He wasn't much for conversation or dialogue; he liked to entertain, and often at the expense of others. If he was interrupted, the interrupter became his subject of choice; he would mock them until they either left whatever dingy Latrobe bar he was at that day or engaged his barbarism, which always ended badly for them. He used to take pride in the fact that he "rarely hit anyone with a closed fist." Truthfully, it made little difference. Getting swatted by a leathery palm the size of a tennis racket launched by a man standing at six foot five and weighing over three hundred pounds, regardless of the age

or size of the receiver, generally resulted in damage one was not likely to soon forget.

I could hear my mother, my small-featured, passive mother, puttering around in her room, trying to busy herself. Trying to pretend she had an excuse for "not hearing" and therefore not intervening in what was going on. My father was born Harry David Miller in the Bronx in 1923. He was born the son of Benjamin Miller, a bastard of whose heritage no one is really sure (we suspect Russian Jew) and who upon being adopted took on the surname "Miller." Ben served as a superintendent in a big apartment building and was married to a six-ways-from-Sunday mentally fucked Czech woman, my dad's mom. My father learned to take and dish out the onslaught early on from her. My mother, on the other hand, grew up one of seven brothers and sisters in a family of Ukrainian and Mongolian descendants. Everyone on both sides of their families drank, and I mean drank in the way of the tragic Eastern Europeans. They made careers, hobbies, and commitments of their drinking. My father drank to become a storyteller. My mother drank to believe the stories. God only knows what about him captured her attention first. What about him caused her to think, *This is the one?* When she met him he was, after all, still married. Only on his third wife at the time, and consequently third family. When he met my mother, then Helen Rose Lechman, a secretary with tiny, slight features, born and raised in New Derry, Pennsylvania, he made the decision to move on once again, as he had twice before. He abandoned the previous family and moved in with her. Perhaps it was the fact that my father had played in the NBA, had been a big-time athlete, and had fought in the war and been wounded. He was more worldly and had, in her small-town eyes, prestige. She longed for a bigger life, a better, fancier life. She longed to be a part of the upper class instead of just watching them go by with their designer handbags and brunches. Maybe she saw him as a way out. He later appealed to the Catholic church to annul

his first marriage (because as we all know, having children doesn't necessarily mean the marriage has been consummated in the eyes of the Catholics, and the church doesn't acknowledge or care about other marriages following the first, so only the first one needed to be dealt with) and proceeded to marry my mother in Virginia before I was born. I didn't find out until I was sixteen that I had potentially dozens of other brothers and sisters I had not known existed until that day. I still have never met any of them, other than my brother Colin, who was, in truth, my half brother and the product of the wife previous to my mother. Colin and I were never given the opportunity to be very close other than early on. Oh, but when we were young . . . I looked up to him when I was young, his wild taste in music, his charm, and what seemed like an ability to know and/or understand everything. He always had an answer, an explanation. He seemed so cool. Later, when that answer became drugs and that wily personality became a dishonest one, we drifted apart. Or rather, he drifted, leaving me to take the brunt of my father's brutality all on my own. It isn't surprising that he ended up in the world of drugs, as we all were looking for escape from the ghosts of where we came from. My mother and father chose alcohol. Colin just went with the pattern laid before him, though his selections of substances tended toward the . . . exotic. I don't know if he chose to live part-time with my dad as a child or if his mother sent him to be with him, but he was there, his childhood split between the two houses. I know that whoever made the decision for him to be raised in that house with my father, even part-time, did him a great disservice.

"All right, now you need to imagine your feet are nailed to the floor. Get in that fight stance and only turn from the waist, and don't look all scared. Wipe your stupid mouth and quit gawking. Pretend you're not a scared little idiot."

Looking back on it now, it makes me laugh. I was so shit scared of him back then, I did whatever he told me to do without question.

Now I know he was giving me terrible advice. You always step with your jab, remain loose in your stance, and whip punches starting from your feet all the way up. You don't "imagine your feet are nailed to the floor." So stupid.

"Now throw that jab out there. *Throw like you actually want to hurt somebody,* not like you're just some pathetic princess. You want me to start calling you 'princess'?"

I balled up my fists and threw them as hard as I could into the center of his giant palms, trying as hard as I could to focus on keeping my feet, floating in my big brother's shoes, from moving even a little bit. Sweat was rolling down my forehead, and my stomach was clenched into an angry tangle of nerves. I was in danger of throwing up, which seemed a better alternative than standing there in front of him right then, except that I knew if I did, he would kick my ass even harder. My punches weren't hitting hard enough. I knew they weren't because he was looking more and more irritated. I couldn't seem to generate enough power to have an effect. I imagined my hands punching clean through his palms to the other side and slamming him in the face. I imagined him, with a surprised look on his face, laid out on the floor. I imagined him scared of me.

My father's favorite quote was "It is better to be feared than respected, for fear lasts longer." He loved to tell anyone and everyone this. When I was diagnosed as being a type I diabetic very early in life, followed shortly by being diagnosed as having a problem with my aortic valve, something in him seemed to decide that he needed to "toughen me up." As though that disease was my choice. He hated that I had any natural frailty.

"You call that a punch? Come on!" he roared. Everything in me wanted him to disappear, to just explode into a puff of dust with my next punch. I begged, pleaded, made deals with God or whoever. I wished as hard as I could. Nothing will encourage religious tendencies more than the feeling of absolute helplessness. Maybe that

is why my mother never missed a service. She attended morning mass every day, both in her church and in my father's. While my father professed to be a Catholic, my mother preferred the Russian Rite church, but she liked to attend both churches. I think she would have gone to a synagogue if she thought they would have her. She would drag me with her every Sunday to her church and then to the Catholic church. I still think the rituals affiliated with both churches are beautiful. I mean, you want to see Christ presented with a lot of pomp and circumstance, go to a Catholic or Russian Rite church. The costumes, the lengthy services, the constant stand, kneel, bow your head . . . There appears to be a level of dignity there, or at least effort. The production alone demands some appreciation. Not to say that other religions don't, and not to say that I really believe much of what any of any religion espouses. But it was pretty spectacular to watch as a kid. In the beginning I used to like going to church with her simply because for those few hours, I knew exactly what was going to happen to me, and I could blend in. After a while, that comfort faded, as I had gone through my confirmation in the Russian church very early, which put a spotlight on me in the Catholic church when all the other kids were going through their confirmations as young teenagers. If I wasn't the odd man out by way of physical difference, somehow my parents found a way to force me to be left of center and, once again, seen as a "weird kid." Plus, my father started to enjoy arguing with the Russian priests. In fact, I think he attended that church specifically to drum up new ways to get into arguments with them.

My mother was always looking for peace. At her age, church was one of the only places she had been taught to seek refuge. Sometimes she would drive me around in her car and tell me, "I'm going to get us out of here, Mark, we're going to go looking for apartments today and then we'll be out of there." By the end of each day, either her guilt over thinking of walking out on a marriage (us Catholics

and Russian Rite have truly cornered the market on guilt; feeling guilty is practically a skill we have perfected) or sheer exhaustion from thinking about how much it would take to actually leave would pull all the steam from her engine. It always ended the same: with shame and booze. We would go back home, she would pour herself something, then she would go to her room and shut the door, and I would be left to face him, his questions, his beer breath, and all that pent-up anger. Colin had learned over time to stay scarce, so he was never there to save me, not that I can really blame him. When he was there, he got it so much worse. . . . Sometimes my parents would spend months not speaking to each other, existing on opposite ends of the house, using me as a carrier pigeon if they needed to deliver information to each other. They never slept in the same room, not for as long as I can remember. She claimed it was because he snored; he claimed it was because she was a bed hog. The truth is, they were totally codependent but they just couldn't fucking stand each other.

"*Come on!*" He grabbed my shoulders and yanked them up, nearly lifting me off the ground. "*Come on! Let's go!*" he bellowed. His anger had reached an all-time high now. This was the boiling point. If I didn't deliver now, I would get tossed, smacked, all the while being showered with soul-crushing belittlement, characteristic of his "boy named Sue/toughen up" regime. The more of a target he made me, the harder he figured I would become. His intentions were to build a callus around my soul that was so big I would never be fragile to anyone. The onslaught was fully intentional. He would either beat me into a greasy smear on the floor, or eventually, I would rise up and become this armored beast that couldn't feel pain. It was a bad plan from the very start. Later on in my life, when I would be standing over him, watching him take his last animalistic rattling breaths of life, instead of being able to generate love, remorse, empathy, or even hate, that callus would prevent me from achieving either catharsis or forgiveness for a long, long time. I would watch every

muscle in his face relax as he growled out a final gasp, and I would, for two solid years, feel nothing.

I took a quick breath and threw my last punch so hard it nearly pitched me forward straight into his chest. My fist skimmed off his hand and glanced right into the center of his wide, leathery cheek. If my heart could have burst through my ribs and run out of the room to hide, it would have. I felt all of my organs just huddle into the center of my body, and all of my extremities went cold. I know now that what really enraged him was not that I had hit him in the face, but the fact that it had been accidental. If I had hauled back and just plowed my tiny fist straight into his eye, he probably would have respected it. I can't say he wouldn't have slapped the bejesus out of me, but I doubt my skin would have tasted leather that day. He browbeat everyone, but he had this odd admiration for hopeless acts of courage. Had I actually *intended* to throw that punch, I might have gotten off lighter. As it stood, though, I had clearly not. The punch landed on his face because I was "sloppy" and "out of control." In short, my ass was grass, and he was about to become the lawn mower.

He stood up completely straight, towering over me, his head pitched at an odd angle. His neck was fused in one position after sustaining a serious injury in World War II. He could hardly turn it at all, so instead he would shift his entire torso in the direction he was looking, making him look like some sort of dinosaur. He grabbed my wrists inside of one of those giant hands and I could hear the jangle of his belt. I had no idea what he was doing.

"Tomorrow, we are taking you to a gym and you'll learn how to do this the right way, since you are obviously too stupid to learn it here. You'll learn it, one way or another."

I was on my tiptoes, my arms yanked completely over my head, my shirt having crawled up to expose a patch of skin right above the top of my pants. I had forgotten how to breathe, and the fear I felt

made me go completely limp. I wasn't fighting him, and he just got angrier and angrier. . . . The skin exposed to air bristled with goose bumps. It was hot enough to fry an egg in that room, but sheer terror was confusing my body to the point of making my hair stand on end.

"Look at you, you aren't even trying to fight. You just let things happen. You'll learn one day, or the entire world is just going to walk all over you. . . . You'll learn."

There was a quick "sssssssp" sound as the wide leather belt slipped from inside his belt loops. I could hear my heartbeat in my ears. The only sentence that ran through my head over and over again was "Don't cry don't cry don't cry." My face was frozen. He spun me around to face the opposing wall; his dresser was there, and one of his collections of watches sat on top of it. He loved collecting them, used to say, "A man isn't properly dressed without a nice time-piece," despite the fact that he never wore any of them. I used to love sneaking into his room when he was gone to hold some of the pocket watches from his dad in my hands, feel the cool, smooth metal and read the inscriptions, some of which were so old they had mostly rubbed off. I tried now to remember what some of them said. . . . I tried to focus on remembering. . . . Something I could just repeat in my head to get me away from this moment . . .

"You'll learn one way or another. If you keep doing it this way, you'll always learn the hard way. My way or the highway."

The belt whizzed through the air and landed right across that exposed patch of flesh. I felt lightning run through me and the room flashed bright white. The pain was brilliantly surprising. I prayed my mother would come in, would hear it and save me, though I knew she wouldn't. I prayed that Colin would come in, rise up, and tear my father off of me, but I knew he wouldn't. I prayed for the neighbor to see what was happening and to come rushing in, shouting and shaming my father into tears. I prayed for him to understand that what he was doing was wrong. The belt came zip-

ping at me again and cut into my skin. I disconnected; it felt like I was floating. I remembered one inscription and began singing it in my head. . . . "Time waits for no man," spelling the words out slowly, giving my mind a place, a pattern, to hide in. . . .

The belt continued to land across my back and behind, until finally, he released my wrists and I dropped to the floor. He carried me to my room. I remember feeling idiotically happy I was being held so close. He laid me down on my bed and told me to take a nap. I was not going to go to sleep, but I closed my eyes anyway. My back was stinging, and my blood sugar started dropping. He brought me a glass of juice. I sipped at it and pretended to be sleepy. He walked out, saying, "Tomorrow we are going to the boxing gym and you'll learn how to really fight," closing the door behind him carefully.

Moments later I heard his car start in the driveway. He was going to the bar. Twice in one day. Not that uncommon. My mother was downstairs, likely cleaning something she had already cleaned several times in the last hour. My brother was out with his friends, getting into some sort of trouble. I sat up, finished my juice, and walked to the mirror in my room. I started trying to stand the way I remembered seeing the boxers on TV stand. I tried to imitate them and threw a few punches. I made the meanest faces I could muster, twisting my mouth into a grimace, growling and cursing, using every foul word I had ever heard uttered. My shirt was sticking to my back, so I knew I had been cut. I demeaned myself in my head for noticing and shouted, "Toughen up!" I would disappear into fantasy worlds often as a kid, where I would create athletes in my head, complete with stats and strengths, all fleshed out in my mind. I would pretend that I knew them. . . . Or that I was one of them . . .

I stood throwing punches until my shoulders ached and I was exhausted. I then went into the bathroom and washed up, cleaning my own back with a wet rag, marveling at the crumbs of dried blood that came away with every swipe of the wet cloth. I changed

my shirt and buried it in the hamper. My mother must have seen it, though she never said anything. My father came home later and we had dinner. He talked calmly about how he planned to take me to a boxing gym the next day, and I smiled back at him, thinking that one day I would know how to fight, and I would soon be stronger than him.

He made good on that promise. The next day I was dumped into the center of the dingiest brick building in Wilkinsburg, on the outskirts of Pittsburgh. The heavy bags were gray, duct-taped in spots, and lumpy. The ring had flakes of dried blood in it and giant dents in the floor, so men circling would occasionally trip or falter, cursing and stomping the ground like animals as they chomped on their mouth guards. For the first time I smelled what a real fight gym smells like. That mix of dirty, wet hand wraps; a musty mildew smell; the inside of gloves—a leather and sweat mix, body heat, and the sweet smell of Vaseline, which boxers use to prevent cuts in sparring. All of those smells converged in that thick blanket of steam that just blended together into one now thoroughly recognizable and familiar perfume. I was the only white face in the room other than my father, and I was by far the youngest. Every single person took a minute to sort of bemusedly gawk at me as I walked in, glanced at my towering father, and then went back to what he was doing. I was handed a small pair of gloves and a tall, onyx man sheathed in sweat sat next to me and said through few teeth, "Okay, we gonna wrap ya hands now, kid." I stuck one hand out and he began wrapping a thin layer of gauze around my knuckles, grabbing single strings of tape dangling from the edge of his shirt to secure the gauze as he wrapped. My father had already left, scooted out the door to head to the bar the minute he knew someone was watching me. I was alone in that place, and yet, with this stranger, this wiry black man in a sleeveless T-shirt, bobbing his head to the soul music cranked in the gym, smiling through more gaps than ivory, and yanking my

shoulders into place, I felt this surge of opportunity rise in me. "You like Motown, son? Yeah, you do, everybody like Motown. *Yeah!*" he shouted, grinning, and I couldn't help but smile back. I didn't even care that sweat was running into the cuts on my back. I didn't care that I knew absolutely nothing about the sport and now suddenly was being forced, once again, to throw punches, the very thing that had caught me a beating the day before. As the sweat began to build up on me once again, my shirt went transparent. This tall man glanced down as my shirt pulled up, exposing my raw back. He gently pulled the shirt down and said, "You got some of that rage in you, kid, you let that out, this is where you come to let that out." I pounded as hard as I could straight into the center of the bag. I was learning the art of exorcism. These men around me, all of them, were working through something. They laughed loud, danced, made silly jokes, and threw punches at each other with a force I had only ever seen on TV, but what brought them here was something else, something deeper and individual. I recognized this; we were all broken pieces of pottery here, and for the first time I believed I had a place in the world.

chapter two

*If I have seen further than others it is by standing upon
the shoulders of giants.*
—ISAAC NEWTON

Frank, my God, put that enormous thing away or you are going to trip Tony when he comes in here, and then we'll all catch an earful. I can hear it now: 'Who let Frank unwrap his cock without hazard signs?'"

Frank Wilson, number 37 for the Pittsburgh Steelers, a tight end who was a draft pick from Rice University, was in the locker rooms after training, sitting on the edge of a three-foot-tall stool, naked. His massive frame pitched forward as his elbows rested on his knees, he was using his towel to blot his face and shoulders. Frank sported great promise: he had incredible athleticism, good looks, and charm that only came with the Southern players. His physique was something that nine-year-old me used to be absolutely baffled by. Huge, muscled, not a bubble of fat. If repeat injuries hadn't been his curse, Frank could have been great. Frank was funny; he loved to laugh. Always making jokes. And Frank had the biggest cock I have ever seen, and will ever see, in my natural born life.

"Seriously, Frank, goddamn. What are you trying to prove? This guy, before he beds down a chick he probably has to call 911!"

Loren Toews, number 51, a scientifically minded genius from Berkeley who at this time was a linebacker for the Steelers, was visibly flinching at the image of Frank's penis dangling off the edge of that three-foot stool and brushing against the floor. The room erupted again into laughter as Frank gripped his enormous member and began swinging it around like a lasso. I was standing in the corner of the locker room, laughing hysterically. I owed moments like these, and many others I would share over the years with the Steelers, mostly to my godfather, Tony Parisi, a former professional hockey player who, when the Pittsburgh Hornets folded, retired and took a job as the equipment manager for the Pittsburgh Steelers. Tony and my father used to get together and talk sports, and "Moose" had decided that between the boxing lessons I received, I needed to be around more real men. Tony had then volunteered to take me on as a ball boy when I got old enough. It would later become my first real job at the age of fifteen, but the paycheck would be the only difference. Starting from when I was about four or five, I spent nearly every summer around these men, hanging in their dorm rooms, where they would read me stories; on the field, where sometimes I got lucky enough to have them teach me how to throw, catch, punt, or buttonhook; and inside these locker rooms, listening to their dirty jokes, watching them rib one another for various things, and doing any and every small odd job I could just to try to absorb more of whatever they seemed to have. I learned different things from each of them, attributes I wanted. Frank made me want to look better physically, and he made me wonder when puberty was going to hit. He also was about to smack a sixteen-year-old, awkward, redheaded Mike Rooney directly in the thigh with a penis so large they used to have to gauze it to his leg just so he could play football.

Mike came wandering in to start cleaning up, picking up the dirty clothes to run laundry, collecting cleats to start brushing them clean, any number of jobs we had as ball boys, when Frank smacked him directly on the leg. Mike Rooney jumped as though he had been hit by a Louisville slugger jammed full of rusty nails. Upon absorbing the full reality of what had just happened to him, and how many were there to witness it, Mike contorted his face and body up into some odd tribal-looking dry heave and shrieked like a four-year-old girl. The room thundered with laughter.

Frank pulled his towel up and smacked Mike on the back. "I'm sorry, little man, I'm so sorry," he said, gripping the towel with one hand and wiping tears away with the other.

Mike, thrilled to be included in a joke with these men, even if he was the butt of it, grinned through a rashy-looking blush and began grabbing up piles of damp, sweaty clothes. He tossed a jersey at me, and the wet cloth of Jack Lambert's number 58 smacked me right in the chest. As I fumbled to keep it from hitting the ground again, Jack slapped a massive hand onto my shoulder and grinned a wide grin (his dentures in place, as he was off the field), saying, "Thanks, kid."

Mel Blount, number 47, a kind-faced cornerback from Georgia whom I looked up to and who grew to be something of a distant uncle in my eyes, walked his jersey to me and placed it neatly in my hands, smiling, and thanked me. Jack Ham, number 59; "Mean" Joe Greene (who hated being called mean actually), number 75; and on and on . . . Titan after demigod stacked their "hero capes" into my hands. This was almost an everyday occurrence in the summers. One of my first summers with the Steelers, I had jokingly called Lynn Swann "Swannie" after hearing another player toss the nickname out. Lynn had gotten two inches from my then four-or-five-year-old face and growled at me, "Don't you ever, *ever* call me that." I trembled until I felt an enormous arm cross over my chest

and number 34, Andy Russell, a fearsome linebacker, leaned in to mirror Lynn's posture and snarled, "Back off, *Swannie,* he's just a kid." I let myself softly close one hand around Andy's jersey hem, gently running the fabric between my thumb and forefinger, and felt vindicated when Lynn Swann stormed off. It was like having the Incredible Hulk standing behind me. I returned every summer after that even though I didn't start getting paid for helping out for another ten years.

I pushed the laundry to the washers in giant bins, where we would then separate all of it neatly. Jockstraps, T-shirts, and sanitary shorts went into small string bags to be washed separately. The players didn't always take their pads out of their practice pants (knee pads, quad pads) even though they were supposed to, so we would have to peel them out. Pants got washed separately. Jerseys were the third pile and got washed on their own. This was my favorite washer to load up as I could count out the numbers, and I knew every single player who went along with the numbers. From roughly 1980 to 1990, I was a part of this ritual.

The shoes were set aside, as all dirt collected in them would need to be brushed out carefully. The pads were stacked on top of the lockers (I used to think dirty pads were the foulest things in the world until I smelled dirty hand wraps getting repeatedly used). Mike and I pulled bits of tape off the players' uniforms and carefully cleaned every bit of them. We finished brushing field dirt from the shoes, and when the laundry was finished we folded, hung, and gathered up the complete uniforms and placed them in the players' lockers. On this particular day I made my way back to the players' dorms. I went to Mel's room, dodging wads of paper tape being lobbed at me by Jack, and wandered in. Donnie Shell, number 31, was leaning against the table. Mel shifted his feet up onto his bed and said, "Grab a seat, Mark." I smoothed a bit of the bedspread out and sat down. Donnie and Mel were talking about

music. So I sat and listened. After a while of hearing them rattle off names, I decided to chime in.

"Hey, do you guys like Jimi Hendrix?" I asked brightly. I was so sure I had just suggested a name that would win me accolades with these two men just because I knew it. I knew the name of a major black rock musician, and I was positive that they would be absolutely blown away. I was wrong.

Mel shifted to his side and raised his eyebrows at me quickly, his face a mixture of surprise and offense, as though he had just witnessed a person de-pants the queen of England. Donnie smiled and just started shaking his head, saying, "Oh no, Mel, oh, you gotta tell him, Mel."

Mel patted my knee and said, "Son, we listen to *Motown*. You know Motown?"

I smiled. I knew it from the boxing gym. "I know Motown. They play it in my boxing gym."

An expression I had never seen before passed over Mel's face. Mel was impressed. "Are you boxing on the side, Mark? That's a tough sport. Heck, that sport is too tough for me! You're a brave man, Mark!"

I went so hot all over with pride I felt like my skin might blister.

After a few minutes Mel reached over and slapped me on the back, saying, "Aw, kid, you are all right. The little Moose is all right."

These were my summers. Between working with the players I would jam training in. I started Tang Soo Do when I turned ten. My first martial arts training. I would come to practice and some of the players would ask me how my "karate lessons" were going. I didn't even care that they got the name of the art wrong, I was just happy they were asking. Some would ask me to "show [them] some moves." I would jokingly show a few things off and then resume work.

When I was around fifteen I was at the field after a training session with the Steelers, talking to the grounds crew, when a few

men from the Chicago Cubs started coming onto the field for batting practice. Carmine from the grounds crew shouted out to Billy Williams, "Hey, Billy! You know this kid here, he's been playing ball since he was probably born! You should give him a lesson or two!"

Billy Williams, the batting coach for the Chicago Cubs, turned his head toward me and flashed a smile. "Is that right?"

I nodded a little too quickly. "Yessir. I've been playing since I was six years old!"

Billy looked around and motioned for me to come onto the field. I stood and started toward him, Billy's stats swimming in my head. I stepped backward to avoid Shawon Dunston, who was running laps. Andre Dawson stood a few feet away, a player who later that same year would be named National League MVP; his stats were ridiculous. I approached Billy and muttered, "Is that Andre Dawson? Oh my God, he had forty-nine home runs and a hundred and thirty-seven RBIs! He's one of the best!"

Billy grinned wide. "Oh yeah? You a fan? Well, hang on just a minute. . . . *Hey, Andre!*" Andre trotted over, and I froze. "Hey, Andre, this young man here is Mark Miller, and he is a big fan of yours. You want to stick around a minute? Seems that young Mr. Miller here is a baseball player himself, and I'm thinking maybe we could show him a thing or two about a thing or two. What do you say?"

Andre grinned, handed me a bat, and said, "You know how to hit, kid?"

I spent the afternoon in the middle of a lesson with Billy Williams and Andre Dawson coaching me. Hours went by. When they finally left the field I thanked them both, and Andre told me, "Keep that arm in good shape, kid, you got a real good arm. . . ."

All throughout high school I played football, basketball, and baseball. I wrestled (because I'm from Pennsylvania and you kind of have to) and I also ran cross-country. I also continued to box and study Tang Soo Do. Sometimes in the gym a few of the guys who

were entrenched in the fight scene would play around with something new called kickboxing.

The summer of 1990 I was working with John Fox, who was the Steelers' defensive back coach. By this time I had gained my own reputation with some of the players. Over ten years of working with these guys, hearing their bullshit, taking their nonsense and giving it back, I had started being known as something other than "little Moose." I was creeping out from under my father's backbreaking shadow with these guys. They knew me as a hard-assed seventeen-year-old, an athlete who favored combat sports. Most of them loved me for it. A few just weren't prepared to deal with a youngster who would "give back." Greg Lloyd was a linebacker then. It crept around the field that Greg had started training in Tae Kwon Do and was telling everyone who would give him two seconds of ear how tough he was. One day in the locker room, Greg started in on me. I was around six feet one inch tall and maybe one hundred sixty pounds dripping wet. A beanpole, all angles and piss and vinegar. I turned and looked at Greg, and in my clearest, most overenunciated voice, the best impression of my father I could muster, I said, "Well, Greg, why don't you tell me where you train and I'll come there. I'll be happy to kick your ass any day of the week."

The whole locker room went quiet for about thirty seconds before one by one the guys burst out laughing. Greg sputtered out a gym name and told me he was inviting me personally, trying to gloss over my underplayed venom with patronizing class. I tried to schedule with him multiple times and strangely, Greg was never available. Something about him creased me so hard, and I could never put my finger on it. He was a sideline bully, a tourist when it came to the actual art of kicking ass. He struck me as the guy who got off on pushing around people who he didn't think would fight back. I had a real problem with that sort of person.

I received a letter from the University of Pittsburgh asking me

to come play baseball for them. I was offered a scholarship based on my athletic ability in baseball. They recruited me as a pitcher. My first semester was golden. But after just one semester my "good" arm was shot, and I had been pulled in another direction. By then I was training to fight full-time. I didn't want to be a professional baseball player. I didn't want to hear my father brag to his friends about how he had prepped me to become this. I wanted to be bigger than that, bigger than him. I didn't want teammates. I wanted the onus to fall directly on my shoulders as to whether I would succeed or fail every time I stepped up to compete. As a fighter, when competition time comes, all you have is yourself. Within one year I was kickboxing full-time.

In 2001 I heard somewhere that Greg Lloyd had shoved a gun into the mouth of his own young son because the kid, who was just twelve years old then, had apparently gotten bad grades. I was glad I had stepped to him once I heard that, even if he had been too much of a pussy to face me.

chapter three

Kickboxing. You ever heard of kickboxing, sport of the future?
—JOHN CUSACK IN THE FILM *SAY ANYTHING*

For as long as I can remember, sports have been interwoven into the fabric of my life, which might seem strange to some, considering I was gifted with not one but two conditions that could have made being an athlete relatively difficult. My father had played professional basketball, my godfather had played professional hockey, and I had grown up around one of the strongest teams in football during their strongest time. This sort of determined that these were the sports I would not be pursuing. I felt like because people close to me had done it, it wasn't new, and certainly if I pursued any of those it would ensure that I would be burdened with opinions and pressure from the get-go. I played basketball and football in high school and a little in college but never took it seriously. What was left then? Combat sports and baseball. My options couldn't have been more polarized. A team sport that relies heavily on the team, and a sport/ grouping of sports that offer nothing in the way of diffused responsibility to the person involved. Be a team player, or be alone. Ultimately, I chose to be alone.

As I said before, I started in boxing. My first training was

in boxing; my first memories of any combat sport are of boxing matches. I began training in Tang Soo Do early on, alongside my boxing. I was attracted to martial arts because, as a child of the seventies, I grew up watching Bruce Lee and Chuck Norris, and I wanted to be like them. Then one day as I was watching ESPN, something new came on. Professional Karate Association (PKA) was the organization, and these guys were boxing, but they were throwing kicks too. . . . It looked like ballet and boxing combined. It was the craziest shit I had ever seen, and I was hooked. I started hearing about fights overseas in kickboxing, and I started doing what I could to get my hands on the tapes of those shows. I sought out training in this particular art, and once I found it . . . it was like falling in love.

Boxing is technical, make no mistake. No boxer worth his salt ever rose to fame on being a "brawler." Somewhere in every known boxer, a technician resides, a thinking man. It's a strange concept to understand, as here is a person playing a chess match, while getting punched in the face. Repeatedly. You have to think about defense and offense, and the punishment of forgetting one or the other is pain. It's so simple. In boxing you have 50 percent of your body that is going to take damage, that is going to get hurt. But in kickbox-ing . . . In kickboxing you are a target from the tips of your toes to the top of your head.

I remember watching Dennis Alexio fighting Stan Longini-dis in an ISKA (International Sport Karate Association) kickboxing fight. Stan came out of the corner and threw a low kick, which Den-nis checked, somewhat halfheartedly it seemed. (The thing to know here is that when a kickboxer "checks," or blocks, a kick, they do it by meeting the thrower's shinbone with their own shin. The idea is that if you take the coming impact and stop it with the flat part of your shin, it will hurt the person throwing the kick more than it will hurt you, and hopefully they will stop throwing them. The key is,

the form of the check has to be proper, otherwise . . . well . . .) A few punches were thrown, then they separated. Stan then backed up, and Dennis stepped out to set up his own kick. When he stepped out onto his left leg, his leg folded like a napkin in a strong wind, as though he had a second knee located right in the middle of his shin. Dennis, who was wearing what looked like a grass skirt (because he's Hawaiian), toppled to the ground in incredible pain.

In boxing, the damage is cumulative, slow, and hard to see. Even brutal KOs hardly ever leave a fighter with egregious and immediately visible damage once they are awake. I'm not trying to take anything away from boxing here. I love boxing and good boxers are amazing, but I wanted to be able to put my opponent's entire body at risk. I wanted to dig my shinbone into the meat of a thigh, or a body, or a neck. I wanted to know how to prevent that from coming. As Maurice Smith says now, "The difference between kickboxing and other sports is, kickboxing always hurts." The very thing that would terrify so many, turn them away from the sport, is what drew me to it. It was savage and beautiful.

I trained locally for many years while still doing other sports, other martial arts, and while still boxing. It was hard to find my way in kickboxing right away given the lack of information and/or training gyms at that time. I tried the best I could to educate myself about certain fighters, fighters I wanted to aim to be like. Rick Roufus, Maurice Smith, Rob Kaman, and Pete "Sugarfoot" Cunningham were my idols. I watched every fight that I could find. I marveled at Rick's side kicks, Rob's low kicks, Maurice's calm inside the ring, Pete's speed. I watched these men crumple other men bigger than them with chopping kicks to their thighs, powerful punches, swirling kicks to the face.

In 1989 a film called *Say Anything* came out. I have always been a Cameron Crowe and a John Cusack fan, so I saw it in theaters. At one point in the film Cusack's character tells his date's father that

she'll be safe with him because he's a kickboxer: "Kickboxing. You ever heard of kickboxing, sport of the future?"

I pilfered this line shamelessly and still use it to this day. It was only two years later that I would experience my first kickboxing fight, the beginning of a long and torrid love affair.

chapter four

I can accept failure. Everyone fails at something,
but I cannot accept not trying.

—MICHAEL JORDAN, THE GOAT

I was sitting in a sweltering room with a set of headphones on, listening to "Flavor of the Month" on repeat. The single had come out just recently, and the full album was just about to drop. The timing on that single was too perfect. The headphones were uncomfortable on my head, and I kept having to move them around, shifting them across my ears. My hands were already taped and heavy feeling. My whole body felt like a duffel bag full of hot angry snakes. Every nerve in me was flickering and flashing. In a few minutes I would fight my first official kickboxing fight. It was just a few days from my nineteenth birthday, and I wanted no gift more than this. Lately my days had been spent either in class, working with the Steelers still, or training. I'd been playing baseball for the University of Pittsburgh, which just fucking thrilled my father. My athletic scholarship was, in his eyes, the culmination of everything he ever hoped to instill in me. My future was laid out. As a pitcher, if I could preserve my arm, I would go pro, take a multimillion-dollar contract (if I was lucky), and he would sit at every game and tell everyone how he taught me

everything. He would smirk, he would smile, he would claim my success. He didn't know that I'd been having to get cortisone shots for months now in my shoulder because of the pain. He didn't know that I spent a whole weekend wearing a hat because I couldn't raise my arm to brush my own goddamn hair. He didn't know I'd been continuing with this fight training. And he didn't know that I was about to fight my first sanctioned fight in just a few minutes.

My gloves were red . . . bright red. My pants were white; underneath my pants were my red shin guards, and on my feet, my red boots. I imagined how my pants would stain if this were a pro fight. My coach was pacing the room. I was almost up. Every second started passing by like murals on the walls of a subway. . . . I was excited. I was overjoyed. I slid my red headgear on and started chomping onto my mouth guard. My taped hands were inspected by the overseeing commission and then were slid into the brand-new soft leather gloves that my coach had been stepping on and attempting to crush for the last forty minutes to soften them up. The laces were tied and taped down. If I had to pee before the fight I'd need a friend to help me. I was literally locked in, and the only way out was through.

This fight was an exhibition match, which meant that there would be no winner and no loser. But I'd know if I had gotten the best of him. I'd know, and that was what mattered.

My coach brought me up to warm up. I began hitting mitts, starting to break a small sweat. We went through combinations; he reminded me what strikes followed certain attacks the best. My foundation as a counter fighter was already laid. I was ready.

You see, this fight, the first fight, would be the telling one. Plenty of people come into combat sports with big ideas of how they are going to be the next Rocky Balboa, the next Jean-Claude Van Damme. I'd guess that more than half of the people who ever set foot in a ring or a cage do it once, and never again.

You see, no one is ever really prepared to get smashed in the face proper by a trained fighter while an audience is watching. Nothing will ever truly prepare you for that. Not street fights, not beatings at home, not even sparring sessions. Nothing compares to the first time you feel completely that the person in front of you truly wants to physically dominate you and has been training specifically to do just that, and that there is a screaming audience just wanting to see you hurt, see you damaged. The opponents who stand in front of you in a ring are driven by an intoxicating mix of fear, competitive desire, and adrenaline. Nothing can prepare you for the first time you get hit in the gut and hear your own breath escape loudly, knowing the other guy heard it. Nothing will prepare you for the first time you end up clinched against another fighter, and you can feel them shaking, their nerves a cacophonous roar, just like yours, demanding reprieve from the damage. The first time a person gets hit in the mouth, they do one of two things. Some recoil in fear and defensiveness, clearly wanting to run the other way. This is completely natural. As human beings we should want to protect ourselves. We should seek safety and move away from danger, not run toward it. Yet some people, some people stand their ground and know when to move forward and when to walk away. These are the folks who have the potential to be glorious fighters. Chris Leben once said, "Strippers and fighters, no one ever does those jobs because they are one hundred percent sane." In a way he was right. At least about the fighter bit. No normal person wakes up thinking that they can't wait to get smashed in the face. We are all working something out in there. Every one of us.

I was not afraid of this fight. I was not afraid of the outcome. I knew what I had come here to do and I had no room inside of me to allow anything other than just that to happen.

My name was called and I walked. As I pulled the ropes down and stepped into the ring, I looked directly into my opponent's eyes. A sinewy, wan kid about my age was standing in front of me. His

pupils were so fear-dilated that his eyes looked like two wet river stones jammed into his head. He was screwing his face up into a series of grimaces and squints, simultaneously wincing against the light and trying to make me think he was truly something to fear. He was transmitting all kinds of hostility to try to look intimidating, and really he just looked like a plucked, underfed chicken being made to dance for company. Fighters, like dogs, can smell fear. This kid looked and smelled like he was terrified, and I almost felt bad. Almost. Then I remembered we were both there by choice. He signed on the same lines I did, so I crossed to my corner and waited. The bell rang, and I flew out of my corner. My steps were inelegant, my hands were shaky, and my timing was off. Not unlike in another first for most teenage boys, I was too eager, too aggressive, too excited. And it showed. One round blended into another. My heart was in my mouth as I went through the motions. My opponent hit me square a few times and I was pleased to find that I didn't seem to need to pause to reflect before retaliating. At the end the referee raises both of our hands and the crowd started cheering. I turned to shake my opponent's hand and saw that he was almost in tears. I knew this might just be his one and only foray into trying to make it as a fighter. I doubted he would be back. And I could not wait to return.

In the shower I went back to thinking about the crossroads that was in front of me. In baseball I was undeviatingly dependent upon other people. In the ring, I had only me. The room for error shrank to being mostly within my control. In baseball the triumphs were distributed among all of the players, as were all of the defeats. I could handle the weight of those falling squarely on me. I had been conditioned in my life to search tirelessly and obsessively for flaws in everything I did. To hone in on them like a laser beam and then seek and destroy. For if I didn't, my father would find them, and he would exploit them. An opponent in the ring will do the same,

only the opponent, unlike my father, is in the unique position of not being the only one issuing an ass whipping, but inviting it upon himself as much as he seeks to offer one of his own. The term "fair fight" suddenly began repeating in my head, and I guffawed loudly. I wanted the fair fight. I wanted the purity of fighting. I longed for it already again. The one-on-one aspect of it. You come as you are, and I'll come as I am, we'll agree on the rules, and we will brawl like fucking balletic savages, and at the end, we'll shake hands, and we will both know what only trained fighters know. We will know our mettle. We will know our fortitude. It will be solidly outlined in our minds, and with those tests come awareness. We will know what weaknesses we still have, for you will have shown me mine, and I will have shown you yours. We will know what we can take, how our hearts hold up when our bodies are battered. We will know that we did it. We survived. Nobody came to get us, nobody came to save us, we didn't wave for help, we fucking took it on the chin and survived. Us, alone. And we will get to leave some of the blood of the demons that inhabit us, that urge us forward, that haunt us, on the canvas.

It is hard to not get romantic about baseball. It requires more skill than most sports. High-level players are like aliens. There is no rhyme or reason for why an athlete ever gets so good at hitting a round object traveling at astronomical speeds with another round object. The application for it in nature is seemingly minimal. But it is beautiful. And I just didn't want to do it anymore. My heart was breaking as I toweled off. I was realizing that the adoration I had had been in the process of being slowly wrenched from the hands of the sport that my father bred me to love. The last existing connection between us almost audibly snapped as I felt myself bending to kickboxing completely. I couldn't lie to myself. Baseball was taking my pride, my health, my joy. Kickboxing gave it to me. When an athlete finds his sport, it is a homecoming. It is both pornographic and romantic. The know-how of a good fighter with the right coach

on mitts . . . The sound of a flawlessly thrown roundhouse kick on a bag . . . The way you know your hands are wrapped right, the smell of new gloves, the creak of a ring whose canvas is a little old . . . It is the set of welcoming arms I never fell into comfortably as a child. The difference between it and baseball is baseball is the blond sweet girl I could take anywhere and know she'd be accepted, because she's nice. Fighting is like the redhead who wears the leather jacket, curses, reads Bukowski, and listens to the Stooges. And you know no one will ever get her, and everyone will judge her, but you get to be yourself around her, and she makes you feel like a man.

I lay back on my bed and my head was swimming. I knew now that I would finish the semester and never return to baseball. My number would go to someone else. I would not go on to try to be a professional ball player. Instead, I would pursue fighting, with a vengeance. I had told my coach before we parted ways earlier in the evening that I wanted more fights.

I got what I asked for. After that semester I quit baseball. My father was epically angry and condescending. He took his humiliating and caustic inventory-taking to new levels. I let it roll off my back. I knew that what angered him the most was the fact that he had no way of relating to this new sport. He couldn't point to fighters he knew or fights he had seen. He had strong attachments to boxing. But kickboxing? I might as well have told him I wanted to go be an underwater surgeon. It made no sense to him, and therefore, he couldn't accurately critique me as a kickboxer. And that was perfectly fine by me.

I finished college. At the age of twenty-three I married my college sweetheart. It was a futile attempt at a marriage from the start. We were too young, too foolish, and I was just setting off on this new career in a sport that would require me to be far from home constantly, while she, in the career she was pursuing, would be tied to the small town she had grown up in. The best I can say is that we

were optimistic and very good friends. Something I have been lucky to keep her as to this day.

By the age of twenty-four I got my first professional fight. By the time I was twenty-six I had had three professional fights and was hunting down the perfect coach. The Internet was in its infancy at the time, so through much searching and struggling I sought out who I thought would be the very best guy for me. At the time kickboxing was blossoming, particularly overseas. There were only two guys from the USA who had made any waves, as the sport was so heavily dominated by the Dutch, French, Russians, Australians, and some Germans. Only two from here were ever anything to reckon with, but those two were a whole other level of ruthless, and I've already mentioned them: Rick "the Jet" Roufus and Maurice Smith. The kind of fighters these men were moved the bar, set it higher. You get maybe one like them every twenty years. Yet they both existed at the same time. Rick was a full-contact karate fighter, the greatest full-contact karate fighter there ever was, who transitioned to kickboxing. Rick, like me, wasn't a big heavyweight. In the years of the six-feet-five, two-hundred-fifty-plus-pound guys, Rick was six feet and maybe two hundred fifteen pounds at his heaviest. He was never big, but it didn't matter. Rick had fought Rob Kaman, arguably still one of the toughest and nastiest kickboxers to ever live, and Rick had planted his left hand so hard into Rob's jaw that we used to joke that Rob's kids were probably born with headaches. He had a side kick that he would throw in doubles. *In doubles.* It shouldn't have worked. It was gut-wrenchingly beautiful. It made no sense that a man could apply such speed and fluidity to such unnatural movement, but Rick made it look easy.

Maurice Smith though . . . Maurice Smith was a specimen. At six feet two and two hundred twenty-five pounds, Mo Smith wasn't a huge heavyweight either. A black man from Seattle with roots in the South, Mo was unexpected. A professional fighter, eloquent,

stylish, and quick-witted. While Rick came on like a ball of violent energy in a fight, flustered and evaded his opponents while attacking with impossibly difficult shots and throwing everything at full power, Mo demoralized opponents by meeting them head-on, taking no damage and pummeling away at them. Rick at his core was a brawler with incredible skill, and Mo was a skilled fighter who just loved to brawl. Mo didn't widely evade, he didn't "explore the ring's space," as we used to say. He cut small angles and popped at his opponents with the same quickness you would expect a person to use when brushing a bee off their shoulder, yet inflicting seismic damage with what looked like no effort. Rick made it look easy to kick a skilled fighter's ass. Mo made it look fun. From the first walk out, Mo's face would never change. He had this incredible "So what?" look that he would wear while he fought. No rage faces, no harried expressions, no wincing. Just "So what?," which made his onslaught seem all the more unbelievable. Mo was more or less self-taught until he rose to a particular level of success, at which point he took it upon himself to seek out every trainer he felt was worth it to learn from. He spent tedious time honing his abilities. He always spoke softly at interviews, never was cutting or classless or brutish. It was as though he had risen to the highest level of alpha that a man can achieve and had nothing to prove to anyone anymore. Before a fight against Mike Bernardo, Mo had walked to the center of the ring. As the referee read out his rules, Mike began grimacing and leaning closer and closer in to Mo, who seemed unfazed. Mo never looked away, never pushed back, just stood his ground. The message was clear: "My mountain; you ain't gonna scare me off, you're going to have to take it." Finally, as Mike pushed harder and harder, Mo did the best thing I have ever seen. He puckered up and planted a kiss full on Mike Bernardo's snarling lips. In one second, Mo defused Mike, and Mike pulled away giggling. Mo barely cracked a trace of a smile. Mo lost that fight to a decision, but he

won the audience clean. There was just something about him. He reminded me of my first trainers in that dingy boxing gym. Big, black, and unflappable. He was so comfortable in his own skin, so completely at ease.

I chose Mo Smith. After flipping through phone books and calling various people, I finally got ahold of him. I will never forget the first time I got him on the phone. I explained that I was really looking forward to getting some better training. How I was wanting to pursue kickboxing more and more, and how I would love to work with him. This is the cool, casual fighter way of saying, *"Please train me."* Mo was smooth and calm as he invited me to come out, train, and see how it went. I knew then that I was coming for what was essentially an audition; no one said that, but that's what it was. A few months later I packed my bags and flew to Seattle to begin training with him. On the plane I listened to Everlast, an L.A.-based rapper who had just had open-heart surgery to correct a defective valve, so I felt somehow connected to him. I tried to convince myself that I was going to be fine. In truth, I had not been this nervous for as long as I could remember. I had never known what it felt like to yearn for approval from another fighter. I was walking into an established pack, and I was going to have to prove myself. There was no way for me to be a big fish in the pond I was leaping into. Hell, I wasn't even going to be a medium-size fish. I was a fucking minnow compared to the barracuda that swam there. But I would be in my element; sink or swim, this was it. Risk nothing, and gain nothing. I was risking it all. I leaned back and tried to sleep, feeling every cord that had tethered me to the ground in Pittsburgh fall away as I pointed myself toward the setting sun.

chapter five

It is hard to get up to do road work when you are sleeping on silk sheets.
—MARVELOUS MARVIN HAGLER

Training sessions in Seattle went as follows: Up at eight A.M. for breakfast; first strength and conditioning training from roughly nine thirty A.M. to eleven A.M. Quick snack and a change of clothes before driving over to the Bellevue Aquatic Center. Swimming training from just after noon until two P.M. (Maurice was big on swimming. I am certain to this day that it is a huge component of why he is one of the only combat athletes I know who never required a knee surgery, shoulder surgery, nothing.) Drive back, shower, meal, and rest. Then at four thirty, small snack, change into training gear, and kickboxing training at Maurice's gym from five thirty until whenever he saw fit. This could mean finishing up at seven P.M., or it could mean nine P.M. If we had a good training session and were finished at seven, sometimes we would shower, change, and go out for a meal together, or maybe to a movie. If it was a rough night and we got finished closer to nine, we would usually end up going home, showering, and passing out, oftentimes on the couch, or even in the shower itself. Nights like that, the only motivation to actually get yourself in and out of the shower quickly was the promise

of food before sleep. The desires and creature comforts of a professional fighter are simple when locked in a solid training schedule. No booze, no excess, just training, food, and sleep. You find joy in whatever particular meal you are going to get to savor. You look forward to little things like silly TV shows or downtime to read. You glorify cheat meals. Brief forays into the "normal world" feel odd. You start sympathizing with dogs on leashes. Everything out there seems so tantalizing and amazing, but it isn't within your reach, it isn't anything you can even taste, not without sacrificing the goal. My existence was fueled by green tea, steel-cut oats, baked chicken, sweet potatoes, broccoli, spinach, whitefish, brown rice, a multitude of testing strips to keep my glucose levels balanced, gallons of water, and the occasional doughnut or bag of popcorn for when I decided to fall off the routine. I saw more of Maurice and my training partners than I did any significant other I had ever had, including my then-wife. The greatest excitement I experienced was hearing Maurice say, "Not bad," in regard to a technique we were practicing, which came very, very rarely, and making fun of whatever new brightly colored, obnoxious Speedo he had chosen to wear to swimming training that day.

"You're already black, Mo, do your really have to wear that?" I said to him one day. "That little piece of cloth is just fighting to keep everything in place. I mean, it is *fighting*."

The other fighters laughed; a few patted me on the back, saying things like "Now, that is the truth!" Mo stood on the side of the pool, sporting some multicolored slingshot of a bathing suit. He was totally disinterested in our giggles; instead, he put on that "So what?" face of his and spoke so calmly you almost couldn't hear him over the sound of the water slapping against the tile.

"First of all, Mark, I'm not black, I am brown. If we were to go to the paint store, you would not find a color that matched my skin that was called black. Black would be the color of the street, or licorice, or

some shoe leather. My color would be brown. It would be called milk chocolate, or rich mahogany, or something like that. Not black. And second of all, I wear this suit because it reduces drag in the water, unlike those floppy ridiculous shorts so many of you are wearing. Have you ever seen an Olympic swimmer wear board shorts in the pool? No you have not. And last, I am sorry that not all of you are as gifted as I am, in or out of the water. I know I'm pretty, but don't hate me because I'm beautiful."

With that, we all died laughing. Mo won. He always won. Sometimes over meals he would take an opposing position to an opinion being clearly presented at the table by someone. He didn't do it to be a dick; he did it because he genuinely liked to hear the defense of the person speaking so strongly. Mo was impressed with conviction, and he wanted to coax it out of people. He didn't like milquetoast people and he didn't like to hear people waffling on subjects. He wanted to get you to claim one side or another on an issue and then he wanted you to stick by it so hard that he wouldn't be able to shake you off. Simply put, Mo liked competition, and that didn't mean he loved winning; he almost loved finding an opposition that refused to bend. He respected that. The few times he would get under another fighter's skin so much that they would criticize him for being argumentative, Mo would lean back and say simply, "I don't argue. I debate." It should really be his patented catchphrase, as anyone who has ever worked with him for any length of time has heard him say it at least once . . . or ten times.

Mo drove a black Porsche. He was always dressed well, was well groomed, and walked with a marked swagger. I wanted to learn everything from him. My father had always sported high-end accessories and driven nice cars, but my father was led around by an air of violent braggadocio. He didn't draw people to him, he drove them away. Mo held a crowd wherever he went. His charisma and intellect allowed him to attract others to him while cleverly fil-

tering out who he wanted to actually get to know and who he would keep at a safe and respectable but friendly distance. Not unlike Mel Blount and some of the other football players I had so admired in my youth, Mo walked with a strength that said he knew himself. And we got along. Amazingly well. A few months into my training with Mo, he sat me down to "have a talk." Mo was very big on discussions of all types, and he would frequently pass by me during training to say, "Oh, hey, I want to speak to you later about things." It always scared the shit out of me, as I had been so conditioned to hear these words as a warning that meant "You're about to get your ass kicked." But with Mo the subject matter could be anything from his asking me if I had heard about a new training technique and wondering what I thought of it to whatever was on the news that week. This particular time it bore the aura of being more serious than previous talks, so I felt decidedly more ill at ease than usual when sitting down with him.

Mo was still fighting, which meant he was actively pursuing fights, which can make for not being the best coach. While Mo had to invest a large percentage of his time in himself in getting ready for different fights, I can honestly and without embellishment say that even when he was still focused on himself, he was the best coach I have ever had. His time spent focusing on himself didn't seem to detract from the quality of attention that he afforded us when he was available in the slightest. He had also begun pursuing something called "no holds barred" fighting, or "MMA," which stands for "mixed martial arts." There was an organization that had been around for a few years called UFC, short for Ultimate Fighting Championship, and Mo was going to be fighting for them. The style was different in that not only would he have to stay polished in his kickboxing, but the rules also included wrestling and potential stoppages from submissions and "taps" to submissions (a move where an opponent gets caught in a submission, meaning a joint

lock or choke, and opts to tap on the body of the aggressing fighter, indicating they have had enough, rather than have their joint broken or be choked unconscious) as well as knockouts. Since MMA was beginning to get a little more attention stateside, while kickboxing seemed to be restricted to mostly overseas, Mo wanted to know if I wanted to stay with kickboxing or venture into MMA. I told him that for now I wanted to stay with kickboxing. Then he offered to try to get me fights in the organization known as K-1. My heart unfurled and fluttered.

K-1 at that time was *the* organization for kickboxing. All the greats were there. Names that would make their mark on the kickboxing world so deeply they would become synonymous with kickboxing itself. Andy Hug, Peter Aerts, Ernesto Hoost—I mean *all* the greats. And Mo had been fighting in it for a few years. He began reaching out to them.

The offer came through not long after that for me to fight Masaaki Miyamoto in Japan. I agreed, but my size became an issue for them. I was walking around at two hundred fifteen pounds, and at six feet four, I was not a thick heavyweight. But Miyamoto was smaller, and the Japanese balked at the size difference. Also, I was 10–0 as a pro going into this fight, which made me a risk. The Japanese liked to try to build records for their fighters by pitting them against Americans, assuming that we were the worst of the worst in kickboxing, and while they didn't stand much of a chance against the Europeans, they felt we were their stepping-stones to beef up their records. I was the wrong fucking American for them, because at that time, seven of my ten wins were by knockout. My right hand has always been a cannon. The fight was pulled off the table real quick once they did their research. The next offer came through. It was to fight Tommy "the Rhino" Glanville in Las Vegas. Tommy was another American. He was a decent fighter, with a decent record, and Tommy was *huge*: six feet two and around two hundred fifty pounds

plus. A cock diesel hulk of a man with a bleached-blond flattop and a jaw so square he looked like a cartoon. I accepted.

I prepared for the fight split between Seattle and Pittsburgh as Mo was getting ready for his own fights and therefore wasn't always around. When it came time for the fight, I flew out to Las Vegas and arrived at the Bellagio. I was brought in on a Tuesday; the fight wasn't until Saturday. Leading up to the fight I had several press conferences to attend, photo shoots to do, and weigh-ins the day before. K-1 treated me like a fucking king. I had never been treated so well by an organization. Upon my arrival I was given a series of VIP passes for my meals, which was entirely generous. We were also invited to charge whatever we might need to the room. I holed up, watched TV or worked out in the hotel gym, and tried to lie low for the most part. When I wasn't needed, I kept to myself. This was my first taste of K-1 hospitality, and I didn't want to blow it. I passed Tommy a few times in the hotel. I was polite, as was he, albeit somewhat dismissive, which I expected.

When the actual day came, I felt like a lightning rod. The grueling weeks of training all faded into a pleasant wallpaper when "game day" came around. This was the shit I longed for. I walked out and stood in the center of that wide ring in the Bellagio hotel in front of a nearly packed house, Tommy's imposing form across from me, sneering. I knew this look, and much to my chagrin a phrase my father used to say came to mind: "Too much fooling comes to crying." Meaning, while you're busy over there mean-mugging, I'm busy over here thinking about how I'm going to smash you. And so, it begins. . . .

First bell. I'm out of the corner and I rush him. I throw a series of short, compact punches and crowd him, trying to grab ahold of his head. I want to knee him, smash his nose up, crush into his liver, start breaking him down. Tommy is very good at interrupting me, I learn. He turns my body and shakes me off. I continue

to crowd him, but my size is ineffective compared to his. He keeps interrupting me, keeps wrecking my game plan with blocking. I start feeling the anger boiling up. Mo always said to me, "You can't fight with emotion; emotional fighters are weak and vulnerable," but I would be lying if I said I never fought emotional. I always took a piece of that unfinished rage in there with me. With my punches finding no purchase, that rage began crawling out of my pores and enveloping me like a cloak. End of round one. I walked back to my corner furious.

"What the fuck is he even doing? He's fucking jamming me up." I'm standing in the corner, ignoring the stool, and my corner is trying to tell me that Tommy, the fucking Rhino, has won the first round. I do not want to hear this shit. "He's hitting you, Mark, he's scoring on you. You gotta play off of him, counter what he throws." *Where the fuck is Mo? I need Mo.*

The bell sounded and I came out, grinding my mouth guard between my teeth angrily. More of the same. Suddenly, in a flash, I saw it. . . . Tommy was bullying *me*. Tommy was driving me back. The ghosts surrounding me dragged me forward on a wave of violence. Don't (jab) bully (cross) me (hook) you (cross) fuck (*cross*). My last right-hand snapped Tommy's head to the side, and he crumpled to the floor like a wilted daisy. The ref ran in for the count, and I returned to my corner hopeful. The calm exterior hid a cheering section inside of me that was screaming right now. . . . *Don't get up, don't get up, stay down.* . . . The ref was counting higher and higher. . . . Suddenly, at nine, Tommy was starting to rise. His legs were rubbery and as soon as the ref said, "Fight," I rushed in. There was blood in the water; time for the frenzy. No sooner did I close the distance than the second bell sounded. Tommy, still dazed, toddled into his corner, and I returned to mine, crestfallen.

"*I had him. I had him.* He was fucking down." I was angry. My corner was desperately trying to bring me back to the now so I could

finish the fight, but I was bound up in thirty seconds ago, reflecting on how close he came to not getting up.

Third round, bell sounded. I came into the center of the ring. We both started throwing. This round was a barn burner. Tommy had been hurt last round but had time to gather himself and recover. So now he was dangerous and pissed off. I was just pissed off. We threw an unrestrained arpeggio of strikes. My shoulders were aching, and there was fire inside my lungs. Final bell, and we went to the corners. I was so stuck in the second round that I barely heard the announcer say that I had lost a unanimous decision. My first loss as a professional fighter. My first dent. I was so furious with myself.

I got back to the locker room and I was bombarded by journalists talking about how the fight was one of the best of the evening, how we really went at it. . . . All I kept thinking about was that second round. And how I wished Mo was there.

That night I lay down convinced that I had to fight Tommy again. I had to avenge this. But first, I wanted to cross the ocean. If I was to fight without Mo in my corner, then I might as well fight far away. I wanted to fight someplace where fights were a part of the people, a part of the culture. I wanted to fight on a soil that knew blood. I wanted to go to the roots of the sport I had been training in.

chapter six

If I tell you I'm good, you would probably think I'm boasting.
If I tell you I'm no good, you know I'm lying.
—BRUCE LEE

I t was the year 2000. The rain was just beginning to fall on the ring in Thailand. The first round ended and I crossed to my corner to take my one-minute break. One minute between rounds. One minute to reflect before it was back into the fray. One minute of an uninterrupted barrage of thoughts. The crowd was so loud it blocked out the sound of thunder from above, and the large outdoor stadium of Pattaya, Thailand, reeked of late-evening bloodlust and sweat. The alcohol-soaked attendees were out of their seats, screaming and begging for carnage. I couldn't believe I was fighting in fucking Thailand. The minute I was offered the fight there, I had jumped at the chance. I knew how corrupt the system was, how rigged the fights could be, but I had to take it. Just before the bell had sounded, ending the round, I had landed a right-hand that would have, with a butcher's precision, taken the jaw clean off of any other man. The shot had spun my opponent into the ropes, and the crowd had leapt up screaming for a finish. Before I could close the distance and shut the lights off on him, the steely Samoan had straightened, adjusted

his neck, and started to come forward again. Ding ding, round was over. No time for love; back to the corner you go.

The wooden stool went down in front of my cornerman, but I didn't sit. I never sit. Some of my coaches have reprimanded me for that in the past, but I rest when the fight is over. I could feel my right hand through my glove. "Fucking guy, I hit him with everything and he didn't even fall down! Unbelievable!" I laughed to my cornerman as he mopped sweat from my face. Across from me on his stool sat Jason "Psycho" Suttie, a six-feet-even kickboxer who grew up hard in Samoa and fought out of New Zealand. Jason's cornermen were Thai, which put the fight in his favor to begin with, not that it mattered. Jason wasn't much for taking fights to the end; he liked to finish people, and so did I. Jason was covered from his waist down in traditional Samoan warrior tattoos, and from the waist up he was covered in scars from gang fights, from being hit with chains, bottles, knives. Jason was not concerned with my 11–1 record going into this fight. His record was 42–5–1. To be honest my record could have been 400–0 and I don't think Jason would have given a good goddamn. The first round had been ugly. Jason was the kind of fighter other fighters tried to avoid. While his record was not without blemish, he was incredibly technical, fast, and like other Samoan-bred New Zealand kickboxers, violently aggressive. Jason took fights into dark places; he liked to force opponents into the corner and rain punches down, heavy and sharp as ax strokes. His hands were like atlas stones and his speed was uncompromising. He had no give in him. You had to weather the storm against Jason in order to win. It was the only way, if you could handle it, for he would not break and his storm would keep coming.

"I did it! I fucking hit him so hard. What the fuck is he made of?" I was still giggling.

"Use your length, Mark, use your hands. Stay out of the corners, don't let him get you into the corners." My corner offered

quiet suggestions while doing the regular squirt, spit, pat-pat with the ice, rub down the arms, neck. . . . I kept staring at Jason, who was staring directly at me. I had hit him with the right hand and I hadn't even knocked him down. This wasn't disappointment running through my mind. I was marveling. Was it the weight the Thais had forced me to cut before the fight, even though it was a heavyweight fight and I shouldn't have needed to cut any weight? Was it the running in the sweat suit the day before, trying to get off the pounds they had demanded, getting pelted by the hot rain while Thai drivers passed by me yelling, "Hey, *farang*, bus stop is over there. . . . Stop running, take the bus. . . ."? Was it the humidity? . . . *God, why didn't he even fall?* Nobody had ever taken my right full force and stayed standing, not before, and no one has since. Seconds ticked by; I snorted. "Un-fucking-believable." Jason's wide face and dark eyes, one swelled slightly by glove rub, stared back. I've always been a big-game hunter. Give me some new-kid tomato-can fighter who bleeds when you yell at him, and I'll refuse the fight. I want to know I'm not safe in there. It's the only way that the relief, that joy of surviving, feels real at the end. It's why I love kick-boxing, especially at heavyweight. I want to know there is a threat in front of me, and with heavyweights, every punch thrown is a potential lightning bolt to the breaker. Every single one could shut the lights off in the city, if you know what I mean. Staring at Jason was like staring at a grizzly bear while I stood in the corner with a bowie knife. One of us was coming away from this with a big hurt on them. Fuck. Yes. Bring it. I came to fight.

Time ticked, seconds flew, the stool disappeared. "You hear me, Mark? *Use your length!*" my corner shouted as he climbed out. Time in a fight is something you cannot understand unless you've been in one. Minutes spent in a ring are simultaneously the longest and shortest minutes of your life. This fight, more than any other fight I have ever been in since, was that way. It was as though some bastard

kid had ahold of the remote control to my life clock and was hitting the slow-mo button and fast-forward intermittently. Tick, tick, out of the corner to the center. Take the center quickly, do not let your opponent cut the ring off and close the distance, forcing you into a corner. Tick, tick, as a counter fighter I don't tend to strike first; wait for the shot, then counter it. Take the morale away from your opponent, make him feel unsure and wary of you as he is punished for every move he makes. Tick, a jab and a cross; I countered, but Jason kept punishing me back. Every shot he landed sent a lightning bolt of adrenaline and elation through me, for I was glad to know I was still standing. Every shot I delivered triggered a roar of applause inside of me. The deep smack of leather colliding with a wide panel of stomach, guts shivering. The thud of shin meeting shin as bone clacks together. Three minutes of solid back-and-forth with no letup. Jason circled to my left, avoiding my power hand, so I knew that while it hadn't brought him down, he had not liked the way that shot felt. It's one thing to get bitten by a venomous snake and live to tell about it; that doesn't mean you're heading for the black market in the morning to buy one for a pet.

The entire second round was akin to running naked through a hailstorm. I like to think that Jason would say the same. The back-and-forth was unrelenting and brutal. From the stands, "Oooaaayyyy," over and over, as punch after punch was delivered. Sweat and oxygen were sacrificed; the ring was wet with it. My shins were purple; Jason had small bruises dotting his head. Ding ding. Back to the corner.

"Mark, he's getting tired"—squirt water, slosh spit—"he's tired now." (*No he isn't, dude, look at him, he's over there thinking about dinner later.*) "Mark, you need to capitalize on that, he's wearing down." Ice bag on the back of the neck, pat pat. "He can't keep up, he's wearing down." (*He isn't wearing down, this is going the distance, and who the fuck would've thought that would happen in this fight?*) "Use

that length, and stay out of the corners, *stay out of the corners.*"(*You don't got to tell me twice, man, no part of me wants to be backed into a corner with this big unkillable fucker on top of me. No. Thank. You.*) "Mark, think of your son, fight like he's behind you, fight like he's standing right behind you." (*That's the violence button right there. Thanks for that.*)

Third round I came out fast. Last round is do-or-die time. You'd be amazed at how much you can do in three minutes if you know that after those three minutes, it *will* end. Dig into your reserves, keep your chin down, and don't . . . back . . . down. I felt like I was out of my body. Nothing hurt; it was just survival. Jason and I collided fast and hard. He grazed his gloves over the top of my head, an attempt at a clinch to pull my head down and slam into my face with knees. I shook him off and shot back. Two minutes. He kept circling, trying to walk me down, but I held my center. Give and take, body shots and leg kicks; tomorrow was going to be one of those "stay in bed" type of days. One minute. Sixty seconds left. That big bear stared at me over his gloves; sweat and hot lights stung my eyes. I started to throw, just throw. Jason met me and threw back. Thirty seconds. Just keep throwing, and don't forget to protect home base. My left hand returned to block my jaw after every single jab I threw, my left shoulder taking shot after shot; he wanted me to fall so bad. Ten seconds. This is it. Swing from the fences. The last seconds are the hardest, for you can see the shore is close, you're almost out. My left shoulder ached from throwing, from blocking. Let your hands fly and what happens happens, just fight. Ding, fucking ding. It was all over.

Fights are always kind of a blur. Like the morning following a drunken evening, you find yourself asking others, "What did I do?" after the fact. During the fight it's all skill and instinct. After, it's adrenaline dump, exhaustion, and back to reality.

I crossed the ring to Jason, clasped his glove between mine,

and thanked him. He nodded and said through his thick New Zealand accent, "Ya hit me hard there!" We walked to the center of the ring to hear what the judges would say. I prayed. Closed my eyes and just silently asked whatever, whomever, *Please, please give it to me. Give me the win.* The decision came through. It was unanimous. I had lost.

I can't speak on what a knockout loss feels like, as I've never suffered one. Decision losses are hard enough. The first thing that goes through my head is, *Why the fuck did I just go through that? Why did I go through that entire thing just to lose? What was the point?* Regret, anger, disappointment, self-deprecation. I'd be willing to bet that every fighter directly following a loss has that brief line of questioning go through his or her head that asks, *Why do I do this?*

Jason stood with his hands raised. After waving to the crowd, which was now so drunk and loud I wonder if they even remembered who was who (though we look nothing alike), Jason walked over to me, pausing to tear some of the tape from his hands, and said, "Eh, fuck all this, all right, let's go get a beer, yeah?" Yeah.

Back at the hotel we sat in our tracksuits crowding up a large section of the bar. First we just hashed out the fight itself. He complimented me, said I was strong. More than that, he said my will seemed "uncompromising."

"Man, I hit you with what I had, you know? I never let up on you; most guys don't have the heart for that kind of a fight. You just wouldn't fall down!" Jason shook his head, peppered in bruises, and sipped a lukewarm Thai beer.

"Yeah, well, fuck. I've never had anyone, not anyone that I've hit with my right that stayed upright." I clinked my bottle feebly against his.

Drunk locals filtered in and out of the bar. Women leaned up against us for a while, then left when we didn't afford them the

attention they wanted. There have been plenty of fights where I crowded myself with booze and girls, but oftentimes it's the company of other fighters at that time that means the most, as they understand what it feels like to survive those compressed minutes inside a ring or a cage.

Jason talked about growing up on the streets, defending himself against street gangs who came at him with weapons. He pointed out his scars, explained where they came from. From his birth, the world had whittled him into a fighter, carved into his flesh what he was to be. I didn't share my stories. Stories about your dad being the enemy, taking the harshest beatings in your life starting from when you are young, but always from the same guy, just don't have the same veneer as fending off tons of Samoan street thugs.

At the end of the night, which was more like early morning, I lay on my bed in my hotel room, every bruise, cut, and welt now firmly standing out. As bad as losing is—and it is a *bad* feeling—I got to thinking about the one feeling, win or lose, that followed every fight. The feeling that brought me back to fighting every time. The minute my opponent would fall or the final bell would sound, a feeling of immeasurable relief, as though the clenched fist my heart often felt like had opened up, if only for a moment. It was a feeling that let me know I had come through it and was still standing.

I started to drift off, thinking of a boat. When I was a kid, the town of Johnstown, Pennsylvania, flooded. Johnstown was about thirty miles from where I grew up. I used to play baseball on a field there. The flood was captured all over TV, images of people pushing cars through mud and water that was quickly rising, while houses stood nearby on fire and befuddled firemen watched from dry patches, helpless as the homes burned. I remember seeing two workers in a boat with giant boxes covered with the Red Cross insignia on the sides, paddling toward what looked like a hospital. I

asked my father what was in the boxes, and he told me, "It's blood. For people who need more of it." I remember thinking about what a relief it would be to those people in that drowning hospital to finally get that blood, and how comforting it was to know that even in the middle of a storm, there was someone with a boat coming if you could just grit your teeth through the sticking point and hang on a little bit longer. . . .

chapter seven

Winning isn't everything, it's the only thing.
—VINCE LOMBARDI

After returning from Thailand I really hoped to try to rematch Tommy Glanville. The opportunity arose promptly, and I was offered the rematch on May 5, 2001. Mo was going to be fighting on the same card, only he was going to be fighting in an eight-man tournament. What this meant was that he would have to fight three times in one night, if he was to win. Eight men are matched into four fights; the four winners then are matched into two fights, and then finally, the last two winners fight each other. K-1 hosts tournaments like this all the time, and they are so fucking brutal. A single injury accrued in the first fight could mean a loss in the second or the third. Small injuries that a fighter would normally think nothing of risking in a single fight have to be considered more carefully. A cut above the eye in the first fight could mean the second fight getting called off due to swelling. Never mind the third. Each fight becomes a balance of trying to win and trying to not take so much damage that the next fight is lost. It's a whole other ball game. I was going to help Mo get ready, and he was going to help me. We both took this card very seriously. Mo had the tournament to win, and I

needed to avenge my loss. You see, losing to Suttie wasn't something I felt so urgent about "fixing." Jason was a hurricane; he was a violent, dangerous fighter who had respected me. Our rapport was good before and after the fight, and I felt that he had thrown everything at me. He was the better fighter that night, fair and square. I was satisfied with that and glad that I had survived. I had earned my stripes just for that. But Tommy, Tommy was different. I knew I was better than him, and I needed to prove it.

Something else had happened before this camp. . . . In January of 2001 I became a father for the first time. Amy, my wife, was a nurse in a ward that dealt primarily with small intestine surgeries and transplants. She dealt with a lot of very sick children on a daily basis. Despite our problems as a married couple—and there were many from the beginning—I knew she would be a good mother, so I had no problem going ahead with planning for a child. At least, not until he was here. Then I was scared to death. This changes any and every human being who is fortuitous enough to be blessed by parenthood. Some for good, some for bad. It shifted my insides around and put a new kind of love, and a new kind of fear, in me that I had no idea I could feel. I was simultaneously more in love with my tiny son, Ben, than I had ever been with anyone or anything ever, and scared of him. The entire reason I fucking existed suddenly was there, in his eyes. I was also petrified of screwing it all up. I was afraid of being a bad father, afraid that somehow I would inadvertently repeat or reuse my father's "parenting techniques." The mixing of this incredibly deep love with this horrible crippling fear and desperate need to protect him made me feel so lonely and sad. I became convinced I wasn't good enough for him. It was as though I had been handed the greatest gift on earth, and yet I knew if I touched it I would break it. The day of his birth I received a call while I was in the hospital. I was offered a fight against Kakuda, a Japanese fighter. I had accepted right away since I just wanted to get

away to think, to feel safe in how much I loved my newborn son. That fight was pulled, just like the last Japanese fight I had been offered, and replaced with the offer to fight Glanville again. With the opportunity to train again with Mo, who was already a father, and hopefully glean some sage wisdom on how to do this dad thing, I jumped at the chance to leave, even though it killed me.

Because of these things, I went to dark places for this camp. I used to sit during drills and visualize the crowd booing me as I walked out, throwing things at me, hating me as I entered, loving Tommy and his comical bravado. I visualized them shouting at me, and all of that irascible moxie would just fuel me, make me want that much more to tear him down in front of all of them. As I would push further into these bitter thoughts, Mo would suddenly quip, "Hey, man, focus!" Or something similar. Then he would make the "So what?" face. That would yank me right out of my anger pothole and back to reality. Vengeance is one of the roads one walks to avoid focusing on the immediate moment, and Mo, armed with his halcyon strength, was committed to bringing me back to that focus. He did his best to force me to abandon my pursuit of retribution, which was as much if not more aimed at myself and my failure than it was at Tommy. Obsessiveness is one of the less dazzling traits you'll find in most athletes. This is doubly true for me.

Mo was facing possibly fighting Duke Roufus (Rick Roufus's brother), Paul Lalonde, Pedro Fernandez, Tomasz Kucharzewski, Michael McDonald, Jean-Claude Leuyer, and Gunter Singer. Mo wasn't worried, as Mo doesn't get worried about fights ever. But the greatest concern for us as his teammates was Duke. Duke wasn't at the level of his brother Rick, but he was still a talent. So we worked to prepare Mo for all possible matchups and focused on what might be the most difficult, imitating their styles as we went along.

I had elected my friend Jason Johnston to be my cornerman. Jason is exactly the kind of man you want in your corner, liter-

ally and figuratively, and this could be plugged into really any circumstance in life. He is the ultimate in backup. Jason was a recon marine before he went into kickboxing. He dabbled in Ironman competitions and fitness figure modeling, alongside being a talented heavyweight kickboxer. Jason had an absurdly sunny disposition, and he was honest to a fault. The guy just leaked positivity and calm. He never buckled under pressure, and he never got heated when things got tense. He was also bullshit-proof. He would tell me exactly what I needed to do in between rounds, without sugarcoating it but without shouting at me. I knew that if I couldn't have Mo in my corner, I needed an equally cool and honest head there to talk to me. Jason was perfect. A few days before the fight, I flew out. Jason and Mo met me there. This time I was fighting at the Mirage. While we in the lobby, Jason commented, "Do either of you act any different before fights? It's bizarre how calm you both are!" To this Mo responded, "Just another day at the office, right?" And promptly flashed the face.

A mutual acquaintance of ours, another cornerman, saw all of us standing together and came over. He smiled up at Mo and said, "You still doing this? You're an old man!" to which Mo deftly responded, "Yeah, but I'm a bad old man." Maurice Smith was almost forty at this time, which is practically primordial for a kickboxer. He had accrued no injuries in his time as a fighter, looked not a day over twenty-eight, and he moved exactly like the twenty-eight-year-olds, so not only was this not an exaggeration, it was possibly a downplay of just how fucking bad he really was.

The days leading up to the fight were standard. K-1 treated us very well but also put us through our paces when it came to promoting. Back then everything in kickboxing was run by Japanese businessmen, with Kazuyoshi Ishii at the helm. Ishii was the epitome of what you would expect from a high-level Japanese businessman and martial arts master. He was always well dressed, and he always

presented himself with maximal class. He demanded the same level of poise and gentility of the fighters he brought to fight in his organization when they were not in the ring. You were required to show up at all press appearances on time, well groomed and in a suit. You were expected to behave yourself. Speak when spoken to, answer the questions asked of you to the best of your ability, and never interrupt or shout either at a journalist, at other media personnel, or at another fighter. Ishii frowned on clownish behavior. He didn't value shit-talking or bashing between fighters. He valued fighters who put on a show worth watching. You didn't have to win, but you had to show fighting spirit. Like the Japanese fans, Ishii wanted to see your heart.

One night on the evening of May 4, Ishii had requested that all of the fighters come to a nightclub in Las Vegas located inside of the Hard Rock Hotel. We were there to do promoting for the fights, meet with media, do some TV interviews for networks, and just generally be available. I was less than thrilled by this, as it was the night before the fight, and all I wanted to be doing was resting. At one point I looked over and saw that Ishii was sitting by himself. My bravery rose and I approached him and sat beside him. He turned to me and smiled. "Mr. Miller, are you enjoying yourself?" His English was a bit broken, but he spoke enough to be a true gentleman and ensure the comfort of the fighters he was employing at any given moment.

I responded, "Yes, sir. I just wanted you to know, I am the American fighter you are looking for, and tomorrow night I will prove it."

He smiled and grasped my hand firmly in his. He seemed pleased with my self-assurance. I stood, bowed to him, and bade him good evening. As I walked away, I felt the bag of bricks I had just harnessed to myself pull at my neck. I had promised Ishii I would win. Fuck it. All the more reason. Now I really had to.

The next day at the venue I sat listening to the announcers call

the fights. Mo fought his first two fights before me, so I was partially distracted, paying attention to how his fights went. Mo fought Pedro Fernandez first. He won, in a unanimous decision. I didn't get a good look at him when he came in the back. I was still focused on myself and what I was going to do. A win was what we wanted obviously, but with a decision it meant he'd spent more time in the ring and in the fight, so there was a possibility that he might have taken damage. It was unlikely, as Mo's style was to take little damage, but the potential was still there. I wasn't sure if he had, so I waited and listened. A half hour later he fought Gunter Singer. At the beginning of the second round, Mo crushed Gunter with a right-hand. The crowd roared. Mo came into the back and glanced at me. I was warming up at this point; I caught his eye just for a moment, just long enough to see that he was unmarked and to see him make solid eye contact and give me a thumbs-up. A few more fights passed and someone from the organization came in the back and called my name. "Mr. Miller, we are going to have you and Mr. Glanville walk out at the same time. So you will meet in the hall and enter the ring together."

Uhh. What the fuck?

That is never how it's done. This threw me. Typically you walk out at completely different times. I mean, you don't even come near each other until the first bell. Fuck this. I didn't want to see him before. I didn't want to nod and fucking half-smile and be forced into either uncomfortable silence or fake pleasantries before I went to beat this guy's ass; no thanks. That's for after the fight. At the end, when it's done, it's a job, and whoever wins wins, and you buy each other beers and it's all water under the proverbial bridge, but before? No.

And I didn't have a choice. Because this was what the powers that be wanted.

I was stomping at the ground by the time they brought me out

to the hallway to walk out. Tommy's big blond head was barely visible on my periphery. I refused to turn and look at him. Nothing personal; it was just better for both of us this way. We got the signal and started walking out. The crowd was booing me, ferociously. This was Tommy's town. As we walked, they started playing a clip from an interview Tommy had done two days before. They had been very secretive when he had done this interview, and I couldn't understand why. It all became apparent in the seconds it took me to get to that ring. I looked up at the screens just in time to hear him say, "Mark is from the Iron City, so that's where his chin was forged. He's really tough. But tonight, he's my bitch."

The crowd roared with cheers. I whipped my head to look Tommy full in the face right before we entered the ring and just started laughing. "Really, Tommy?!" I shook my head. *All right fucker, it'll be like last time, only this time, you won't get up.*

Tommy was in the corner shimmying like a show pony. First bell sounded. *Let's go.*

I came out baiting him. The game plan was to keep everything straight down the pipe, let him back me up, and then unload. Fighters get cocky when they think they are backing you up. They get brave. I let him drive me back a few times, clinching on him when he got close. He threw a few low kicks, and I checked them. He hated it. Absorbing the impact of a kick on your thigh is stupid, because you can't do it very many times before your leg is dead. But if you lift the leg being kicked, stiffen the lower part of the leg, and "check," or take the impact on the shin . . . Trust me. As bad as it might hurt you, it hurts them far worse. Tommy was pawing at me. I was circling out, frustrating him. He feinted a low kick and I lifted my leg to check, but he went for my back leg instead, dropping me to the floor. As I was pushing to get myself up, he placed his fucking foot on my back, as if he was going to stand on me while I was on all fours. The ref yelled at him to get back in his corner. I got up. A few

more pitty-pat exchanges occurred and then I was back in the corner. Tommy had me angry.

In Tommy's corner he learned that he had a split over his eye. He also got told by his corner repeatedly to not "follow [me] around." Tommy had a weak gas tank, and he tired easily. They couldn't figure out how I had made contact with him, and now they were worried. Shit was happening that they hadn't counted on, and Tommy was getting tired. I was in my corner fresh as could be.

Second round started and he began pawing at me again, desperate to gauge distance. I threw a right kick slicing directly at the top of his thighs. It hurt him, and off of that I threw a knee directly to his sternum and circled out. Tommy followed me, followed me, followed me. . . . I threw a kick, and he checked it, but I got a solid jab and a cross off on him. The cross bobbled him. He stepped back. Eager, I rushed in and threw another big cross, which he sidestepped, and I threw myself off balance and ended up on the floor. Tommy came up behind me and pretended to hump my back. The crowd cheered. I have no tolerance for this bullshit. You wanna showboat, fine, but you better beat me decisively now; otherwise, you're going to look like showboating is all you have. And I intended to exploit Tommy the next time he fucked around in there.

The ref scolded Tommy, recommended that he cease with the shenanigans, and Tommy feigned feeling contrite. He came back with his paw bullshit again. Then he jammed me up, hugging on me so tight the ref had to pull him off. I could feel his breathing getting labored. I threw a spinning back kick that was ill timed; I didn't have enough distance and I just knocked myself off balance. Pause; okay, back to it.

I came out with an ax kick. Crowd liked it. Tommy flashed slight concern before jamming a kick into my thigh. *I'll take it for making*

you look like a boring pud. You got jokes? I got skill, motherfucker. We clinched up a few more times, and the bell sounded.

I went into my corner, and Jason smiled and asked how I was feeling. "I feel good. And I think I hurt him."

"He's not looking so fresh, Mark, that's for sure."

And he wasn't. I was pacing in my corner. Tommy was plunked on his stool heaving away. Big muscles need big oxygen. Tommy was built for looks, not stamina. I may not ever have had Tommy's size, but I don't wear out in the second. I started punching into my gloves with fifteen seconds to spare. "Let's go let's go let's go."

Tommy pulled himself off the stool, a deep breath following before his mouth guard was put back in. He met me in the center and hugged me. Third and final round. I appreciated it. Not two seconds later he clinched me up again and turned me around to face the crowd. This time, I showboated. Throwing my arms up and shrugging at the crowd as if to say, "Hey, he clearly came here to hug, I came to fight." The crowd cheered for me. Tommy shrugged and looked irritated. I had gotten his goat.

I threw a kick and it grazed the top of his cup. I paused and offered my glove. Nut shots happen in fighting; they aren't intentional (unless you're a complete dickweed and you don't trust your skill to get you by), but it's only right to put your glove out if you think you might have grazed a guy. It's the universal sign for "My bad; sorry, dude." Tommy patted at his groin for a second, then gave me a glove bump, as if to say, "All good."

I threw another kick, and Tommy grabbed my leg, backing me into the ropes. As my back was against the ropes, I felt him cranking my leg higher and higher. . . . This motherfucker was trying to dump me through the ropes. I pitched my body forward as the ref pulled him off of me. . . . But I was firing on all cylinders now. I was done fooling around.

I came straight at Tommy with a series of jab/crosses, three to be exact. The third cross dropped him to the canvas. Tommy was, as they say, "on funny street," looking to see which house was his. His legs were rubbery as he got to his feet at five in the ten count. He rolled his eyes and marched around the ring, trying to tell everyone watching, *I'm fine. I'm totally fine.* The ref waved for us to go back to it. I rushed in to finish and he kicked my legs out. I got up and threw a kick as Tommy landed a cross. We clinched up and were broken apart. I had a fuse burning behind my right elbow; I wanted to hit him hard. Then my opening came, and I hit Tommy so hard his head went winging to the side. If he hadn't been backed up to the ropes he would've crumpled. Instead he leaned on me and locked his arms around me for balance. Once again, we were broken apart and told to go at it once more. I fired off a few more shots and the final bell sounded. The bravado melted, all the showboating stopped, and the hostility faded. Tommy crossed the ring and hugged me, even planted a kiss on my cheek. I smiled. We thanked each other's corners. Fighters play reserved and bitchy until the fight is over; after that, unless I really never liked you, there's no reason to hang on to it. We just beat on each other for nine minutes. I'm over it.

I stood in the middle waiting for the announcer to read the decision. . . . Split decision. That means two judges had it one way, and one judge had it another. I started praying my ass off. *Come on, damn it, just give it to me, I earned it.* . . . The announcer read that one had it scored for me, another had it scored for Glanville, and the third judge had it for me. I fucking won. The crowd lost its mind. I bowed to them. Shit had just changed in an instant. I had just avenged that loss.

On my way back to the lockers, fans were throwing things at me to sign, girls were grabbing me, and guys were patting me on the back.

I walked into the back as Mo walked out for his final fight. My high from my win was keeping me elevated, but this was serious. My mentor was fighting the final fight for a tournament. I kept my ears open to listen.

The commission came into the back and started looking me over. I started getting incredibly antsy. *I'm fine, I just want to hear about Mo.* Round after round passed. At the third I couldn't figure out just by listening who had it. Then I heard it announced: draw, one more round. In K-1, if a draw is declared, then the judges can request that the fighters fight another round. To get another round in the third fight of the night is a nightmare call. Mo had just gotten it. I was ready to throw those commission guys off of me and go running out to the hallway to watch. Mo's final round started. I was fidgeting in my seat.

The round went to a decision. This could not have gotten any more stressful. I needed him to win or my win wouldn't feel as good. I actually cared about him. His wins mattered to me almost as much as my own. The announcer began to read the final decision. Split decision. *Holy shit, I'm going to have a heart attack tonight.* I listened. . . . *Mo won.* I let out a bellow so loud the entire crowd in the back fell silent.

After a few minutes Mo came sauntering in. He looked around, and his eyes settled on me. He walked over and stuck his hand out, and the first words out of his mouth were, "How did you do? I couldn't hear it, how did you do?"

I stood there stunned. . . . "I won, Mo."

"Oh, that's great, Mark! Congratulations, good!"

He looked . . . relieved.

"Mo, who gives a shit how I did? You just won an eight, man! That's fucking crazy, man! You won!"

Mo shrugged and just said, "Yeah, but you won too, so that's good."

As he walked away I felt for the first time what it must feel like to have such a familial bond with another person that you celebrate their successes as much as you do your own. Where you don't compete with them to be better. Where your successes are allowed to be your own. And I felt that that feeling was returned, by one of the greatest American fighters who has ever lived.

chapter eight

If thy brother wrongs thee, remember not so much his
wrong-doing, but more than ever that he is thy brother.
—EPICTETUS

In every one of the fighters I met I was searching for a connection. I was searching for a brother, not unlike the one I felt I had lost—and I lost Colin many years before he died. I loved my brother. Just admitting that makes me feel like someone opened up my rib cage and ran their fingers over my guts. I don't know if I have ever admitted that before now to anyone but him, and even then, it was so very long ago. But I did. I loved Colin so much that it was torture watching him break down, and turn into what he became, and lose all of the traits that made him what he was to me. What hurt the worst, though, was feeling him abandon me and, instead of acting as my big brother, becoming a person I had to worry about, a person I almost had to shield myself from. He was supposed to be my protector.

Colin Kelly Miller was born July 30, 1962. Colin's mother was one of the many marital casualties my father left in his wake. Colin, being the by-product of their brief marriage, split most of his childhood between our house and his mother's. I never met

his mother, even when we would take him there, as she would stay cloistered in her house, never come out to say anything, probably because my father was always there, and my father was not exactly on good terms with any of his exes. He wasn't really on good terms with anyone.

Even though I have five other brothers and sisters (that I know of), Colin is the only one I ever knew. Colin was ten years older than me. When I was five years old Colin was fifteen; he was tall back then, five feet eleven, with blue eyes and gritty good looks in his youth. He always looked older than he was. He listened to Bob Marley and ZZ Top, and he had a way of "holding court" with people. Colin was charming and incredibly manipulative. While I learned how to fight, he learned how to beg, borrow, and steal his way through life. Most of the people Colin ran across never knew that they were about to be swindled. Most of them never knew to blame him after they had been.

Colin was a button pusher. One of those kids who liked to push people to see what would happen, a trait I may have, to some degree, learned and adopted. Where Colin was more naturally aggressive, I was more resilient. Colin liked to provoke my dad, liked to stand up to him, get in his face in the beginning. I knew well enough to keep my fucking head down, and even that didn't always help. Colin just didn't bounce back as well from the consequences. After every time he and my father would go at it, Colin would disappear for a few days. He would run out the door with a bag slung on his back grunting curse words and blistering epithets at my father, all forced through gritted teeth that were holding back sobs. It got to him. He would always pause at the door to glance back quickly, but Dad never chased after him. Not to punish him further or to hug him in apologetic contrition. Once my dad was done kicking the shit out of you, he was done with you, period. "One crime, one punishment," he used to say. The cruelty in the house wasn't something Colin

could hunker down and absorb the way I had tried to do. Colin was a violent-tempered crustacean pulled out of his shell, totally vulnerable and ill equipped to be in the family he was born into. I often wondered if subconsciously he went at my dad hoping that over time he would be able to form a callus over himself against the physical and emotional brutality. Let's face it, we all want to believe that we can survive the ugliest of wars when they come to us, and we all cringe at the recognition of our own frailty. Colin was sensitive naturally. It was what made him so empathic, and therefore capable of tapping into people's simple needs and making them like him, trust him, so he could get exactly what he wanted from them.

Around the time Colin turned sixteen he was getting in a lot of trouble. I wasn't privy to a lot of what exactly was going on then, and I sure as shit wasn't going to ask questions. I found out bits and pieces via my mother. Drugs, car thefts, prostitution rings, robberies, scams, assault . . . The arrests piled up. He was never around. And he wasn't right anymore. If it wasn't one drug it was another, or booze, really whatever he could get ahold of. He became a garbage can, just filling up the holes with quick escapes. At eighteen Colin got arrested for being part of an auto theft ring. The judge gave him two choices. One, hard time. Two, go into the military. Colin was secretly terrified of prison. Plus, he knew enough to know that as far as the public is concerned, you come out of prison, you're an ex-con. You come out of the military, you're a soldier. Regardless of what the person has learned or not learned, one affords a far better tint to be cast over them.

I don't know exactly how long he served for. I know that he was eventually kicked out. I don't know the specifics, but I know that he got out of serving a prison sentence, which was all he cared about. Shortly after leaving the military, he came home for Christmas. I was fourteen or so then. Colin walked in wearing a ZZ Top T-shirt that looked like he had slept in it. I knew immediately that he was

different. He was distracted and sort of vacant. He sat down next to me and started small-talking. About the snow. About the food Mom had made the night before. Then suddenly he started talking about Dad. Dad wasn't in the room, but I remember how nervous I felt, knowing he could walk in at any moment. Colin leaned in close to me, his pupils shrunken. He told me that Dad had beaten him so bad one time that blood had flecked the walls, where he could see it spray every time a new swat landed. He told me that Dad had beaten his mom up, that she had told him about how horrific it had been being with him, how violent he was. He regaled me with tale after tale of his having to fight to survive, how he had been beaten nearly to death multiple times. My head was swimming with wondering what was real. Why the fuck was he telling me this? And if this was true, why had he left me for so many years to deal with this, to defend myself alone? He told me that he couldn't forget about those times. He told me that every time he tried to sleep he would wake up fighting the sheets, terrified that Dad was there. He said that he just needed to get out of his head, and that was why he did so many things that got him in trouble.

I don't know why he felt compelled to share this with me. Colin always had an agenda. No story was ever delivered without a reason. I just don't know what the reason was. Why at that moment did he decide to tell me all of that? Was this his sick way of bonding with me? Of sharing that he somehow knew how bad it could get? Was he trying to protect me? Was he telling me in his own way to get away? God knows we never spoke about it before or after that. I don't even know if all of what he fucking told me was true. And I can't fucking ask him now. . . . Not that he would tell me the truth if I could.

The next day he left. He seemed rushed. Just told everyone he had to go, and he left. The day after that, very early in the morning, the phone rang. It was an odd time for a phone call, so I strained to eavesdrop, as I was curious. It was Colin calling. He was in jail. He

had left the house and driven as far as Ohio. Once he got there he had gone into a bar. My heart ached. Colin in a bar was a bad thing. I never saw him actually take drugs, but I saw him drink an unholy amount on several occasions. Like other addicts, he might start off slow, but it would snowball quickly into a slew of shots and bottle purchases, and then the real "fun" would begin. It was never "just one." Never. Colin didn't need a lot of time to escalate either. He could put away a lot of booze very quickly. Apparently he had wandered out of this bar, and no sooner had he gotten behind the wheel and turned the key than the cop behind him hit his lights. He had been waiting for Colin to come out. Colin was sitting in some shit jail in East Bumblefuck, Ohio, drunk and giving my dad his snake-oil "feel sorry for me" spiel to bail him out. My father was pissed off, and for once I didn't really blame him. Colin didn't even try to avoid trouble anymore. He just did stupid shit constantly and with such arrogance, or maybe he just didn't care. Either way, he still hated being in a cage, and there he was pleading on the phone with the most unsympathetic human being on the planet to get him out. To my utter shock, my dad agreed. The condition was that Colin had to handle paying back the bail bond on his own and that he had to show up for his court date, which he too quickly agreed to do. Bail was posted and Colin disappeared into the ether. When Colin's court date came up, he never showed. That day my dad turned to my mother and said, "I am done. I am done with him, forever." And he held to this promise. Years would pass and Colin would call on birthdays, on Father's Day. My mother would always answer, and Colin would ask to speak to my dad. She would come up with some watered-down excuse, say he was in the bathroom or busy. Meanwhile my dad would sit close by, waving his hand and mouthing the words "No, no, I won't talk to him." This went on for years. He froze him out completely. I felt stuck. I couldn't fix the relationship between them. I couldn't save my brother; he didn't want to be saved. I wavered

between agonizing yearning for him to be in my life and roiling anger at him because he didn't want to be there enough.

Without family functions to bring us together, I didn't see Colin anymore after that. I heard through various people where he was—North Carolina; Washington, DC—but I didn't see him, not for long stretches of time. I was living my life and he was living his, if you can call that living. My wedding happened, and he wasn't there. My children were born, and he was absent.

In March of 1994 I was driving through Latrobe. It was right around my mother's birthday, and I was going to take her out. I stopped at a red light right near Saint Vincent Cemetery, the cemetery my parents would eventually be buried in. A horrifically junky car pulled up next to me, and in my peripheral vision I could see the driver waving to get my attention. I turned, and there was Colin. He looked awful. Like some animal had been using him as a chew toy. I rolled my window down, a half smile on my face, and he said, "Excuse me, but do you have the time?"

There was no sarcasm in this question. He wasn't doing it to be funny. That slaughterhouse glazed look in his eyes told me this. My own brother didn't know me. The smile left me and was replaced with a stony look, hiding the crumpled-up feeling inside of me. He had no idea who I was. I stammered out the time, and he thanked me and drove off. Never a fragment of recognition passed over his face. Not one blip of a signal to tell him that this man whom he was speaking to was his flesh and blood, his brother. All systems running in him were down. He had succeeded in escaping so far inside himself that even family had become foreign. Somewhere inside my heart I felt strings break.

It wasn't until Father's Day of 2006 that I actually saw him face-to-face and had a conversation with him. I didn't mention the red-light encounter and neither did he. My feeling is that he wouldn't have remembered it if I had. I was amazed to see him at a fam-

ily gathering. He had weaseled his way into seeing my dad again, mostly by the clever use of a current girlfriend who was motivated by her own selfish gain. Inevitably the whole day was uneasy, and it didn't help when Colin started asking for handouts. That day ended badly. After that I saw him around occasionally at bars. I drank socially then, but it was rare. If he was there, I'd sit with him, I just didn't have the strength to try to avoid his addiction, and I didn't care. Half the time if I didn't tell the bartender ahead of time not to allow him to put anything on my tab, he would start running it up the minute he saw me sitting there. I would never chase him down or try to get the money out of him. I would just accept that I should have been more careful, and I would pay the tab. I dealt with the fact that this was as much of a relationship with my big brother as I was likely ever going to get, and I still wanted one so badly that I just accepted it somehow. I just didn't know what to say to him anymore, especially if we weren't drunk.

chapter nine

Courage is the resistance to fear, the mastery of fear,
not the absence of fear.
—MARK TWAIN

I am a fighter, which means that to some degree I had to get comfortable with doctors, hospitals, and injuries very early on. I am also a man living with a congenital heart defect (CHD) and type I diabetes. It is interesting for me now to think about how little those conditions affected my life, how they never made me feel any different, any less strong, until they did. That was partially my father's doing. He wouldn't have me feel any less strong, health conditions or otherwise. I faced countless surgeries on my feet, my knees, my shoulder, my face, my back, all because of the career I had chosen, and I faced them with a knowing shrug and almost a smile, aware that I put myself in a position to incur these scars, these badges. I was never sidelined by CHD, only by things I had invited upon myself. . . . Until finally, it caught up with me.

In 2004 I became a father another two times over. My wife gave birth to twins. It was both wonderful and heartbreaking, as our marriage was truly on the rocks. The pregnancy and birth of my sons Ronan and Patrick delayed the inevitable for a while, though I was not

emotionally available to Amy, and my eye was wandering. My career was not quite at the level I wanted it to be at, and much of that was self-inflicted, as I was now a professional at self-punishment. If I didn't perform well in a fight, I took all the tools my father had ever given me, went into a depression, and castigated myself for months. Now that I had "bad father" and "lousy husband" slowly being added to the list, I could barely stand myself. In 2006 I moved to Austin somewhat temporarily. Truth be told I was bouncing all over the place just trying to find someplace to be. I was trying to get away from Amy, and I was afraid of staying close to my kids. Maurice and I had fallen out of contact and I was too shy to try to find him. That spring I had been told about something called the S1, a kickboxing organization that would be putting on fights in Miami, Florida, in August. They wanted me to fight. So, in the month of June I went back to Pittsburgh to get my medicals. It wasn't uncommon during a routine checkup to have the doctor clearing me look startled at the sound of my heartbeat. It was highly aberrant and had been since I was born. A few times in the past I had been sent to get EKGs to make the promotions feel more comfortable about clearing me. I had never run into a problem. I had a weird valve, one that would need to be replaced most likely when I was in my fifties; that's what the doctors had told me. By then I would be done with fighting, so I never worried. This time, the same thing: the doctor requested an EKG. I huffed and puffed but I went ahead and booked it. A few days later I went and had the EKG. The doctor called me later that day and told me, much to my shock, that I should go and see an actual cardiologist. Something was off. Of course something is fucking off, I told him, you know me, I have a weird fucking valve. Regardless, he sent me to a heart-specific doctor "just in case." A few years previous I had had to jump through similar hoops. My cardiologist that time had put me on a treadmill and made me do a "stress test," where they hooked me up to all kinds of electrodes and machines, and I ran as they slowly elevated the tread-

mill and increased the speed. At about a minute in I had grabbed my chest and started shouting, "Oh my God, I feel so light-headed, what is happening!" The nurses freaked out, and the doctor, white in the face, ran to pull the plug on the treadmill. Before they could shut me down I started laughing and begged them to increase it. I ended up running at the highest elevation at the top speed for five minutes before they felt satisfied. I also got the highest rating on a stress test ever performed in that hospital, and a whole lot of angry looks from the doctors. The bright spot now was my looking forward to playing my mean little trick all over again.

The cardiologist requested an echocardiogram. After I had it I made time to go and visit my orthopedist. I had had back surgery ten years previously. I was training very hard and my back had started bothering me again. He decided that it was essentially overuse, and he suggested that I stop training for a while. I smiled at him, shook his hand, and decided that I would be totally ignoring that advice. I had grown incredibly good at ignoring doctors. As I was walking out of the building from visiting my back doctor, my phone rang. The office of Dr. Staffen, my cardiologist, the one who had performed the echocardiogram, was calling me. I answered and the nurse told me to be in his office first thing in the morning.

"What is this about? At least tell me what the fuck this is about," I grumbled at her. My tone was terse, but my heart was jumping. I knew enough to know it isn't a good thing when a doctor demands that you see him right away.

"I can't tell you any more, just be in his office first thing in the morning." She hung up quickly.

I didn't sleep more than ten minutes that night. The next day I walked into Dr. Staffen's office and my ass was barely on the chair before he decided to let loose with the "good news."

"Your ejection fraction is hovering around twenty percent, Mark. A normal person's is sixty-five percent. Your heart is in bad shape,

my friend. Very bad shape. Not to mention your left ventricle is now enlarged given how much you have been taxing it, and to compensate for the malfunctioning valve. There's no way I can give you my blessing for this fight. No way. It would be a suicide mission."

I should mention . . . I have a serious problem being told what I can and cannot do by anyone, much less a guy in a white coat who has clearly never set foot in a ring or cage.

I didn't feel fear initially. It was odd. I felt anger. Intense, violent anger. I wanted to flip the doctor's desk over and grab him by his neck. I wanted to scream at him, "What the fuck do you know? You don't see how I train. You don't get to tell me what I can and can't do. *Nobody* tells me what I can and can't do. You're not my fucking dad."

And I *liked* Dr. Staffen.

Instead, I asked, politely, and through gritted teeth, for a second opinion. He gave me the name of some doctor over at Allegheny General Hospital. I called and made the appointment for July 5 to have a transesophageal echocardiogram.

Now, I don't have a problem being anesthetized. I have a problem with the idea of waking up in the middle of a procedure. To do this particular echocardiogram they feed a camera down your throat to get readings of your heart from a closer proximity. They also knock you out to do this, because human beings statistically don't like having cameras stuffed into their throat while they are awake. In fact, they tend to get relatively combative. I was reassured many times that I would not wake up in the middle of this procedure. Well, I woke up during the procedure. I started flailing and trying to scream, which caused me to gag violently. Thankfully, it was at the end of the procedure, so they had already gotten what they needed. I was restrained and pinned down as the tube was fished out of me, then turned to my side as I continued to gag and retch. Needless to say, I wasn't in the best mood when the doctor came back to read me my results. Some flimsy bearded jerk-off in a set of heavy glasses and

a white coat, with the bedside manner of a houseplant, came over carrying a clipboard and told me, without making eye contact, that my career was over. This pasty little prick who probably had never even lifted a weight in his life, much less been an athlete, told me that my fucking ejection fraction was actually 15 percent, that my fucking left ventricle was definitely enlarged, and that if I continued to pursue training I would probably fucking die. That my future would definitely entail surgery and a mechanical valve, which would put me out of work as a fighter forever. I blinked at him and nodded, hardly hiding my distaste for his snide demeanor. He started discussing the specifics of the surgery I would need and I cut him off with a loud *"Can I go now thank you"* and made for the door with him calling after my back, saying, "Mr. Miller, I highly recommend that you look into getting this surgery."

I got on my plane back to Austin with absolutely no intention of pursuing surgery. If the end result was that I would die in the ring, then so fucking be it. I just didn't care. But I was going to fight, at least one more time.

Austin is next-level hot in the summer. In the United States, there is nothing harsher than a Texan summer. It isn't just hot, either. It is humid beyond belief. We are talking occasional highs of ninety-five degrees with 90 percent humidity. A simple stroll down the street feels like walking through sheets of hot syrup. People hide in the summer. They either bounce from one air-conditioned building to the next, or they post up at the river and float half-submerged in water, drinking Lone Star for hours, until they have thoroughly pickled themselves. I had been training at a gym in Austin called Randy Palmer's South Austin Gym. While training there I had met Justin. Justin is his own breed of human being, and it is the best sort. He is the brother I always wanted. Justin is as open-minded as he is moral. He is accepting, and empathetic, and hard-nosed about human kindness. When I first met him he was a chef at a fine res-

taurant. He came into Randy's to train in kickboxing; he was familiar with Muay Thai, as he had previously been to Thailand, where he had done a stint as an English teacher. Justin was gifted gypsy feet when he was young. His mother was an author and afforded him a life lived all over the world as a child. Her career didn't tie her down, so she moved constantly, and this meant that she raised an incredibly worldly and compassionate person. Justin looked like he should have been a bouncer. The first time I saw him he came to one of the classes I was teaching at the gym. He was six feet two and huge with a flattened nose from multiple breaks, enormous broad hands covered in scars, and a freshly shaved head, standing in a ratty T-shirt and gym shorts. He looked like an old-school British pugilist. But the influence of a life lived abroad, a life touched by an abundance of culture and difference, glimmered through Justin at all times. We connected very quickly, mostly through bad jokes and an appreciation of different things—music, art, and food. Justin invited me to his restaurant, and I invited him to my classes, and eventually to be a person whom I trained one-on-one with. This wasn't just me training him. Justin was a fast learner, and he helped me too. Justin was the closest friend I had had since childhood. When I returned from Pittsburgh we met at the gym to train. He immediately asked what the results had been. I tried my best to bullshit him.

"Mark, seriously? I don't know if anyone has ever told you, but you are total shit at lying, man. Now, what did they say? Is it your valve?"

Justin's inky eyes were drilling into me and his expression was shifting from one of mild irritation to one of worry.

"The guy said that my heart needs surgery, but it's whatever. I'm not doing it before this fight. The end. No more. So let's just train."

I turned around, feigning annoyance. Justin snorted behind me and muttered, "Oh, *yes, sir.* Terribly sorry to have put you out, *sir.*" He started gathering pads up and climbing into the ring.

We trained like this for few days, neither of us really saying anything. Justin was right. I've always been a bad liar. I can't hide very well, so I default to what I was taught. You come under fire, you just bark at people and they leave you alone. Justin wasn't afraid of me. He didn't buy my idiotic posturing, and he actually loved me like family, which made him a bigger threat. I didn't want my mask of stoicism to slip in front of him. I didn't want him to see that I was actually scared and he was the one person who might have been able to coax it out of me, so I was rude, dismissive, and standoffish. Finally one Thursday, everything changed.

Justin had been tolerating my self-indulgent pouting since I had returned. He hadn't pressured or pushed on me further, and he even allowed me to show up and really not talk at all. In true Justin fashion, he was just there, without requirement or demand; he was just there to support me. This Thursday it was particularly sweltering. The walls were sweating, it was so hot. Thick rivulets of condensed sweat collected and oozed down the peeling walls of the gym as we trained. Justin and I were in the ring, doing some pad work. He had brought the suitcase pad, a pad designed to be held by a little handle and braced against the lower leg for the person throwing to practice low kicks against. I was throwing kicks for one round, during which Justin's eyes kept flickering across my face strangely. At the bell Justin suddenly threw the pad down and turned away from me, mumbling, "Yeah, well, we're fucking done for today, dude," rubbing his brow with his fingers in a totally vexed manner.

"We're *done*? What do you mean we're *done*?" I pulled one glove off and started walking toward him. "That was one fucking round! I know it's hot, but what the shit, Justin? . . ." I pumped extra venom into my inquisition. Justin was pacing around, avoiding me, his back to me. Something was wrong, and I was defensive. Suddenly he whipped around, his expression a twisted mix of concern and anger. He came within inches of me. He didn't yell. Justin didn't yell.

Instead his voice took on a parental tone laced with irritated exhaustion, and he spat his words through gritted teeth.

"You know what, why don't you go look at yourself, Mark? Just go have a look at yourself. You're blue. You're fucking blue in the face, and I'm not going to stand here and cosign on to your self-destructive bullshit." He reached a hand up and wiped sweat from above his eyes. Either the heat was doing it, or Justin was near crying. His eyes were red and shining. "You look like a fucking corpse, Mark, goddamn."

I muttered something. Something abrasive and flippant, but I ducked under the ropes and made my way to the bathroom. Truth be told, I didn't feel right.

In the bathroom I walked in with my eyes down, approached the sink, splashed water on my face, and glanced up almost as if by accident. I was trying so hard to be casual. It shook me to my core to see myself. I had no color at all. My lips were a sort of fish-belly gray. There were minor shades of difference between the whites of my eyes and the rest of my face. I looked like what I was, a piece of garbage just circling the bowl. Nearly dead. And scared out of my fucking mind.

I walked out of the bathroom to find Justin standing right by the door. I tried to smile.

"Dude, I look like shit." I laughed.

Justin didn't crack a smile. He folded his arms across his chest and cocked his head to one side. "Yeah, I know. I know you do. You look awful. Now, call your doctor." Then he handed me my phone.

I made no effort to protest.

I called Dr. Staffen, whom I had also informed that I had no intention of having surgery before I left Pittsburgh. I told him that I may have made a poor decision initially and that I wanted to discuss my options.

Dr. Staffen put me in contact with the Cleveland Clinic, currently the best hospital for cardiology and heart surgery in the country. I was clear, clear as a bell that I wanted to come back to fight. I

didn't care how. There had to be a way. Dr. Staffen did the legwork to place me at the Cleveland Clinic and in the hands of Dr. Gosta Pettersson, the man who would be doing my surgery.

The options were discussed. Having a mechanical valve put in was off the table, as I would then definitely need to be on Coumadin, a powerful blood thinner, which would make returning to fighting completely impossible. The option I was considering was a procedure that would instead put in either a cadaver valve or bovine valve to replace my defective valve. *If* my heart returned to its normal size once the defect causing it to enlarge was fixed, and *if* the healing went so perfectly that I didn't need to be on any blood thinner (there was still a good chance that I would), then that would be my only chance to return to the ring. The drawback? I would need to have the valve replaced in fifteen years, as it would wear out, and *none* of those ifs were guaranteed. My heart might still stay enlarged, and I might still need to be put on blood thinners. But I had to try.

I decided that I would rehab in Latrobe at my parents' house because this allowed me to be close by but not in the same house. This was a difficult decision, but I needed to be in a familiar place, even if it was a difficult place. My mother jumped at the chance to get to take care of me, and to my surprise my father offered to come to the hospital in Cleveland to be there for me when I came out. He had never offered to be there for me in any capacity before. It almost brought me to tears hearing him say it.

The night before my surgery I sat in a hotel room, texting people. The risk of mortality for a normal person during a valve replacement surgery isn't terribly high. For a diabetic, the level climbs slightly higher. I had friends messaging me, wishing me luck, making jokes. Suddenly Justin popped up. *How are you feeling?*

I told him I was good. I felt fine. Excited to not have to train for a long time, which was a lie, given that the idea of being restricted for so long absolutely terrified me.

So, can I have the Thai shorts that Rick Roufus gave you if you die?

Typical Justin. Cracking jokes. I told him he could have them, complete with Jérôme LeBanner's blood spatter! Then he turned serious.

Be strong, Mark. You're going to come back to fight, I know this. Let your heart heal. Just let it. I love you, brother.

I had literally never heard those words before from a man in my entire life.

The next day I woke up very early and drove to the hospital with Amy, my friend and still my wife, but mostly a woman with strong know-how when it came to surgeries and hospital stays. I was taken to a room where I was changed into a gown and a ridiculous cap. Before I was taken upstairs, where they would hook me up to several machines that would monitor every possible life force in me, Amy, whom I was barely still making it work with but who was still by my side, snapped a picture of my throwing up a "hang loose" sign. As they hooked me up to the IV and began explaining the anesthesia, I felt this fear in me surge. I didn't want to have to do this. I didn't want to have to risk it. I wanted to go home. I wanted life to be normal and without all of this. I wanted to just go back to training.

"Now I want you to count backward from ten, Mark . . . ," the anesthesiologist said calmly as the liquid made its way through my IV. . . .

I love you too, Justin. I love you, Mom. I love you, Dad. I love you, Colin, Amy, Benjamin, Patrick, Ronan. I love you guys. Please be with me, God, or whatever is out there, or anywhere. Help me. Be with me now. Make it all okay. Make it go well. Let it be the best heart surgery ever, and let my heart heal. Let me come back. I must come back. I have to fight again.

"Ten . . . nine . . . eight . . ."

chapter ten

People fear death more than they fear pain.
It's strange. . . . Life hurts a lot more than death.
—JIM MORRISON

. . . They are pulling something from my throat. . . . I feel like a fish being yanked from some black depth and into the light. Everything is watercolor and without borders, shapes mashing into each other. I am panicking, reaching for anything and everything, struggling to breathe without agony. In my mind I am being forced back by a slew of arms into some soft coffin; sleep takes me again before I can fight back.

. . . It's been hours since the first time I awoke, but I don't know this . . . not yet. All I know is pain. My world is eclipsed by an oppressive veil of ache that starts at my center and bleeds out. Every breath I take is preceded by a bargaining, a prayer. . . . Please, God, let me just breathe without this pain and I will do anything . . . *then I breathe and the sledgehammer, the elephant's foot, drives into my sternum again. I am almost hiccuping, and I have tears in my eyes. Jesus Christ, am I alive? Is this right? Something must be wrong. I expect to look down and see some gore-coated clawed hand dressed in a tangle of veins shredding through my center, carrying with it every nerve that has ever coursed through me.*

I start to reach one hand up to wipe my eyes, only to have my arm stop an inch or so above the bed, but my muscles continue to contract and I let out a gasp as the resistance instigates a cacophony of screaming within the nerves in my chest. I am restrained. I have this image of wishing myself through the bed, backward, away from the pain, the restraints, and just falling to the floor whole again. I feel like the earth after a tornado has ripped it up. My arms shredded trees lying to the sides, my chest once a road, now with a swath cut through it, the piping ripped up, my dick some sad dead animal left by the side of the road, taped to my leg with a tube dangling from it. . . .

I turned my head to the side and met the eyes of my father. My first feeling was terror. Here I was splayed out, totally helpless, and he was right next to me. I don't know what I thought he might do, and the fear faded quickly as he saw my bleary eyes blink and my attempt at looking surprised through the myriad of drugs I was on.

"If I didn't know any better I'd say you were about three sheets to the wind! You look blasted!" He chuckled a bit, but his attempt to bust my balls was feeble. My father looked like he hadn't slept. He looked worn, and he looked frightened. Again, this was a first.

Amy sat next to him. My wife. My wife with whom I had three beautiful children. My wife who had put up with so much bullshit from me. There she sat, smiling. Amy was an RN in a hospital at this point, and so she wasn't just a support in my life but was the best kind of friend you could want in a hospital. She immediately stood up and placed a hand gently on my face. She looked clearly into my eyes and said, "You're okay, Mark, you're going to be okay. The surgery is over and it went well. Just try to sleep."

"Fuck this, I'm hungry. I need food." I was mumbling, I was so drugged up. They had me on a specific diabetic diet as per the endocrinologist's orders. It was awful, and my body historically has burned through more carbohydrates than most diabetics are told to

eat given how athletic I am. I wanted real food. My father lit up upon realizing that this was a problem he could solve.

"Well then, let's get you outta here and get you some food. There's a Polish deli right across the way. But you're gonna have to walk. Your choice though. It's either more of this crap or a proper Reuben! What do you think?"

His eyes were sparkling at the idea of disobeying authority. He was such an asshole, but he was a rebel at his core. The idea of getting me to go down an elevator and to walk across a walkway while wearing a hospital gown and hooked up to machines thrilled him, because he knew it would piss all the doctors off. He was an equal-opportunity miscreant who valued quantity over quality. The more irritated folk, the better.

"Yeah, let's go. I gotta go."

They both helped me up and onto my feet. I shuffled slowly down the hall, every step and breath a new sting. When doctors would look at me funny, my father would boom, "He's just getting a little air, just for a minute," cutting off their arguments before they were made. I'd have been more worried if Amy hadn't been there as well, moving whatever tubes were around me to keep me from catching on anything. The three of us made our way down the elevator and outside into the brisk evening air.

We plunked down at a table while others in the restaurant stared. We all ordered Reubens, and goddamn if it wasn't the best food I have ever had in my life. I looked at them both. You are given new eyes after major surgery. My wife, still here after all of my absentee behavior. We might not make it work, but our friendship was cemented in those moments. My dad, a tyrant and the bane of my existence, but the only father I will ever know. I had a gentleness in me that wasn't there before. I was glad to be alive, glad they were there, and really glad to have this awesome fucking sandwich.

After we ate, they returned me to my room and I fell into a blissful slumber. I spent the rest of the next day and a half going in and out of sleep. Nearly every time I would open my eyes, my father and Amy were there. Sitting, waiting, watching.

When finally I was awake and functioning after several days, I started asking about my catheter. I wanted it out. I had jokingly said before the surgery, "So if you are going to put one of those things in, please make sure you take it out carefully. You're taking part of my heart; at least leave my dick intact." On a Saturday morning, the day before they released me, they woke me up early and sent some young nurse in to remove it. I braced myself as he pulled the sheets back, grabbed ahold of the tube, and unceremoniously gave the most vicious yank.

"*Hey, man, what the fuck! You're going to tear it off!*" My typically bass voice came out like a high-pitched teenage squeak. My worst fears were coming true. Not only was I at kitten strength, but here some half-wit was about to tear my penis off and I wouldn't be able to do anything about it.

"Just relax, sir, I know what I'm doing." *Yank. Yank.*

"HOLY SHIT! ARE YOU KIDDING ME? ARE YOU KIDDING ME? GUARDS! SOMEONE! HELP!"

My shouts echoed through the hospital as I tried to crawl away from this fucking sadist, who I was convinced at this point had a personal vendetta against me. The charge nurse came in upon hearing my yelps and hurried over to the bedside.

"Okay, you know what? Why don't you go on, I can handle this." He dismissed the other nurse rapidly as I glared at him.

"Hey, *thanks for not taking it with you!* Is there anything left? Holy shit . . ."

I leaned my head back on the pillow as the charge nurse deftly deflated the balloon and removed the catheter in one quick and painless pull.

"I'm so sorry, Mark, he's new."

"It's okay, man, just next time maybe don't send the new guy to pull out the catheter. It's like he was trying to start a lawn mower, for Christ's sake. Thank God I already have kids because I'm pretty sure now it's just for show. . . ."

We both laughed. Shortly after that, I was allowed to go to the bathroom by myself. I kid you not, the first time I tried to pee after the catheter incident, piss shot in a stream at a perfect right angle. To avoid painting the walls I had to pee sitting down for a week. Thought he had fucked me up permanently.

Sunday morning I was released and went to my parents' house. I was supposed to spend twelve weeks doing *absolutely nothing*. My father and I spent the time watching sports and cracking jokes. One morning we went to Sunday breakfast together and one of the guys at the diner made a crack about my tattoos to him. He barely raised his eyes before muttering, "He's a grown-ass man, he can do what he wants."

At the twelve-week mark the doctor said they would do an echocardiogram to check both the size of the left ventricle, the part of my heart that had enlarged (it had enlarged to seven centimeters; it's never supposed to go over five centimeters), to see if it had shrunk back down, and to see where my cardiac ejection fraction was at. Only then would I know if I was ever going to fight again. After a few weeks I was finally allowed to remove the bandage and actually take my first shower. Peeling that bandage off and seeing the unbelievable mess of gore, and hiding behind it an eight-inch incision, was sobering. There was blood caked on so thick, I almost couldn't see the dissolving stitches. In the shower I went after cleaning all of that off obsessively, despite the pain. It made my soul ache to see myself so battered, so bloody, and not by my own choice. I hated it.

I was doing my checkups at Latrobe Hospital with Dr. Staffen

a few times a week. I was on ACE inhibitors and painkillers. I had successfully avoided needing to take Coumadin or any other blood thinner, which was fantastic. I avoided taking my painkillers as long as I could and sometimes would go through a day without any. Given my brother's background, pills freaked me out. At the sixth week Dr. Staffen proposed that we do the echocardiogram early. He said I was healing very rapidly, and he felt that it wasn't too early to check. I was terrified. The results of this test would in fact be either the green light or the death toll for my career as a fighter.

The evening of my echocardiogram, the phone rang. I answered it hurriedly. The voice on the other end was Dr. Staffen himself.

"Mark . . . you sound out of breath. Why?"

"I just rushed to the phone, what's the story?"

"Mark, *don't rush* to do anything! At least not yet. Listen, I don't know what to tell you. You're a freak of nature. Your left ventricle is down to normal, and your ejection fraction is at sixty percent already. You are way ahead of schedule, my friend. We can start rehabilitating you now. Congratulations."

That was it. Barring a serious setback, I had just been given the green light. I would rehabilitate and go back to training. And I would fight again.

I got off the phone, and if I hadn't thought it would have brought me to my knees with pain, I would have screamed. Instead I laid a hand flat against my chest and just closed my eyes and mumbled, "Thank you."

My rehabilitation lasted until the beginning of 2007. I welcomed the year with an open heart (ha ha) and an open mind. I felt hopeful. In mid-January I was done. I cannot tell you how incredible it felt to be told that I could go back to training. That day I went to a local gym, intending just to get a sweat on, just to feel the leather in my hands. I pulled my jump rope out and started at a slow pace; it felt like dancing. Pulling my gloves on just to swat a bag felt like

embracing an old friend. I was working lightly for an hour maybe, when suddenly a sharp pain struck me right in the center of my chest. I stopped immediately and pulled my gloves off; running a few fingers over my chest, I felt a strange springy lump.

Then my phone rang.

It was my mother calling. My father was sick. Something was wrong, and they were taking him to the hospital. I changed my shirt and jumped in the car to drive to the hospital, a drive I could at this point probably have made with my eyes closed.

The hospital staff was already sick of my dad by the time I got there. There was nothing they could really tell him except that he was big, broken-down, and old. They suggested he fix his diet (a subtle suggestion was made to him to perhaps slow down his drinking), but that was it. We went home and I called my doctor, the memory of that shooting pain in my own chest nagging at me. Two days later I was in having my chest X-rayed, then staring at a bright glowing coil on the X-ray film that wound its way up my sternum.

"So, that is the wire that is essentially holding your chest closed right now."

I think Dr. Staffen had grown to like how I didn't get grossed out easily, so he let the technical verbiage fly a little looser when he talked to me.

"And this lump that you are feeling is this little thing."

His pen hovered in a circle over a tentacle of the glowing coil that seemed to reach out to one side. "A piece of the wire has come slightly uncoiled and is pushing out. So, someday we may have to go in and fix that." He turned and looked at me. My expression must've said something to the effect of *Not today, bro.* He nodded and basically told me it didn't need to be done today. I left, running a finger over my strange little wire lump as I walked out.

I went back to training every day, slower at first, easing into it. Then more and more. My father fell sick again in early February.

The doctors were a bit more concerned, but he was adamant that he was fine. He was flying to Las Vegas to see the NBA All-Star Game. He had been going to most of them from 1997 on. The younger players loved him, as he was such a throwback, and on occasion I had accompanied him in the past. My mother was pissed off that he was leaving. She was worried; though she wouldn't ever tell me what the doctors had said, she clearly didn't want him to go. Despite anyone's advice or concerns, he checked himself out and flew to Las Vegas. He was supposed to stay for five days. The day of the game, February 18, which was a Sunday, my mother called me to tell me that he was flying back home that day.

"Mom, it's the day of the All-Star Game. . . . Why would he be coming home today?"

"He's not well, Mark, he wasn't well when he left but he just *had* to go. . . . He's really not well."

Her annoyance was barely hiding her worry. I knew how this went. He would go in for a few days, she would pitch fits about how he never took care of himself, and then he would get out and be fine for a few months, rinse, repeat. My father was eighty-three years old at this time. I had done the panicking thing before. I refused to worry right away. When she said that he was going to be taken to the VA hospital right by the airport, rather than Latrobe, which was closer to home, I felt a little more concerned.

He was in the VA for a week, maybe a little longer. I honestly don't know. I didn't go see him. I don't know if I was avoiding it or if I was just so focused on getting my sea legs back, so to speak, that I just didn't make the effort. They weren't letting him out of the VA because he couldn't walk on his own, yet if he was left immobile in a bed for too long his arthritis chewed him up, which meant a few poor nurses had to lug his giant frame up and move him around at least a few times a day. They moved him to Latrobe Hospital finally. The reports I was hearing about him were that he was being an

ornery asshole and berating everyone. I just didn't want to hear it. Or maybe I didn't want to see him like that. It's one thing when you have an ornery asshole who holds his own; it's another when you are expected to spoon-feed the very man who kicked the shit out of you for years. Post–heart surgery I felt gentler about people, but all this meant was I had no energy to offer to his nastiness. He bounced from Latrobe to different care centers, then back to Latrobe. I finally went for a few visits. I heard that Colin was in town, and my mother was asking me to please come to the hospital, potentially to run interference. I had to go.

I had barely walked through the hospital doors when I saw the curly head and glasses turn toward me. He was standing there with the same awful woman he'd been holing up with for a year, the one who kept calling on the phone, who had accompanied him to Father's Day the year before, his enabler. Colin was so lost. Maybe some part of him was there to connect, to feel close to family, some buried, barely alive fragment of his spirit that hadn't been burned away, but mostly he was there for his own selfish reasons. Junkies only know how to support their own habit, not other people. He was primarily there for personal gain, and he knew what we all thought of him, which made him mean and caustic. I was maybe two steps in the door when he made a crack about my heart surgery and asked, "Did they finally fix that weak heart of yours?" He dropped a hand on my shoulder, which I threw off with such force it made everyone in the lobby gasp. His girlfriend stood up and stretched an arm across him as he offered up the most ridiculous attempt at hurt feelings.

"Come on, Mark, I was just busting balls, you're my brother."

Cheap shot. It worked. Hearing him use what I had always wanted him to find important as a dagger to get at me was intolerably painful.

"Colin . . . You stay the fuck away from me."

His girlfriend opened her mouth to speak and I immediately held one finger up in her face and shushed her. I hadn't stopped walking.

I entered the room to see my dad, his face furrowed in anger.

"You don't let that sneaky bastard or that trashy woman with him anywhere near the house, do you understand me? Keep them as far away from the house as possible. He gets nothing."

This comment hit me like a wrecking ball. "He gets nothing" meant my father was referring to the divvied-up property after he and my mom were gone. . . .

"I won't, Dad. I won't."

I wish I could tell you we had a heart-to-heart conversation, my father and I. I wish I could tell you that we shared a tender moment. That he apologized, or that he even hugged me. But he didn't. We shot the shit as per usual, and I walked out. I hugged my mother and left, ignoring my brother and his tears, which could have been genuine, though I doubt it.

That was the last conversation I had with my father. By Wednesday, April 18, the doctors had been saying that the end was on the horizon. All he really did anymore was lie there and utter these terrible guttural groans, like some great dying dinosaur. That night I sat by his bed. I had been doing as he asked, keeping Colin out of the house, though he had tried to come in so many times. My mother was already on a medication to reduce the amount of ammonia in her blood, a by-product of her lifetime of drinking. I had been trying to remind her to take it. I told my dad this. I told him how the Yankees were doing, his favorite team. The team he used to tell me stories about, how he used to sneak into games as a kid. He loved Joe DiMaggio. I told him about Ben, Patrick, and Ronan, his grandkids. How they were doing. How they missed him, how he had been such a good grandfather to them, strangely enough. Then this surge of something from deep inside of me welled up. I wanted to hug my

daddy, but I couldn't, so instead, I leaned as close to his ear as I could and I told him . . .

"Dad, I want you to know. I know you didn't mean it. I want you to know that I forgive you, Dad. I forgive you. It's okay, Dad. I forgive you."

I had pieces of the speech he used to tell me he witnessed in person floating through my mind. The speech that Lou Gehrig gave when he had to retire. The speech that he made me memorize. I whispered a piece of it. . . .

" 'Today . . . I consider myself to be the luckiest man on the face of the earth.' . . . Three forty career lifetime batting average, four hundred ninety-three home runs, he drove in one thousand nine hundred ninety-five runs and he played in two thousand one hundred thirty games consecutively, Dad. He only stopped because . . ."

I wish I could say that he opened his eyes, that he reached out his hand, that he let me know he heard me. Instead, he let out a terrible sigh, and Harry "Moose" Miller died.

I buried my father in St. Vincent Cemetery in the plot he had for my mother and himself. My mother was already making comments about how we should just go ahead and dig hers up, because she didn't want to live anymore. She had totally given up. I had to plan the funeral, pay the hospital, the mortuary, etc. etc. . . . All while telling Colin to keep away, when all I wanted was for him to get his shit together and help me, be the brother I needed right now. The show he put on at the funeral with that woman was Oscar worthy. He made sure to shake everyone's hand, cry on everyone's shoulder, and talk about how he had always been so proud of his dad. More than half the people he laid this sad-son routine on came to me later to say, "I had no idea Harry had more than one son." Little did they know.

I didn't shed one tear. I couldn't. Something inside me locked up when my dad died.

And 2007 was just getting started.

chapter eleven

Drink to me.
—PABLO PICASSO'S LAST WORDS

I have become a caretaker of last words. I wish I could say that more often than not, final words are meaningful, and relevant, and infinitely quotable, but they usually aren't. Oscar Wilde's reputed last words, "This wallpaper will be the death of me—one of us will have to go," are probably fairly accurate and completely accidental. Dying people who take any amount of time to die usually know they are dying, but they don't tend to know when exactly. Sometimes they get lucky enough that they pepper each encounter with amusing allusions and therefore get lucky, so that when the hammer finally falls, their last words are seen as deep and mournful. Something that lets us, the living, feel as though we have been privileged with a glimpse at the bridge that crosses between the planes of existence. That somehow we know by their words that they knew they were going and dug deep into the troughs of their collected knowledge and experience to gift us the real diamonds of a life lived. The truth is, more often than not, the final words are something like "Grab the bedpan" or "Can you ask the nurse for more water?" or "You know, I think I should rest, I don't feel well." The final words of a loved one

aren't usually the most important. What is, and what will keep you awake at night, is what your last words were to them.

Amy and I officially didn't work anymore. We had stopped working long before, but right before my father got really sick it became abundantly clear that we were not going to make it work. I had fought it. I didn't want to be like the man who had built up multiple families, only to skip out on them all, except for me, my mother, and my brother. But I also didn't want to be like him and be the man who stayed out of obligation and just hated her. I didn't want to become mean and awful to my children. I didn't think it was in me to be that way, but knowing that I grew up with that as my option scared me, terrified me. I loved them too much to stay and risk finding out that that was in me. So while I was still in Pittsburgh after my father died, I was not playing husband or father. I had built a sort of cage around my heart. I spent a lot of time trying to handle the affairs left by my father, trying to coax my mother to *want* to live, and weirdly enough, drinking with my brother.

This was the only relationship I could have with either of my remaining immediate family. My mother was retreating. I hated that Colin drank or did any of the dumb shit he did, but after my dad died, I ran out of strength to push him out of my life. I ached for him. I saw how outside of the family he was, mostly by his own doing, but I found myself incapable of staying angry. For behind that anger was pain, years and years of pain and hurt, and the dam of anger I had walled it behind was cracking. I was exhausted. I just needed a friend. I just needed my brother, somehow. I took him the way I could get him, and even sank to his level to meet him there, and while I deeply regret signing off on his addiction by partaking in it, I don't regret spending some time with him. It was all I had. It's fucked up, what you will do for family.

My mother had no will left in her. The medication she was on, lactulose, a powerful drug used to treat complications due to liver

disease, forced her to pass all the toxic crap in her body fairly violently, so she would just not take it. If she didn't take it, her ammonia levels would climb sky-high and she got incredibly loopy. Both of my parents had been on a fast track to self-destruction since before I was alive. It's been mentioned that the myriad of complications that I was born with are quite possibly related to the fact that my mother smoked and drank through her entire pregnancy. After my dad died, she started to wither, and it pissed me off incredibly. I remember one argument we had when I had decided to do some yard work for her and come inside for water, only to find her drinking at the kitchen table, barely able to form a coherent sentence. A lack of real food, not taking her medication, and drinking even more than usual rendered her a mumbling wet brain more times than I like to remember. I lost my temper.

"You know, I get that you never gave enough of a shit about us to fight for us when we were little, but the least you could do is fucking care about yourself enough to not fucking die in front of me. Can you do that, Mom? Can you do me that one fucking kindness?"

I never cursed in front of her. Cursing would earn me a shoe getting tossed at me. But this time I let fly. I wanted to scare her, to shock her, to fucking hurt her. The dirt on my father's grave was still fresh and here she was trying her best to join him, and I couldn't handle it. The next step was tying her bony body down and shoveling that medicine into her drawn face. I would have rather had her hate me and try to survive just to spite me, which she was *very* good at, than just let herself disappear. To my horror, she just turned her head to me as I stood there sweaty, red-faced, and trembling, and just blinked her big black watery eyes, as though she had no idea what I had just said. It wasn't long before she was entering the hospital herself.

Once she had spent a few days in the hospital and her ammonia levels had been stabilized, it was amazing the person who emerged.

She had no memory of my tantrum, or she didn't mention it, and I was content to leave it that way. While in her hospital bed she called me in to have me sign some papers, giving me power of attorney. She laughed about it. How it was so unnecessary, but it needed to be done. She was released shortly after.

Mother's Day came. I took her to a steak dinner and bought her her favorite movie at the time, *The Notebook* (I know, I know). We had a wonderful night. I remember feeling that I wanted for her to be happy. I wanted her to have a good night. I wanted her to have the best fucking night ever. It's all I ever wanted for her. I wanted her life to be better, for her faith in herself to not have been squashed by a psychotic dictator of a man. I wanted for her to feel that it was safe to have feelings again; I wanted that for all of us. But I was willing to settle for knowing she'd had a nice Mother's Day. I think she did. I hope so.

Two days later she went to a follow-up doctor's appointment and was promptly readmitted to the hospital, which she was not happy about. My mother was seventy years old. She was old but not ancient. Up until my father had gotten sick, despite years of hard living, she had looked young for her age. Now, though lines were drawn on her face, she was still relatively full of piss and vinegar. She was angry at being in the hospital, and though she carried herself with a certain level of what she considered to be manners, she made no effort to conceal the fact that she didn't think she needed to be there any longer. I visited her every day, and every day she let me know that everyone was overreacting and that she needed to go home. On the afternoon of May 18, I visited her and was told that she would be released later that day. We talked about nothing important. Nothing. She was flippant and bored. I had plans for later that day, so I waited patiently by the phone so I could pick her up and take her home before heading out. The call never came. That evening I started calling around, and no one in the hospital seemed to know where she was. I reached out

to Amy, who wasn't super fond of me at the moment but was able to find out more since she was a nurse within the same health system. Amy found out what floor she was on and the name of a doctor I needed to request to speak to. My temper was rising. . . .

I got the doctor's primary assistant on the phone, who reassured me that my mother was being kept for observation. I pushed on her. I knew what my mother's floor number meant. You cannot bullshit a person who has spent the better part of the last year in and out of hospitals. My mother was in the ICU. I needed an explanation, and I needed one for why no one had called me. The lady told me that there had been a mix-up, that each person responsible for notifying me of the change of plans had thought that the other was going to call me, so no one actually did. She also again reassured me that my mother was there only for observation, that the doctor would call me the following day.

Colin had been fluttering around all this time. He was mostly in Washington, DC, at least as far as I knew, but he had been calling a lot. I had been trying to make peace with him, but addicts don't want peace, not while the drug is in charge. The most recent phone call had resulted in my hanging up on him after he actually said to me, "I can't believe no one told me that she was in the hospital. You need to let me talk to her." I had been standing right in front of her when I hit "end call." I just couldn't tolerate him. The unbearably melodramatic performance he had put on at my father's funeral, crying on everyone, talking about how great my dad was and how he was so close to all of us, made me feel sick to my stomach, not because of what he had said, but because I knew what motivated him to do it right then. And always with that girlfriend, hovering, watching, picking what she wanted to claim as her own the minute no one was there to defend it, telling him what to say, keeping him sick. It's like they were shopping for different things, one for goods, one for feelings. Just a pair of vampires. I wanted real interactions, a real

connection with him. What he offered up were feelings with hooks attached, expectations attached, an exchange for goods and services almost. His love was the currency he offered up, expecting stuff in return. He was being controlled by a self-serving need inside him that was pushing him to just take from people. It hurt too much. I couldn't deal with it.

The morning of May 19, the doctor called. I answered the phone and asked about my mother's condition, how she was feeling, made some joke about her temperament. I was gifted with this gentle gem of a response: "Well, Mark, the truth is, it's not a matter of if anymore, it's a matter of when."

The dam holding back the adrenaline in my body now had a crack in it. I felt like my veins were being flooded with black ice water, like some funnel of ocean was being brought up from the dark deep. I was shaking so hard I could barely hold the phone.

"What are you saying to me?" My voice was quivering and parched sounding. Anger surged and yanked in big oily waves through me as I realized I sounded like I was going to cry, and that couldn't have been further from the truth. I didn't want this "doctor," this harbinger of shit and suffering, to think that I might have been crying. I wanted him to know that I was exactly who he should fear forever. That I had a world of seething darkness in me, a theme park of tentacled monsters squealing around inside my body, and they all saw him as prey.

I cleared my throat for good measure.

"She was being held for observation, that's what I was told, so who fucking lied to me? And who fucked up *exactly*? *Would that be you?*"

"Mr. Miller, I am just trying to prepare you. Her condition is very poor. She doesn't have long, and I want you to be aware so you can make arrangements."

Quick side note—when people say "make arrangements," they

really are trying to cover their ass and let you know that maybe you want to schedule a session or two with the local head shrinker, because truth be told, there is nothing to fucking arrange really until that person is stone-cold dead. You can't prepare the mortuary. It's their fucking job to take in dead people, and hopefully you have a file that says exactly what that person wants done with their corpse after they are dead, so once that heart stops, it's really a plug 'n' play of lawyers, funeral directors, etc. etc., and you just get to sign a lot of paperwork and a lot of checks. But until then, it's a waiting game of the worst kind. And I, having done this before, knew this. The extended family were the only people left to inform, and in my family, the ones who needed to know already knew. They'd been watching each other die off for years. My mother had four sisters and two brothers, all of whom, save one brother, had died before she did, and he would pass the following year. She was next in line. This was not a surprise. This was expected. But it wasn't expected today. There were no fucking arrangements to make. This is what we do. We bury each other. This cowardly piece of shit just didn't know how to tell me kindly that my mother, the woman who brought me into this world, was slowly fading like the afternoon sun.

"I really appreciate that, doctor, I really do." There was no masking the venom in my voice. I felt like one giant cancerous seething tooth-riddled bile duct. "Here's what I'd love to know. I'd love to know exactly when between you holding her for observation and now that you determined that she was *this* sick. How *exactly* did you misdiagnose her *that badly?* You were going to fucking release her and now you're fucking telling me she's on her way out? Actually, you know what, fucking forget it, I'm coming to the hospital. If I see you, I'm going to carve her fucking name into your back, you fucking quack. You stupid piece of monkey shit motherfucker." With that, I hung up.

Half an hour later I walked into my mother's room, escorted by

hospital security. Apparently they took threats very seriously there. The doctor was nowhere to be found. I heard later that they had sequestered him in a completely opposite wing of the hospital and that all personnel had been instructed to say that they didn't know where he was. The idea that a full-scale cover-up of a doctor's whereabouts had been launched because of an angry phone call that I had made, which had also sent said doctor to cower in a corner somewhere, filled me with a bitter joy.

My mother saw me and half smiled before waving one ricepapery and blue-veined hand and saying, "Oh, this is ridiculous," in the frailest voice I'd ever heard her use. Over the next few hours she went through moments of absolute clarity, and then she would seem to float away again. When she was present we talked about common things. There was no sense of urgency to the visit. I told her I loved her before I left, and that I would see her in the morning. It was odd; that was something my family just didn't say to one another, not ever. The words felt awkward coming out of my mouth, and I was almost glad when she didn't say it back but instead nodded.

The next morning the phone rang. It was the doctor's assistant, who had taken to calling me, as it was made clear that my mother's doctor would no longer have any contact with me. She let me know that in the night, my mother had slipped into a coma. They were recommending that I move her into hospice. Hospice. Let's talk about what the word *hospice* means. It means, in short, the place you go to die that isn't your home. Hospice is essentially a hotel for the old and sick who check in to die with the comforts of pain medication and professionals monitoring their last moments to make them as comfortable as possible. Hospice is what happens when the machines making a person live are removed and they don't die right away. For the people who need hospice, I'm sure it's great. To hear the word *hospice* when you are being told that is where your mother should go

is awful. It is one more step into the stark and frigid reality that very soon, you will have no parents left in this world.

She was taken off of machines and moved that day. I was with her almost constantly after that. The afternoon of the twenty-second of May, around five thirty P.M., I squeezed her hand and told her I would be right back, and left to go in search of food. I posted up at Sharky's, a local bar and grill nearby, and sat down to have a sandwich. The air was soft, a little cold. I finished eating in peace. I felt slightly less tense after taking my insulin and leaving the restaurant. I was driving back to the hospital when my phone buzzed. It was a text message. My cousin Bebe had arrived at the hospital that day. Bebe and her brother Jon are arguably the only sane, not-drunk people in my family. It baffles me, in fact, that they have turned out so incredibly normal, considering how everyone else turned out, including me. Bebe and I have always been fairly close. I paused at a stop sign to check the text. Bebe was texting me to tell me that my mother was dead. She had breathed her last while I was busy shoveling a fucking fish sandwich into my mouth. I hadn't been there.

I arrived at the hospital and walked into the room. Bebe walked toward me and grasped me in a massive hug. "Oh, Mark, I'm so sorry."

"Thanks, Bebe, that's nice of you to say."

I felt like I was in slow motion, like I was some humanoid robot version of myself that had had all the emotional parts removed, as I walked toward my mother.

When people die, even if they haven't been dead for long, they stop looking like themselves. The muscles of their face relax so much that they look like a bad sculpted rendition of the person they once were. The dead also release everything in their system. Complete core-dump evacuation, so the room was none too fresh, and all I could think was how much she would have hated that there were

people there to see her like that. I have no idea how much time had passed before they came to take her down to the morgue. I don't even remember how I got home that night. I know that that was the beginning of a two-and-a-half-year relationship with insomnia. I would not know a good night's sleep for a long time.

chapter twelve

You know, if I were to die right now, in some fiery explosion,
due to the carelessness of a friend, that would just be okay.
—SPONGEBOB SQUAREPANTS

I buried my mother on May 26, next to my father, in St. Vincent Cemetery. I received a number of phone calls, letters, and flowers. I responded to about half of them. On the morning of June 5 I left for San Jose to start training at a well-known gym there. My friend Paul Buentello was preparing for a big fight there, and I was flying out to help him. I was also flying out to get away from Pennsylvania, to get away from death. Little did I know, you really can't outrun that shit.

Training in San Jose was awkward. I was surrounded by incredibly high-level athletes—some are now belt holders in various organizations—and there I was, barely coming back to train, thirty pounds lighter due to muscle loss, and a complete head case. I no longer slept. I was lucky if I got three hours of actual rest in a night. Most nights I would go on these walks and just . . . walk . . . all night. Otherwise I would end up lying in bed at night, staring at the ceiling, just swirling through my unbearable fucking existence, and sort of really get into being a complete misanthrope. I had cre-

ated this entire fashionable character around my frozen core. I was an abysmal person. Amy hated me. That was fine by me, because I hated myself. I was running from every responsibility and shirking everything, and I couldn't handle the sound of her demanding and disappointed voice anymore, so I just shut her out. I ignored her calls, which meant I didn't talk to my sons very often. I just felt like I had no purpose or place. I had no idea who I was. God I was a miserable piece of shit. Because I wouldn't sleep, I would frequently just pass out wherever I was. Sometimes on the mats at training, which really earned me the respect of the other fighters. Makes your training partners think a lot of you when you show up and give less than 50 percent. It didn't help that everyone treated me like I was made of porcelain because of the scar, until one day when Paul Buentello, who was a huge Mexican heavyweight originally from Amarillo, Texas, and I were sparring. Paul was my closest friend out there and kept me going when I easily could have just slipped away. I still talked to Justin, but Justin expected more of me, wanted me to care about my life, my training, my health, and I just couldn't live up to that. Not now. Paul let me be fucked up, but he also yanked me back in line before I went over the edge. Paul and I were moving around, and Danny Acosta, one of the greatest combat sports journalists out there, was sitting by the ring watching us, waiting between interviews of the various fighters who would be fighting on an upcoming stacked card. One of the other fighters called out, "Hey, Paul, be careful, man, that guy had heart surgery."

It was serendipitous. Right as I turned my head away to tell the guy to shut the fuck up, Paul landed a haymaker of a right-hand square to my sternum. The thud was unbelievable, and Danny's eyes went wide instantly as the force drove me back. As a journalist he reports on what he encounters, but he had not wanted to watch a guy die in the ring today. Paul stopped for a minute, then grinned

through his mouth guard and shouted, "Yeah, he can fucking take it!" as I laughed. Danny exhaled a sigh of relief. So we continued.

The night of June 22, a few of us went out for food and then headed over to Paul's after-party. He had just knocked out his opponent, so we were fit to celebrate. I couldn't tell you everything that we did. I know that that evening bled into the next morning and established a series of bad habits. Something broke in me as I figured something out. Alcohol made the ghosts disappear. Alcohol in abundance made me comfortable with not caring—in fact it facilitated it and even coaxed out a smile or a laugh. That night I tapped into a genetic pattern that had been set for me long before. That night I fell in love with booze. The very next day I boarded a plane to Pennsylvania to see my kids, my half-assed attempt at being a better father, and to handle some things. I reeked of alcohol even still when I landed. Amy's anger with me broke long enough for her to try to reason with me; she tried to convince me to care enough about myself to not die and leave my kids fatherless, like I was. . . . I stayed only long enough to see them; I had already mentally had one foot back on a plane to leave since the minute I landed. I flew from Pennsylvania to Austin to continue training. Or at least that is what I told myself.

I holed up at Randy's gym during the day, and at night I went out with Randy. Randy had a massive personality, and everyone in Austin seemed to know him. He was big, black, and muscular and wore crazy silver rings on his fingers and leather jackets. He drove big trucks or motorcycles. I mean, everything about Randy was larger than life. I liked going out with him a lot; it meant a ton of liquor and no responsibility to entertain anyone. I had been avoiding Justin. I mean, I had seen him, hung out with him briefly, but he was always trying to protect me or get me to do healthier things that didn't involve drinking, and I didn't want to go there. Plus I could feel him wanting to ask me, for real, how I was doing. I didn't want

to tell him that I wasn't sleeping, that I hadn't cried, and that I didn't give a fuck about anything, including me. He wasn't going to let it go like I was hoping, and one night he cornered me. He pulled me aside at the gym, put that dark-eyed glare on me so I couldn't flinch, and shot me straight through my fucking core.

"You know, Mark, it was in this gym that I saw you nearly kill yourself because your passion for your sport was so strong. Now I just see this sad excuse of a guy going through the motions. You look like absolute shit. You roll in here with black circles under your eyes, you smell like you're half-cooked on last night's booze still. . . . What do I have to do, man? I am scared for you, Mark, I am scared for you. I miss my friend. . . ." Justin had one of his massive hands planted directly over the scar on my chest and was pushing me backward in something between a pulse check and an outright shove. I did what came naturally at the time. I brushed his hand away and turned my face away as I muttered, "Well, don't worry about me, I'm fine."

Justin didn't give up that easily. He followed me and reached out to hug me. His eyes were starting to well up. Tenderness was a direct threat. The only key that was left to that massive safe I had sunk deep into the sand at the center of myself, that safe that contained all my pain, all my sorrow, all my fear, was honest kindness. This bore the horrific potential to unlock all of that. I couldn't do it, not now. So I did what I was taught to do by my father. I reacted defensively and with hostility. "Justin, dude, get the fuck off me. I'm fine."

Justin pulled away, hurt and angry, and just shook his head. "Wow. I love you, Mark. I hope you figure this shit out." With that he grabbed his gym bag and walked out, wiping his eyes.

A few nights later Randy and I went out. I had met a bartender the night before and had gone home with her. A doe-eyed young thing who was equally as fucked up as I, but who had enough of a vocabulary and an interest in music to keep my attention for at least another go-round. It also helped that she was a bartender, so

I saw the writing on the wall: she was never going to tell me to stop drinking. Her age and lack of education also meant that she was never going to expect much of me. We had gotten up late that afternoon and gone for food, and then for drinks before she went to work. By the time Randy and I met up, I was already on one. The unreal horror of my drinking was that I never could black out. I never forgot. I remembered everything. But I tried really hard to forget. Randy and I met up at her bar, a crusty, smelly dive located on South Congress. We stayed there for a while and then drove over to another bar.

Randy was liquored up when we left the first place. His driving inebriated wasn't something I gave two shits about at that time; in fact I would have driven myself if he had handed me the keys. I was on a piss-in-the-eye-of-destiny warpath, just daring the universe to kill me, almost asking for it. I was a type 1 diabetic post-open-heart-surgery patient who had just buried both of his parents that year, so a DUI seemed almost laughable. We stayed at the second place just until I knew that the bartender was going to be off in a few hours, and we decided to head back to the first bar. The route from the bar we were at to her bar was a straight shot and then a quick right into the parking lot. Randy and I climbed into his massive Dodge Ram truck and headed down Congress. Suddenly Randy turned down a side street. I looked around, confused. . . . This wasn't the right way. "Hey, man, you turned too—"

Suddenly I was in the air. For a split second I was almost comforted by my weightlessness. The shrill crunch of metal against metal was the soundtrack to my brief flight before my head made contact with the windshield, shattering it completely. I landed on the hood of Randy's car and looked up to see the back end of a Jeep inches from my face. I had no idea what had happened. All I knew was that it felt like someone was pouring warm water over my head and face, and my eyes began to sting. I was asking, with squinted

eyes, "Hey, man, Randy, what is going on . . . why is there warm water on my face?" I laughed. . . . Suddenly, sirens . . . I laid my face on the warm hood and closed my eyes. . . .

In the emergency room the nurses were rushing me along, asking me questions. Had I had anything to drink that night? I laughed again. They asked me if I was on any other drugs; I told them insulin and "awesomesauce," then I laughed again. They cut my shirt and shorts off, and I asked what was pouring all over my face. . . .

"Mr. Miller, you have been in a very bad car accident. You were not wearing a seat belt and you went headfirst through the windshield. You have some very serious cuts on your head and face. We are going to have to use a brush to pull the glass out, and you are going to need stitches. Do you understand me so far?"

Fucking whoa.

"Yeah, I understand. I'm cool with it. Stitches don't bother me, but I wish you hadn't cut my clothes though, I liked them. . . ."

The doctor pointed to a soggy brick-red pile of rags and said, "I don't think they were salvageable anyway, sir."

They picked glass out of my face and head, and stitched up chunks of my eyebrow and my scalp. I was put through a CAT scan, and it was determined that I had a minor concussion and a bunch of small cuts and bruises. They wanted to keep me overnight for observation. I had no fucking interest in staying overnight in a hospital. None. I didn't have my insulin, my phone, nothing. All of it was in a bag in the crushed remains of the car. Against their strong recommendations that I stay, I checked myself out. They asked me if I had anyone who could come and get me. I tried to remember Justin's number. The only number I could remember was the bartender's. So I called her.

"It's three o'clock in the fucking morning, where are you? I thought you stood me up! I've been calling you all night." Her voice had no concern in it, just mild irritation.

"Well, I was kind of in a bad car accident on the way to the bar, so I'm at the hospital now. Can you come and get me?"

I slept at her house that night, went to sleep almost right away, real healthy for a concussion victim, I know. The next morning I was standing by the wreckage of the truck, which had been towed to a parking lot on the other side of town. She stood close by, fidgeting with her car keys and smoking nervously. She kept muttering, "Jesus Christ . . . ," over and over again.

The car was completely crushed, and there was blood on the hood. I picked through glass to retrieve my bag and phone, which were both unharmed and sitting on the floor. I pulled my Humalog pen out of the bag, attached a needle to it, and took a lap around the car so I could quickly take a shot in my abdomen without her watching (I hate when people watch me take shots). As I stood, pulling off the now-used needle and repacking my pen into my bag, she asked, "Can I get you anything? I mean, shit . . . You had a really fucked-up night. . . ."

"Yeah. Drive me to a liquor store."

chapter thirteen

*I have learned now that while those who speak about one's
miseries usually hurt, those who keep silence hurt more.*
—C. S. LEWIS

I was lying on my back inside the sweltering apartment of this bartender
who was too young for me, who was not good for me, and
I was hungover, again. I needed to get out of Texas.

After the wreck, Randy and I were estranged from each other.
It wasn't his first DUI, and I didn't want him to have to take the fall
for all of my medical bills. Truth be told, we were both at fault to
some degree. He should never have driven, but I should never have
gotten in the car. Hell, I should never have gone out with him in the
first place. I was still light-years away from being healthy, but I was
not interested in being close to anyone who wanted to suggest that I
should somehow look beyond the fact that he was driving the car and
instead place the onus on myself. I didn't want responsibility for *any-
thing. Away* from responsibility and feelings was the direction I was
moving, not toward.

Amy had shifted from hating me to full-on trying to reason with
me, which only meant that she was genuinely scared. The marriage
failed. We didn't work as a couple. But there was no denying that we

were, and would always be, close whether we liked it or not. We had three children together; there was no avoiding it. So she was launching a full-scale attack on my ego in order to try to scare me back into living healthy. I heard a lot of "Oh, great job, Mark, I'm sure drinking excessively and partying with little girls is a great way to ensure that you will come back to fight. Just brilliant." I hung up on her a lot. Mostly because I knew she was right.

The ugly truth that the movies don't tell you is that after people die, and after you bury them, you still have a mess of bullshit to clean up. One of those fun things being a will. Colin had made himself incredibly present after my father died, and while I know that somewhere deep inside him he must have felt some sadness, it was mostly because he wanted to see what was going to be left to him. After my mother died, we got to pore over the will. Colin got nothing. It was clear as day. Not a dime. Not even a trinket with a note attached. Nothing. It fucking ripped me apart to be sitting next to him as he was told this. The drug monster in him was disappointed, but what was worse was the pain I knew he had buried somewhere deep inside, that fear of being unloved, unworthy. This reinforced all of his feelings of being worthless. After initially learning this, he disappeared for a bit. Then he resurfaced. After having consulted his girlfriend, he decided that guilt was in order. He started calling me and trying to manipulate me into feeling like I owed him some of the money that my parents had left me. In a moment of weakness, or exhaustion, or maybe pity, I decided to send him a few grand. I felt, at the time, that that was generous. I hadn't been left a small fortune, and I myself was burning through what they had given me, living like my own form of cockroach. I had told him it was for his birthday and that I hoped that he would use it for good, knowing full well that he was going to blow it, probably in a few days, on drugs.

I left Texas for Pennsylvania on August 1. It was the twins' birthday on August 5. I had friends and family I could have stayed with,

but for some reason, sleeping on the couch inside my parents' old and oppressively memory-heavy house seemed an appropriate self-punishment. I would lie there night after night and just get dizzy with the amount of self-loathing I had. The five stages of grief are supposedly denial, anger, bargaining, depression, and finally acceptance. I was somewhere between anger and depression. I hated them for dying and leaving me with everything to handle. I hated them for being such shitty parents before they died, and then dying and not ever fixing it. I hated them for never showing me that they could have been better. And mostly I hated myself for being such an emotional cripple after their passing. I didn't feel depressed so much as I felt like nothing mattered. I was sort of amazed at how little attachment I felt to anything . . . other than my kids. I couldn't kill that off. So I just avoided them for as long as I could. When I saw them this time around, I felt I needed to stay for longer. I couldn't deny how much I had missed them.

On August 14, my phone rang. Colin was calling me. Again. He had been trying to call me and I had been avoiding his calls. This time I answered. He was so obviously fucked up, it pissed me off instantly.

"Seriously, what the fuck do you want, Colin? I gave you money. What the fuck do you seriously want?"

"Wow. I just wanted to see if you had even made the effort to visit Mom and Dad at their graves. You haven't, have you? Did you even care about them at all? It's amazing to me that they left you anything when you obviously didn't care about them, but I got treated like some awful piece of garbage and all I did was try to do things for them. . . ."

He was slurring his words, and the volume of his voice kept growing and fading as he allowed the phone to slip from his face and then caught it, causing the pitch to shift in some sort of odd melodic Doppler effect. It was the drug addict's song, sung by the most prac-

ticed balladeer. I knew he was fucked up. I knew this wasn't even him. In fact, I didn't know *who* Colin even was anymore. Then I heard it. . . . I heard a female whisper in the background. . . . And I fucking lost it.

"Oh, okay, Colin. Thank you for the brilliant advice. I love taking advice from a fucking junkie. And tell that bitch to shut the fuck up too. That cunt doesn't get to contribute in any way. You two are just a pack of fuckups."

"Then what are you, Mark . . . huh? *What. Are. You.* You're a *big child.* A *baby.* Always the precious baby Mark, always the favorite, and you know what? That's the only reason you made it, because you were born weak and *you are weak.* I could beat the shit out of you then and I'd do it now, you coward. You don't know what a hard life looks like. If I was there I'd kick your ass so hard you'd wish—"

I cut him off. *Baby* was what my father used to threaten to call me when he was trying to hurt me. *Baby* was a bad word. And here was my big brother using our father's weaponry against me, *knowingly.* With everything I'd had to handle, and without him there to help me, I had no kindness left.

"*You know what, Colin* . . . I would *love* to see that. I'd love to see you try to kick my ass. You know why? Because you're such a fucking tough guy over the phone, but you never seem to be interested in actually trying to solve this. Let's meet up, motherfucker. Let's do this. Or how about you go ahead and admit that you'd lose and instead do what you do best? Why don't you take that money I gave you and go buy your fucking street junk and just take yourself out like we've all been waiting for you to do."

I hung up. I wish I could say I regretted that instantly, but it was like so many other conversations and arguments with him that it felt like just one more exhausting, painful, pathetic spat. Nothing remarkable.

Over the next few days I spent my time either handling more

of my parents' affairs, hanging out with my kids, or drinking in any one of the many unbelievable dive bars that are near the Latrobe area. Sometimes I got lucky enough to get picked up by some poor woman drunk enough not to see how utterly unavailable emotionally I really was, and then I'd get a place to sleep for a night. Or rather a place to drink more alcohol, and at least be entertained by some new naked body instead of being flung around by my own thoughts.

Early August 19 I was in the gardens at Lynch Field, training a few guys outside. It was hot and bright, and I could smell the remnants of last night's conquest on my skin and the alcohol leaching through my pores. My phone started ringing. . . . I pulled the pads off of my hands and answered it, wandering just out of earshot of my clients as I heard, "Mark, I'm calling from the Southwest Greensburg Police Department. . . ."

I knew this officer. I was confused. I hadn't had a run-in with the law in a long time.

"Mark . . . I need to let you know something. . . . Uh . . . in a house in Youngstown . . . we found Colin. . . . We found your brother. . . ."

This had to be a mistake. Youngstown was just miles from where I was. Colin was in DC. This wasn't right. "He's been in DC . . . ," was all I could mumble.

"Mark . . . state police found him." He kept faltering. My anxiety was climbing. *Just fucking say it already.*

"Okay. Is he in trouble?" I knew this wasn't the case. My whole body went so cold that goose bumps rose up on my arms.

"Mark, by the time the paramedics arrived, there was nothing they could do. It appears that he in fact overdosed. I'm sorry, Mark. They wanted me to call and tell you. I'm so sorry, Mark. . . ."

I was enraged. This is not the reaction you are supposed to have when you find out that the last living person from your childhood has perished.

"*What the fuck was he doing here?* How long had he been here, do

they know that? Did they fucking figure that out? That motherfucker came here? Where? Where did they find him? Some fucking ditch? A squat house?"

"Mark . . . he was found in a house in Youngstown. A female friend—"

I cut him off.

"I'm just going to stop you right there. I don't care what hooker junkie he was holed up with. . . . They found him in Youngstown? What . . Well, if he was with someone, then how did this shit happen?"

"Apparently she left for work and when she returned he was motionless on the floor, so she called the paramedics."

I had told him to go die. And he fucking did. My last words to my brother, the last words I would ever say to him, and that he ever heard from me, were my telling him to go die, and he did it. Way to go, bro. That's the most successful middle finger you have ever given me. You win.

"Okay. Fine. Well, I guess . . . good. We all knew he was going to do it sometime, right? I mean, he was already in his forties; amazing he made it that far. Junkies don't exactly live long. So, oh well. Thanks though."

I was shaking. Somewhere between pain and anger exists this suspended sort of space. I felt like ripping a tree out of the ground and smashing everything. I felt like punching holes in all of the cars I was looking at. Across the field there were kids laughing. *How the fuck are they laughing? This isn't a normal day . . . how do they not know?*

"Mark, there's . . . there's one more thing. . . . You are the only next of kin we could reach. . . ."

Oh no. No.

"Mark, we need you to come in and identify the body. I'm so sorry."

Oh, fuck you, Colin.

Of the five stages of grief, I had bypassed denial. Now anger was all I knew. But next to the anger was something more insidious. Something worse. Relief. I was relieved that he was dead. Finally, no more late-night phone calls. No more wondering where he was, what he was doing, if it had happened yet. Finally I didn't have to worry anymore.

The next day I swung by the Westmoreland County coroner's office. I walked in and everyone shrank away as I told them who I was and who I was there to identify. I think I said, "Colin fucking Miller," too. I was so full of anger and hate that I needed to leak some of it out just to keep from melting.

They brought me in the back and walked me toward a table that had a sheet draped over a long form. I started sputtering, "Come on, let's go, I don't have all day."

All of this bluster, this bitterness and anger, was sealing in a hurt that to this day I cannot accurately find words for. A man I had always wanted to love me enough to help me, protect me, teach me how to be a grown-up, had abandoned me and used me up instead, and now, now he lay cement hued and shriveled on a table, and I had to say, "Yes, that is my brother." Anger aside, the pain is still crushing to me.

They lifted the sheet. There on that steel table was my brother. He looked like he had been dipped in gray paint. My heart flinched and crawled backward as though it was trying to quietly sneak out of my body and away from all the pain while I was busy being angry.

"Yeah. Stupid motherfucker. That's him." And I laughed.

There was nothing funny about it. I just didn't know what else to do.

As I walked to my car to drive back, I had a simple thought. I was about to sleep in the house I grew up in, where my mom, my dad, and my brother had all been terrible role models, where I had fought so hard to become more than what they had established for me.

And now I would sleep there alone, because they had all left me behind.

I spent the evening lying on the couch and looking online for plane tickets. I had to leave; I couldn't leave fast enough. I shot a text to Justin, something sad and stupid. Something like *Oh, hey, so my brother is dead. How awesome is that.*

He responded in true Justin fashion: *I love you Mark, and I am so sorry.*

I didn't respond. I lay there all night, not sleeping. I had no remaining immediate family left. And I still hadn't cried.

So that was my 2007.

chapter fourteen

I just want one person I can rescue and I want one person who needs me.
Who can't live without me. I want to be a hero, but not just one time.
—CHUCK PALAHNIUK

Colin wasn't buried but cremated, and his girlfriend took his ashes. I didn't even try to fight her. I don't even know where she scattered them. It seemed sort of arbitrary anyway, the idea of fighting over his ashes. All of my good memories of Colin were tied in to music, and not only can you always visit a person whose memory you keep woven into music, you can't fucking get away from them. I started avoiding the radio. I started wearing headphones everywhere with a steady diet of good nineties hip-hop playing constantly. In 2008 Beats by Dre released their headphones, which were perfect. Given that I have one cauliflower ear from my wrestling days, I can't wear conventional earbuds. Those allowed for me to more effectively ensconce myself in my music and keep from having to interact with the outside world.

Two thousand eight was a blur. I decided I needed to start taking my training more seriously, so I ventured out to Las Vegas to train at Randy Couture's gym. The talent level there at that time was intense, and I liked that Randy was an older fighter, older than me,

who wouldn't balk at the idea of my making a comeback. While I was there I met Cory, a friend in Las Vegas, and his mother, who took me in for a while and tried their best to keep me alive. Las Vegas was a bad place for me. When I wasn't training I was restless, and Vegas offers any number of sins to keep a restless person busy. The bartender from Austin and I were still involved, but I was rarely in Austin anymore, and I really didn't care about making it work or about staying faithful, so I wasn't. I would walk from Cory's house to the strip clubs late at night and post up at a table, drinking and enjoying the free attention. When you attend a strip club enough times, the girls get used to you and start feeling safe around you. They are out to make money, but they also want someone they can vent to. More than half of the ones I ended up meeting were functioning on at least one illegal drug almost all of the time, and they all could smell the broken on me, which for broken people is just an aphrodisiac. I spent a lot of nights at various apartments and taking cabs back to Cory's, only to walk in after no sleep, grab my gym bag, and head out to train. More than once Cory's mom caught me. She had been a nurse for many years, and she had that same "you can't bullshit me" eyeball that Amy had been starting to acquire. Women in the health care industry are fucking tough. They hear all the excuses, over and over, and they have to navigate them, so when she would stop me in the hallway and say, "Mark, you look like hell, are you sleeping?" I'd avoid her eyes and mumble, "Yes, ma'am."

She'd stand there, unimpressed, scanning over me, and then she'd say something like "Well, I'm making chicken tonight, so you should be here for dinner, eat a real meal for once. And here, take this." She'd hand me a brown paper bag with a banana, a bottle of water, and oftentimes a sandwich. It was more mothering than I had experienced in a very long time. Then she'd walk past me saying, "You really should sleep, you know. You'd feel better if you did."

Cory was like Justin. Brotherly, caring, concerned, but also a

fun-lover. He tried to keep me motivated in training, even though I was doing such a half-assed job. Cory would drink with me, but he would also frequently say things like "You know, this really isn't stuff you should be doing, you're better than this."

A majority of 2008 was spent bouncing between Austin and Las Vegas this way. I was drunk a lot. When I wasn't drunk, I was stoned. When I wasn't stoned or drunk, I was miserable. I had no idea how to get out of the rut I was in. So I decided to pull yet another geographical switch at the beginning of 2009 and move, this time to Los Angeles.

There was a management company there that had talked about wanting to work with me, potentially help with my attempt at a comeback. They helped me pick out an apartment in L.A.'s newly flourishing downtown, and they got me a few connections, but that was it. I had been talking online back and forth with MC and member of hip-hop group Dilated Peoples Rakaa Iriscience, so when I finally moved, he welcomed me into his group. Rakaa's crew was far from sober, but they were upbeat, thoughtful, creative, and productive. Rakaa is a practitioner of a martial art himself, so he appreciated what I did and the training that went into it. We would sit and politick about all manner of things. Rakaa is one of the greatest people I have ever known and very quickly took to calling me family, which prodded at a newly sore spot in me. He used to ask me why I was going out so much, what I was partying for. He used to say, just like Cory, "You're going to have cut all this out, Mark, you can't train like you need to while doing all of this."

Right after moving to Los Angeles, I scheduled an appointment with Mister Cartoon, a well-known gritty black and gray tattoo artist, to have a Japanese *hannya* mask tattooed on my neck. At this point, with the time off, I had been building up my collection of body art and had finished my sleeves as well as a good portion of my neck already. *Hannya* masks traditionally represent jealous female demons

in old Japanese theater. Seemed fitting to put one on my neck after partying with that bartender in Austin. Mister Cartoon wanted to put his spin on it. The drawing he came up with was of a *hannya* mask crossed with a sad clown. The resulting tattoo looks like a clown desperately trying to be frightening by wearing horns and fangs but unable to hide the sadness in his eyes. Clowns are a Mister Cartoon specialty. It could not have better represented me at the time. A clown trying to convince the world that he was mean and ferocious but in reality was just one big bucket of sad. Cartoon didn't flinch or act affected when I told him my stories. Neither did Estevan, his business partner, who was also a photographer and videographer. In fact, no one from their crew really did. They listened, nodded, and then quietly, in those L.A.-softened Mexican accents, they would each say, "Man, that's tough," or "That's brutal, but you made it."

Every one of them had a story. Both Cartoon and Estevan had grown up on the streets of Los Angeles, running with gangs, deep into drugs; both of them had lost friends, family, grown up hard and ugly. And they both had gotten out of it alive. Sober, talented, and with a work ethic that Mexican-Americans seem to have invented, they both had forged new lives for themselves. They were rough. They both had undeniably dry senses of humor, and their empathy for others came in amazing waves. One minute you would see them laugh at a crackhead Dumpster-diving outside the studio, and the next you'd see them driving directly into the heart of skid row to drop off meals they had purchased just for that purpose. They were both equally callused over and deeply compassionate. And even better, neither of them slept very much. Most of Cartoon's work was done late at night, so he would be in the studio easily from seven P.M. until four A.M. It was perfect. I suddenly had a place I could hang out around good people. I still wasn't sleeping, but at least I wasn't drinking as much.

Over the summer of 2009 I was visiting gyms in the surround-

ing area, but I really wasn't training much. I was floating at this point. Burning through what money I had left. I had no plans, no idea what I was doing. I still had it in my mind that I wanted to come back, but I really didn't know how to begin doing it. In August of 2009, I was thrown a life preserver.

It was the evening of August 2, and I was supposed to be staying at my friend Tim's house. Tim lived in North Hollywood, and Tim had a car. The following morning I was catching a plane very early to Philadelphia. I was attending an MMA event there. Shortly afterward I would be either renting a car or catching a short flight to Pittsburgh, where I'd be spending some time with my kids, whom I hadn't seen in a while. I was supposed to stay at Tim's house, and he would drive me to the airport in the morning. He had to pick me up from my apartment first. And he was late. I was exhausted. I wanted to get to his house and fall asleep on his couch for an hour or so. I didn't sleep much, so when I knew sleep was coming I got protective over it. I was pissed off that he was late. Suddenly, he was calling me. I answered.

"Dude, I'm coming to get you and we're going to my house, but we are going out tonight first."

This was not what I wanted to hear. I was trying to *avoid* going out. I was trying to stay away from alcohol and partying. "Where the fuck are we going? Dude, I don't want to go out. And I'm starving, I need to eat." I would go days without eating regular meals. My weight had plummeted. I was maybe one hundred eighty pounds at best at this point.

"Dude, seriously, I'll bring you food. I've been out at dinner with this chicky and she wants to go to this bar, so we are going."

The implication being made was that Tim had an opportunity to score and therefore wanted to meet up with this girl. Now, two things are important here. One—Tim was not a lady-killer. He was overweight, socially awkward, and kind of obnoxious. I

couldn't stand him when he would drink, as his obnoxious tendencies would be enhanced. It was horribly embarrassing. Two—I had played wingman to Tim twice already, and both times it resulted in my getting dates, without my trying, and his getting shafted, and then getting really really whiny with me. I think that the juxtaposition of the two of us when placed before a female truly resulted in an unfair advantage for me. In my current state I was brooding, heavily tattooed, still in decent shape, quiet, and undemanding of attention. I also wasn't impressed easily, which I found that girls in Los Angeles considered very appealing. Tim came off as desperate, loud, and ridiculous. It never worked out for him when I played wingman, so I really don't know why he kept asking me to do it, and tonight I was really angry, so that meant tonight, she was really going to love me.

"Fuck. Just bring me some food, man. Please." And I hung up.

Tim showed up at my door *without food* and dragged me out. I made him stop on the way. He told me, "We'll be picking chicky up and then walking to the bar from her place." The way he kept calling her "chicky" was making my skin crawl.

We pulled onto a crowded Hollywood residential street and started hunting for parking. Once parked, we walked up the street to a small building, and Tim knocked on the door. The door opened, and all I heard was "Yeah, come in, I'm just pre-gaming!"

The inside of the apartment looked like Marie Antoinette and some bondage-obsessed mad scientist had converged and decorated. Bookshelves flanked the doorway and were overflowing with books of all sorts, on everything from ancient soapmaking to Irish history. Above a massive blue velvet couch was an almost Giger-esque painting of a skull screaming. Underneath a window was an old gynecological table with a massive drape over it, and next to two large candlesticks was a muffin tin filled with what looked like tiny seedlings. On one wall was a large framed photograph of a girl's face

wrapped in a tight rubber mask, the only parts of it visible a pair of massive blue-green eyes and large red lips parted as another girl bit onto her tongue. Tim was now staring at this photograph a little too hard, as I heard "Oh, that's me in the hood."

Standing behind a minibar area in the tiny kitchen was a tall woman with very strong features. The kind of features that were so strong that had they been arranged in any other way, they wouldn't have been attractive, but as they were, they made her look like she was brought here from another time. She looked foreign at the least. Eastern European or something like that. Her skin was icy pale. Her nose was prominent and very straight. Her cheekbones were high and sharp. Her mouth was small but full lipped and heart shaped, dressed in blood-red lipstick. Her eyes were feline, crowned with dangerously arched brows and encircled in some mess of turquoise and black, making the blue of her irises burn. She was wearing a short cut-off white leather jacket with short sleeves, and her left arm was clad in a whirl of color, various flower tattoos crawling up it. She reached up with her right hand to brush a lock of long copper-fire hair behind an ear and then stretched out her left, holding a short, fat tumbler full of golden liquid and ice cubes. "Here, Jameson and ginger ale."

Tim was a liar. There was no way this girl had gone on a date with him, not one that she knew about anyway. And there was no way she was assuming that this was a date now. I couldn't even hide my disdain at his attempt to try to pass this woman off as a willing participant in his imaginary dating life. I turned and cast him a look of utter disbelief. He shrugged and acted as though he had no idea what I was on about.

"You guys want these?" She gestured to the three drinks sitting on the counter.

"No. I'm not drinking," I said as I stepped forward. "And I'm Mark, by the way."

"Oh, cool. I'm Shelby. I'll just drink them myself then." And she tossed all three drinks back speedily. "Let me just grab my keys and we'll go." She came from behind the bar to reveal shredded blue jeans and spiky black boots. I figured that flat-footed, this girl must have been huge, because in these shoes, she was eye-level with me.

I saw a tangle of leather and snakeskin crumpled on the edge of the couch "This your purse?" I asked, lifting it up by a strap.

"Oh yeah, thanks! What do your knuckles say?" she asked. I turned my hands over and made two fists. "'Lead Pipe.' Oh. So you're a badass. Well, at least you let everyone know." She said this without a hint of a smirk. She took the purse from me and walked past me; her perfume smelled like leather, tobacco, and frosting. I was in fucking trouble.

Shelby had this weird, almost aggressive presence. Everyone who reads this and knows her will know exactly what I'm talking about. She pulled the oxygen out of a room. She didn't have to say anything or do anything. She was commanding, almost masculine. One of her friends once said to me, "She is a force of nature," and there couldn't be a better description of her. She had hurricane omnipotence within her. And right now, at this first meeting, she was making me feel very uncomfortable, as I was not prepared to actually meet a girl I would find interesting for another few years.

She was walking ahead of us at a clip that was forcing both Tim and me to speed up. She was walking like she wasn't with anyone else. It was bizarre. Like she had no idea that we were supposed to be going with her. At a stoplight crossing, she stopped and turned her head. Seeing us struggling to keep up, she rolled her eyes and motioned with her hand. "Come on, you are going to miss the light." As I got closer I saw her hand, a silver band on her ring finger.

"Are you married?" I asked.

She sighed heavily, indicating that there wasn't an easy answer.

"Yeah. I am. I guess. I never see him anymore. He just . . . Yeah, he isn't around much." She dropped her head suddenly and then stomped her foot. "Ugh, this fucking light . . ."

I looked at Tim again, this time almost parentally. He cut me off. "Oh, don't even . . ." And he was right. Who was I to judge?

We got to the bar and a security guard who was clearly enamored with her brought us inside and showed us to a table. Shelby started a tab and instantly ordered shots. This girl was running from something and running hard and fast. I knew this pattern.

"I'm not drinking," I told her again.

She narrowed her eyes. "That's fine. I'm ordering you a shot anyway."

"*I'll drink it!*" Tim shouted. Shelby got up and moved to the opposite side of me to ignore him. Her body was turned to face me directly as I was staring straight ahead. Now she was going to start grilling me.

"So what's your deal, man? What's with this 'brooding sad guy' shit?"

I burst out laughing. "Is it that obvious?"

"Well yeah. And why aren't you drinking? I want you to drink with me." She held up a dripping shot glass full of whiskey. I grabbed it.

"You want me to drink with you? Okay, fine." I downed the shot, grabbed ahold of her shot, downed that, and then grabbed a beer. "You don't know what you're asking for."

"Hey, whatever. So Tim tells me you're flying out of town tomorrow. What for?" She grabbed the beer out of my hand, took a long pull, then wiped the rim with her hand, leaving a red smear across her palm.

"I have unfinished business. And I'm going to watch some fights in Philadelphia. What about you? Tim told me that you're also heading out of town in a week or something like that?"

She straightened her shoulders and ordered more drinks. "Yeah, I'm flying to Cincinnati for a month."

"Jesus Christ, what for?"

"I'm piggybacking on my friend Josh's training camp. He's a professional fighter getting ready for a fight. I used to train in boxing, and I've been wanting to get back into it. . . . Just been needing a change." She got a distant look in her eye and reached for the beer again.

"So you're going to be training out there. You ever trained at that level before?"

She laughed. "No, I've never done most of this shit before. But I need to get away. I need to go do something for myself."

"Are you worried about how hard this is going to be? I mean, you're going to get your ass kicked on a daily basis, honey, you ready for that?"

She passed the beer back to me. "Yeah, well, it's better than sitting in this fucking apartment waiting for attention and drinking myself stupid every night."

This girl was lonely as hell. She had nothing about her that said married. She didn't carry herself with her the air of someone who was married. She seemed preoccupied and sad. Over further conversation I found out that her husband worked nearly sixty miles away at a place that had opportunities available within five minutes of their home, but he refused to switch locations. He rose at five A.M., drove to work, and came home at eight P.M. exhausted, expecting food and sex. She had no one to talk to. She was a good conversationalist and was just wasting away in that apartment waiting for someone to engage her brain. So, she had decided to pursue what she loved, and what she loved just happened to be combat sports. I felt my heart swell. I felt proud of my profession for the first time in a long time. After trying to be a compatible half, she was diving headfirst into her own passion. She was just leaving. I had originally jumped into

fighting to get away from something else, so I understood. She had this animalistic desperation about her, but if she was afraid of her new ventures, it didn't show.

Later that night a very drunk Tim, Shelby, and I ended up being driven to her doorstep by a mutual friend. As the car pulled up to her door she drunkenly fumbled with her keys and said, "Well, all right, g'night, guys."

I popped up and said loudly, "Well, a man should always walk a lady to her doorstep," and I hopped out after her. I could feel Tim's eyes boring holes into my back.

We walked up to her door, and she turned and said, "Hey, thanks for being awesome, I hope you find whatever you're looking for, you know."

"Hey, give me your phone," I said. She handed it to me half-bemusedly. "I'm putting in my phone number, so that you don't do it and forget whose number it is tomorrow when you aren't drunk. We should hang out again, but by ourselves, okay?" I'd already decided that I had every intention of meeting up with her in Cincinnati, even if it meant I had to hitchhike the entire way to get there.

She smiled at me. "Yeah, sure," she said, and closed the door in my face.

Who the fuck is this girl? And what brought her to me now?

chapter fifteen

The capacity for friendship is God's way of apologizing for our families.
—JAY MCINERNEY

It didn't take Shelby more than a few hours before she started texting me after I gave her my number. After that, we were in contact every day, nearly every hour. We talked about authors we liked, what inspired her to pursue combat sports, films, art, everything. Everything except for our sad lives and the stories we were running away from. By the time she landed in Cincinnati we were already good friends. Several days later I was standing inside of a gym called the Sweatt Shop watching a thick-shouldered, bald-headed beast of a man named Shane put Josh, Shelby's friend, through some of the meanest and most creative strength and conditioning work I had ever seen.

"This guy is a fucking genius. He is really who inspired me to want to be a trainer," Shelby whispered. She was referring to Shane. Moving deftly from modified powerlifting moves to explosive plyometrics, Shane was blurring the line between torture and training. He walked alongside Josh carrying a stopwatch, glancing at it every few seconds and speaking very calmly. There was no shouting, no anxiety-inducing urgency in his voice, just supportive persistence

and a constant reminder of the time. Within twenty minutes Josh, a stocky and good-natured West Virginia lightweight fighter, had thrown up twice and crawled through his own vomit once. Shelby was beaming.

"You should see his wife. Strongest woman in the world, and kills at sprints. This guy builds explosive endurance muscle tissue better than anyone I have ever seen. I want to do what he does more than anything. I want to build better athletes." She was completely lit up. Josh was currently strapped to a sled, vomit slicked on his forearms; Shane was sloshing a hose at him as he passed by. Shane's wife Laura stood to the side holding a small black Staffordshire terrier and smiling a bright smile. She looked like she could benchpress a Ferris wheel.

Shelby had told me through multiple conversations what had led her to this point. She had grown up in a house with parents who didn't like violence and eschewed combat sports. She used to sneak into various friends' houses to watch boxing fights. As she got older she sought them out more frequently. In June of 2003 she saw the third Arturo Gatti–Micky Ward fight. She had been an Arturo Gatti fan going into the trilogy, and this third fight cemented Arturo as not only her favorite boxer but her inspiration. She recounted the fight on the phone to me once with almost shocking accuracy.

"In the fourth round Arturo went to throw this body shot and caught his hand on Micky's hip, breaking it. He telegraphed it right away, shaking it and looking at it. The whole rest of the fourth Arturo was stunned. Then he went to his corner to Buddy McGirt, one of the best trainers in the world, and as he sat down he looks at Buddy and he says, 'My hand, my hand, I broke it' . . . and Buddy did this thing where he just said, 'What do you want me to do about it, Arturo?' and Arturo Gatti stopped, thought about it, and said, 'I just have to deal with it.' Fifth round, he favored his right hand. Sixth round he got *rocked* by Ward. . . . Suddenly, he turned on the jets.

Arturo won that fight on pure heart. Changed my life. I started pursuing boxing right after that."

She had met Josh through a mutual friend. Josh was a character. A five-feet-five-inch MMA fighter built like a fireplug, with a country West Virginia accent so thick he sounded like he was faking it. Josh had incredible tenacity in training and is to this day one of the most amiable people I have ever met. You'd be hard-pressed to find anyone who has a bad thing to say about Josh. In an act of desperation to find a new path and to get her away from Hollywood, Shelby had asked to come to Cincinnati and train with him in exchange for fixing him a few meals and just generally being company throughout his camp. She hadn't played around either. She went and bought a *gi*, shin guards, a new pair of gloves, and a customized mouth guard, and had packed a small suitcase full of supplements and training clothes and flown out to sleep on a sandy air mattress and train sometimes six hours a day. She had already learned how to burn ringworm off using hydrogen peroxide and Clorox; she had already had her own training session with Shane during which she had thrown up and wept before calling me to tell me how awesome it was. She had busted her nose in a sparring session. She had been kicked in the crotch full force by an Olympic Tae Kwon Do competitor. She had drained a cauliflower ear (Josh's were magnificent) and she had accidentally kicked Josh's kickboxing instructor square in the face during a head-kick drill when he had told her that he doubted she could lift her leg that high. She hadn't worn makeup in nearly three weeks when I got there. For a woman who came from a world of false eyelashes and red lipstick every day, this was a huge change, and she was absolutely loving it. Her passion for it was inspiring. I had almost forgotten what it was like to love the sport so much.

"Oh my God, I need to shower and then go get somethin' ta eat!" Josh was a sweaty mess but was still grinning. He offered his

hand and then laughed as I grimaced at it. "It's all good, man. I'm fixing to go wash off, you can get me back then."

Over a carefully balanced meal of chicken, brown rice, and steamed broccoli, Shelby started her pitch. "You see, Josh, Mark was a K-1 fighter, and I think he could really add a lot to your camp. . . ."

She was selling me as a coach to this guy.

Normally this would be unheard of. At this point Josh was about three weeks out. Established camps start oftentimes six to eight weeks out. Josh already had a kickboxing coach, but he suddenly piped up with, "Man, I would love to have you help me with my trainin'. And if you wouldn't mind, I'd also love to have you corner me on the night of my fight. My kickboxing coach can't be there, and I would really be honored to have you in my corner."

I had to go back to Pennsylvania. My son Ben was having a small operation to have a birthmark removed, and I needed to be there for it. But I agreed to come back afterward, to help Josh and to be in his corner. It had been years since I'd been in or near an actual fight. I felt old but excited.

Upon my return I started working with Josh. Every time, Shelby would stand in the corner quietly and watch or would work a bag. Her form was far from perfect, but she was driven. Finally one day she approached me and asked if I would mind holding pads for her, just once. After that I would train both her and Josh at different points during the day. They were both infinitely coachable. Open to listening, committed to perfection, and polite. Even with our friendship, as it were, to this day when we train together Shelby and Josh both call me either "sir" or "coach."

Josh walked at a heavy weight. Between fights he had a tendency to blow up, that West Virginia diet not suited to his athletic lifestyle. He was around 190 pounds. By the time I met him his initial weight cut was well under way and he had shaved down to about 170. When the time came for him to weigh in the day before his fight, I opted to

enter the sauna with him, Shane, his friend Eamon, and a few other friends of his. Shelby would have gone in with us had the health club we cut weight at allowed her to. She was as much a part of the team as I was, and sitting in a steam room with a bunch of naked guys smeared with Albolene wasn't a big deal if it meant being a support. Josh sweated out his remaining weight, and then we made our way to the venue in Eamon's car. He weighed in at 155 on the nose. We headed out to get him fed and into bed. Next day was fight day.

Shelby had never seen an MMA fight up close. She had been privy to unlicensed boxing fights earlier in her life and had even participated, but this, this was going to be different. And it's always worse when your friend is fighting instead of you, because you have distance and time to worry. Josh was the main event. He entered the cage with myself; his jujitsu coach, Jim; and Shane in his corner. Shelby sat beside the cage chewing her cuticles.

Round one, Josh landed some heavy hands, but his opponent wanted to play the blanket game, taking Josh down and pinning him while inflicting minimal damage. Jim kept shouting, "Josh, you *need to get up*," while Josh desperately searched for ways to grab ahold of a limb. Josh was winded; this weight cut had hurt him. In between rounds I encouraged him to use his hands, stay away from kicks, and cut angles. All three rounds looked virtually the same. Josh would land unholy-sounding blows on the guy, then he would be taken down and smothered. At the end, Josh lost, three rounds to none.

Shelby came running into the back room, pushing past security to where we were.

"Josh is fine, Shelby, he's fine. He's over there eating a candy bar." I pointed to Josh, who sat smiling his bright smile and shoveling a Hershey bar into his face with ferocity. He had a black eye but was otherwise totally fine.

"I've already been checked out, I'm fine. He's not so fine, though." Josh pointed with one sticky finger at his opponent, who

sat in a chair surrounded by commissioners and paramedics, gagging into a bucket and crying. He was taken to the hospital, and it was determined that he had a multitude of injures—a bruised larynx, a broken nose, bruised ribs, and a few other things. This is why I preferred kickboxing to MMA. In kickboxing, that guy wouldn't have been able to win a fight on takedown points. He would have had to stand and face Josh, and he would have lost. It seemed ridiculous that Josh was sitting here happily eating candy, and his opponent was leaving in an ambulance, yet his opponent was deemed the undisputed winner.

"I needed that win, damn it. I needed it. Let's go to the bar, I have credit for my fight pay with the casino, we are drinking tonight." Josh was doing what so many fighters do. You get a win, you party for a few days, then you hit the gym and get back to it. You lose . . . and you party to forget. It makes no sense, but I have seen it done a thousand times. Josh wanted to go drinking, and I knew what this sort of drinking was going to look like. I reluctantly followed him to the bar. This was going to be bad.

Shelby had changed since L.A. She wasn't the same drinker. She had a shot of whiskey and then just proceeded to nurse a beer for the rest of the night. It didn't interest her anymore, almost seemed to bore her. Something had changed. She didn't seem so sad, so lost. Instead, she and Eamon made it their jobs to start removing half glasses from Josh when he wasn't looking and dump them out, for Josh and I were on a mission: Get as drunk as possible. I don't know what I drank; I know at some point I had tequila, Jägermeister, vodka, whiskey, some sort of cherry-based alcohol, all kinds of stuff. Shelby and Eamon kept trying to take glasses from us to limit our intake, but it wasn't working; we'd just order more. Finally, the money started to run out. We had drunk almost all of Josh's fight pay, and while Josh had a room at the casino, we had to drive back to his house to sleep. As we climbed into Eamon's car, Shelby made

sure to stick me in the front, saying, "This is a Mustang; when you puke you need to be able to do it out a window."

Puke? I *never* puke. Not ever.

Twenty minutes into the drive, I puked.

I puked straight into my hands, and then, after Eamon, the ever-tolerant driver, rolled down the window, I tossed it out, only to have it splatter on the back side of the car. Eamon pulled into a gas station to hose off part of his car so the paint wouldn't get eaten off, and to buy me a shirt since I had vomit down the front of mine. I was humiliated. This was not me being cool. This was me clearly being out of control, a feeling I did not like. I could hear my father's angry voice inside me saying, *"Toughen up."* Eamon came out of the gas station and handed me some four-dollar shirt he had just bought for me to change into. In my idiotic drunken state I simply used the shirt as a rag and wiped the vomit on my shirt off with it. "Or you can do it that way . . . that's one way to do it," Eamon said sort of bemusedly.

Once we got to the house, Shelby forced me to check my sugars and take insulin. Then she forced me to eat, something I did not want to do. After that, she started a shower and led me down the stairs to Josh's basement, where the washer and dryer were. She stood there tapping her foot while I stripped down to my boxers and handed her my puke-covered clothing, which she dumped into a washing machine. I leaned on the washer, sulking.

"Mark, you'll feel better in the morning. Don't worry." She was trying to console me, but she was irritated. I could hear disappointment in her voice. She had looked up to me until now.

"Yeah, I'm just mad though," I slurred. I couldn't make a lot of sense out of my feelings, but I knew I was upset. What I would come to realize was, I hadn't felt proud of myself in a long time. The way she and Josh had seen me made me feel proud again. Made me feel like a fighter again. Made me feel like a person again. And here I was, in neon-blue boxer-briefs, standing barefoot in a base-

ment, drunk off my ass, while the one person alive who saw me as her hero washed my pukey clothes. What a fucking winner. The self-loathing was so oppressive I wanted to crawl into the washing machine and just hide.

"Mark, it's fine." It really wasn't fine. At all. "Just go upstairs and shower and you'll be okay."

As if I hadn't already made a lovely impression, I decided halfway up the stairs that it made no sense to wash some of my clothes and not all. So I stopped, pulled my boxer-briefs off, and hurled them at the washer, instead landing them on Shelby's shoulder, and in trying to dismiss the embarrassment, shouted, "*I don't give a fuck, so what,*" as I clomped up the stairs to greet Eamon with my stark nakedness.

"*Really?* This is like the fifth one of my friends I've seen naked today! Can't one of them be female? God!" Eamon shouted, causing Shelby to burst out laughing. He was referring to the sauna, where he had accompanied the rest of us earlier.

After my shower I came out in a clean pair of underwear and some shorts Shelby had left in the bathroom for me. I wandered out to the couch that was opposite her air mattress and flopped down. She was watching old cartoons and handed me a glass of water. "You need this, believe me." I finished the entire glass and then went to refill it. By the time I came back she was asleep.

The next morning we all got up and went for breakfast. Josh met us, his black eye much more prominent now. As we sat down and ordered coffee, Shelby turned to me, her blue eyes incredibly bloodshot. "You okay, kid?" I laughed.

"I didn't sleep hardly at all, kept waking up to check on you," she mumbled.

"Why? I was fine. Once I threw up I was all right."

"Mark, you're a type one diabetic, your sugars are delicate, you could have experienced a low in the middle of the night. I don't need

that to happen." She had been doing her reading. In fact, that's all she did. Shelby was already in the middle of pursuing a single certification in sports science and strength and conditioning training at the recommendation of Shane and was an avid reader. If she heard about a new condition/product/diet craze she would go read about it until she had read everything there was to read. She had been pulling up multiple articles about type 1 diabetes since we first met. She now knew how utterly irresponsible I really was, and it was frustrating but comforting.

She sat stirring her coffee. This was the last time I was going to have this teammate feel with her. In a day or two we would fly home. I would go back to my giant empty loft downtown and she would go back to her sad apartment in Hollywood, where all her neighbors would either funnel alcohol down her throat or make fun of her for trying to pursue combat sports. It wasn't right. We were a good team.

"Hey, Shelby, I have an idea. . . ."

"Yeah? What is it?" She turned to me, rubbing one eye and yawning.

"My loft is a two-bedroom. It's nearly two thousand square feet, and I have a lot of room. I could train you if you structured meal plans for me, and you wouldn't have to pay anything. It would be a working relationship and—"

"Mark, what are you asking me?" She laughed a little and dropped her chin into her palm.

"I think you should move in with me. I would handle everything, and you could just focus on finishing your certifications. . . ."

And in November of 2009, that's exactly what she did. She brought with her her boatload of furniture, her cooking, and her unbelievable worrying over me. On one hand it was a pain in the ass, because I could no longer slack or misbehave. On the other hand, I started sleeping, and I mean sleeping a minimum of eight hours a night. It was amazing. She earned her first certification within

months and set about putting me on a structured diet plan and a strength and conditioning regimen. We worked out of various gyms, bouncing from one to another. I had her to keep me in shape, but I had no skill coach, and I had no fight scheduled. With no money coming in, I was burning through the last of my cash very fast just keeping us alive. I had lied about how capable I was of taking care of both of us financially, but I wasn't about to ask her to go to work, even though she wouldn't have cared, not after I had promised. In retrospect I should have been at least a little forthcoming about the situation and how dire it was getting. I hid it from her; I just didn't want her to worry. She was working so hard, training me and whoever else she could get her hands on, staying in touch with Shane to continue learning from him. . . . I just didn't want her to have to give up, and I was convinced I could get something going before things got too bad.

One night we were doing mitt work in the loft when I heard voices. Shelby paused and ran over to the big old windows. She stuck her head out and started talking. As I approached I saw two heads peeking out from a loft window across the way. They quickly introduced themselves as Adam and Mikee. They were asking what we were up to and wanted to invite us over sometime. They said they had seen us working in the loft before and were really impressed with the hard work they saw. We chatted for a few minutes. Learned that they both were interested in pursuing careers in fashion. Mikee had rugged rock-star-ish looks while Adam, more clean-cut, looked like he could have been an actor. I would learn after spending more time with them that both were quintessentially fashion oriented, and though what they wore looked easy on them, it was also carefully chosen, each piece. Mikee was loving, sweet, took to hugging me and telling me he loved me very soon after we started hanging out with him. Adam was tough, dry witted, cynical, big-brother-like. We shared a love for fashion and art, and over the next few weeks we

had many a conversation at nearby cafés about these subjects; then something new came up. Mikee and Adam were both in recovery. They were both sober. Outside of the cigarettes they smoked and the coffee they drank, they abstained from substances. Mikee shared his path, his story; it was as though I was listening to a version of my brother's story, but one where he got out. Mikee had been deep into drugs. He'd seen the underbelly of Los Angeles laid out before him. Yet here he stood, smiling, open, one of the most emotionally raw people I had ever met. Adam's sobriety was newer, fresher, but he still had this raw sort of attitude when talking about himself. They seemed so fearless, so committed to honesty. I felt that I wanted to walk this path. . . . But I wasn't ready.

On Thanksgiving Shelby made a massive turkey, chestnut gravy, mashed potatoes, Brussels sprouts, and a pie. She packaged up leftovers and handed them out to neighbors she called over. When Mikee came to receive his, he offered us both a hug so big it could have cracked us, followed like always with a sincere "I love you guys!"

Christmas came and I decided to go visit my kids. Shelby set up a miniature Christmas tree for when I returned so that the gifts we were going to give each other could stay there until I got back. Pennsylvania was bad for me. Outside of my children, there was nothing there for me but ghosts. The friends I had left tried very hard to keep me preoccupied when I wasn't with my children, to keep me out of the bars. Most of them did anyway. Right when I landed in Pennsylvania I had gone to visit my old doctor. I had been feeling under the weather, and it turned out I had a low-grade respiratory infection. He handed me a bottle full of antibiotics and sent me on my way. After a few days I ended up linking up with one of my tattoo artists. He had decided he wanted to do some work on my ribs while I was in town, but before starting he opened up a bottle of tequila. After a few sips we abandoned the idea of doing any tattooing and just decided

to drink. Upon emptying the bottle, I sent Shelby a text. I don't know if it was guilt or what . . . but I needed to send it.

Hi. I'm drinking A LOT

I did not get a positive response.

Oh good for you. And while you're on antibiotics too! You must be so proud of yourself, just stellar behavior for a "professional athlete."

So I did the only thing a drunk would do. I sent this.

:(

She didn't say anything. I knew she was pissed. At this point I was sitting at a bar in Greensburg with my tattoo artist and a few of his friends. Alcohol wasn't the only thing being passed around. The truth of the matter is, oftentimes when I drank, I didn't just drink. If there was pot available, I smoked pot. Cocaine was a favorite because it allowed me to drink more. I was definitely partaking in one, and possibly both, of the aforementioned "side dishes." I got up to "use the restroom" and accidentally left my phone. Apparently my tattoo artist saw this as a chance to jump. By the time I returned, the damage was done. I picked my phone up to see a *rant* from Shelby . . . something like this:

Oh sure, no problem. Tell him to have a fucking great time. Tell him to have a blast. Tell him to have a few more drinks and maybe drive home! And tell him that if he ever gives his FRIEND his phone again I'll be more than happy to find a new place to live.

The tattooer sat there looking sheepish.

"What the fuck did you say to her, dude?" I asked. Shelby was not fucking around, and now she was really angry.

"I just told her she shouldn't be so controlling and should just let you have a good time once in a while." Oh jesusfuck. He had no idea how deep he'd dug me in.

I had drunk brain. I had drug brain. So of course my brain was telling me, *YOU MUST CALL HER. YOU MUST. IF SHE DOESN'T ANSWER RIGHT AWAY THEN YOU MUST KEEP TRYING UNTIL*

SHE ANSWERS YOU. So, like a grown-up, I started calling her, obsessively.

I got a single text in return after my fourth or fifth attempt at a phone call. It was very short and went something like this:

I am too angry right now, and if I talk to you and hear that you are smashed I will lose my cool. Please give me about fifteen minutes to cool down and I will return your call then. Thank you.

Oh man, that *thank you*. It was so *cold*. It was the final word. I was instantly ashamed of myself. She was fucking right again. Drunk when I met her. Drunk to the point of puking in Cincinnati, and here I was drunk and out of my mind in a bar in Pennsylvania in winter. We didn't have a sober driver, and the roads were icy. I was playing Russian roulette with my life drinking as a type 1 diabetic anyway. Here I was risking it blatantly in the town that my kids lived in. I was not having fun anymore. I asked to be taken to Amy's house. I still had a key she had given me so I could come and go with the kids when she wasn't there. Her house was close, which meant minimal driving and minimal risk. I wanted to go lie down.

I was dropped off at Amy's door. My self-loathing grew like a heavy coat over my shoulders. I quietly unlocked the door and got myself settled on her couch. I thought about my kids finding me and smelling the alcohol on me like I had smelled it so constantly on my father. I knew Amy was going to be so pissed off. The drugs were wearing off. I sat on the couch, my phone facedown on my lap, and fell into a terrible, accidental drunk sleep.

Around three hours later I awoke with a start. I had only meant to rest, not pass out. My phone was blinking at me. I looked at it to find I had forty-three missed calls and sixty-seven texts. My heart froze. I was so fucked. The calls were mostly from Shelby, but there were calls from local friends, friends in L.A., friends in Cincinnati. The texts were also mostly from Shelby and ranged in flavor from pleading for me to respond just so she could know I was all right,

to outright threats that if I didn't respond and she found out I was alive and ignoring her on purpose, she was going to throw my very expensive television out the eighth-story window. I didn't even read through the other texts from a myriad of friends she had called who were begging me to call them or her. . . . I called her right away. She answered immediately.

"*Hello?*" She had been crying, I could hear it. And she was angry.

"Hi, Shelby." I winced.

"*Fuck you, Mark.*" And she hung up on me.

I called her right back. This time she was a little bit calmer.

"Where the fuck have you been? I have been trying to call you for three hours now. After one, when I didn't hear from you I started threatening you. Then when I didn't hear from you after that, I called hospitals, jails, I called Eamon, Josh. . . ." She trailed off, starting to cry again. "I pictured you dead in a ditch. I can't have that, Mark, and your kids don't deserve to find you reeking of shitty booze in the morning. Amy doesn't deserve you basically breaking and entering in her home just because you drank too fucking much. You can't do this anymore."

I know, I told her. I know.

Amy was as pissed off as I expected her to be with this. In the morning she angrily took the key from me and told me that I smelled like a disgusting hobo. I showered and brushed my teeth, hoping that my kids wouldn't notice. But I knew. . . .

When I returned to Los Angeles, Shelby sat down by her miniature Christmas tree and, before giving me my gifts, said, "I have to say something to you. I don't think I can handle you drinking anymore—"

I cut her off.

"I can't handle me drinking anymore. I will never fight again if I keep this up, and I know I need help."

In the next few days I told Mikee and Adam I wanted to go to a meeting. They took me, shaking, frightened, and full of self-loathing, into my first meeting. They held my hands through the prayers and through the introduction. And for the first time in my life I heard myself say out loud that I was an addict and that I needed help, something my brother never could do. Suddenly I felt so much remorse for how hard his life must have been. I met a group of people who were gritty, tough, strong. People who had stories that would make most people's hair stand straight up, and all of them were there, white-knuckling the desire to tune out life, smoking an abundance of cigarettes, drinking gallons of coffee, and supporting each other. Shelby picked me up afterward and asked me how it went. I gave her the only real answer that there was to give.

"I am scared shitless, but at least I know now that I have a chance."

My Tuesday meeting became a constant. I never shared, but I sat there, quietly, listening. The shitty thing that nobody tells you is that when you first get sober, you get to deal with feelings suddenly. Feelings that you thought you had kept at bay. The worst came when I was walking with Shelby through a department store and suddenly a song came on. A song I connected to my childhood. A song that out of nowhere dredged pristine and tender thoughts up through the black sludge that filled my memory vault. I stopped dead in my tracks and turned to Shelby in a panic. "We have to leave."

"What's wrong, Mark? Are you okay?" She was already quickening her pace to keep up with me as I made for the door. "Mark . . . talk to me."

She reached for my arm and I yanked it away. I had very little left keeping me together. Anything could tip me over. The last few hundred feet to the door, I ran. I sprinted. Once outside I turned and ducked behind a planter and felt my body fold in half in excruciating

pain, and suddenly, without any way to stop it, I started to sob, and I mean full-body-collapse sob.

Shelby went to hug me but I waved her off. Instead she stood beside me with one hand on my back, her eyes welling up next to me. She had known this was coming.

I cried for the better part of twenty minutes. I cried until I felt like I had no guts, until I was choking and almost gagging. I cried until I was exhausted. It was midsummer of 2010 and this was the first time I had cried since my family had died. These were the first tears I had been able to access.

The song was "The Rainbow Connection," and the line that crumbled me up was "Who said that every wish, would be heard and answered . . ."

Shelby didn't know about my family. She knew they were dead, but she didn't know when or how. It was time to tell her.

chapter sixteen

Last year we said, "Things can't go on like this"
and they didn't . . . they got worse.
—WILL ROGERS

I sat Shelby down and I told her everything. Well, almost everything. I didn't tell her that we were almost out of money. I don't know why I couldn't tell her. She kept asking me if she needed to get a job to help or if she could do more to earn her keep. . . . But the truth was just having her around was enough for me emotionally, even if it didn't pay the bills. I didn't want her to leave, and I was afraid that if I told her we were going to both need jobs and we were probably going to need to move to a less luxurious place, she would. I was not, and am still not, used to people liking me for me. So, I lied and prayed that something would happen before the money was gone.

Part of my sobriety was being of service. I opted to volunteer with Shelby at a dog rescue. Every Wednesday and Friday we would show up and walk dogs that were at the rescue, maybe give them a bath, a hug, whatever. The rescue she had chosen to volunteer at specialized in "danger breeds," German shepherds, rottweilers, and a lot of pit bulls. You can't imagine how much I identified with

these dogs. So completely misunderstood. Those days were some of the best days. We would each get a dog and just disappear on a trail by ourselves with them for a while; unable to walk two dogs close to each other, we were each on our own. It was just me and a dog. I had some of my very best conversations those days. You'd be amazed at what good listeners they really are. Over time the woman running the rescue began to trust me more and more, and since I was one of the biggest volunteers they had, I was being given some of the harder-to-handle dogs. Big cane corsos, Neo mastiff/pit bull cross-breeds, huge dogs, one hundred pounds and up, and some of them with terrible leash manners. I knew what they needed. I would bring my running shoes to the rescue, strap them on, grab the leash, take off, and just run them. Run the anxiety out of them. Run them until they couldn't be mad, untrusting, or scared anymore. That's all that a dangerous or aggressive dog is, a scared dog. I should know. I ended up with more than a few very large pups collapsed in my lap, happy and slobbering, after these runs. I felt like it should have been me laying at their feet. I got as much out of it as they did.

Shelby, in the meantime, was trusted with some of the smaller but more difficult dogs and had started bonding really hard with one, a smallish pit bull named Ali (yes, like the fighter, and yes, he came with that name). He had had a difficult past, and we would find out later from various vets that he had sure signs of abuse on him: grid marks on paws from being electrocuted or burned through some kind of mesh; scars all over his face and forelegs, most likely from fighting; and a highly aggressive disposition toward other dogs, but he was an absolute love to her. He trusted her, and she had a soft spot for the broken ones. By the end of May, Ali was a new roommate and was taking full advantage of the size of the loft by charging from one end to the other before popping onto his hind legs for "hugs." He was amazing. You can't be in a bad mood when you have a big

silly dog so excited to see you every time you walk into the room. But he was another mouth to feed. I had people, and animals, depending on me. The noose was getting tighter. I needed to fight again, and for the first time, I actually really *wanted* to fight again.

I was training full-time now, and it felt so good. Shane flew out and stayed with us for a week, helping Shelby to tweak my conditioning. My diet had leveled my weight back up to 210 without disrupting my insulin needs. Amy and I were talking civilly again and she was very happy to hear that I was clean. I was healthier and happier than I had been, but I was also terrified.

One night at one of my meetings, I decided to take the next step in my sobriety. I had been drawn to a man named Matty, a former fashion entrepreneur who had lost almost everything to drugs and alcohol. He had gotten sober and was rebuilding himself into not just an incredible person but an incredible businessman once more. Matty had the same open kindness that Mikee and Adam possessed. He was always there with a hug, always checked on me after meetings, always smiled when I seemed to open up a bit more. Matty still looks like he might be twenty-two years old. Bright green eyes and dark hair with a soft New York accent. He was sensitive enough to be gentle with me but had enough grit to not get rattled by my harshness or ugly stories. One night I approached him. He had been talking to me about his new business venture, Android Homme, a high-end shoe company. I was fascinated. He was so passionate, and I knew I needed someone who would understand passion for a career by my side. I asked him if he would be my sponsor. It was one of the hardest things I have ever forced myself to ask another person. The risk of rejection was massive. Then Matty, unintentionally, lightened the mood.

"Well, Mark, Android Homme is just starting, but I would love to talk about how maybe we could be a sponsor of yours—"

I cut him off.

"No . . . no, Matty, I want *you* to be *my* sponsor. My sponsor in recovery. Not for your company to sponsor me as an athlete . . . although I'm open to that as well. . . ." I laughed nervously.

Matty's eyes sparkled. "Oh, Mark, I'm so sorry I misunderstood. I'm honored. I would love to, and, Mark, thank you for trusting me and for asking me. That's a real gift." He grabbed me in a hug, and I turned away quickly. I was crying a lot lately.

Between working actively at my sobriety daily—and it is work— training, trying very hard to get a fight, and keeping the impending doom of being penniless from Shelby, I was stressed. I tried to focus on the good things . . . and the not-yet-grown-up part of me tried to ignore the bad . . . even when I went delinquent on rent and had to work out a deal with the landlord to let me do payments . . . payments I couldn't even keep up with.

Fights were hard to come by. Most organizations didn't want to touch me. I was thirty-eight, a type I diabetic, and post heart surgery. I was a risk. I was even looking into MMA fights, which held no interest for me. I would get one organization interested, and then they would give up. The glut of MMA fighters out there made me less interesting and more difficult than any promotions wanted to deal with. I was teaching here and there, mostly with NFL guys and a few hockey players, but there were no professional fighters in Los Angeles for me to teach continually. In Pennsylvania, follow- ing the death of my brother, I had spent some time working at a gym there called LionHeart. I had been the head MMA trainer and had overseen professional fighters such as Phil Davis, Paul Brad- ley, Jimy Hettes, Jon Jones, Dominick Cruz, Dave Herman, Char- lie Brenneman, and a few others. I was and still am a good coach. I wanted to work with pro athletes if I was going to teach, and I wanted to still have time to train myself. I was clinging to the idea that I would come back to fight, but that hope was dimming, and was about to get a lot dimmer.

In August of 2010, one early morning Shelby was making coffee and heating up some premade oatmeal/quinoa concoction that she made for breakfast for us. I could hear Ali's collar clinking against his bowl and his little nails against the polished concrete floor. Suddenly there was a knock at the door. It was nine A.M. No one came by this early. The building had a doorman and a required sign-in sheet, so there was no way this was a solicitor . . . oh no . . .

I could hear Shelby putting Ali in his crate and going to answer the door. Then I heard it.

"LAPD, ma'am, we are here for an eviction. . . ."

Shelby went silent. Then she said, in the most agonizing voice, "Let me get Mark, this is his place actually, he'll explain, I'm sure this is a mistake. . . ."

I grabbed a backpack out of my closet and in seconds threw some things in that I knew I would need right away. I had known this was coming. . . . I just didn't know it would be today. . . . I thought I had more time.

A knock at the bedroom door, and I opened it a crack, and there she was, wide-eyed. "Mark, there's been a mistake, there are cops at the door. . . ."

I open the bedroom door to reveal that I had a bag on my shoulder, and her expression fell. I tried to reason with the cops, but there was nothing I could do. We were going to get locked out. We had to take whatever we could carry and leave, and they would be locking the door behind us. Right as Shelby started to really panic, the landlord showed up and tried to calm her by saying she would keep the place locked, but that we would have fifteen days to get our property out, so we wouldn't have to worry about it going onto the street.

Then Shelby asked, "Well, how much do you need? I mean, how much is he overdue for? Maybe I can help. . . ." My Pollyanna Sunshine friend. My perpetual optimist . . . she started rifling through her purse for her wallet.

The landlord's face fell as she said quietly, "Seven . . ."

Shelby brightened. "Seven hundred? Oh, I can do that!"

The landlord placed a hand on her arm. "No, honey . . . Seven thousand . . ."

There it was, out loud. My failure in a number.

Shelby dropped her purse in shock. She turned to me and her eyes were burning. She was crying, and angry, and disappointed. I hated it. I had completely failed her. She went from having a home, a home she loved (she regularly told me how grateful she was to be living there), and feeling secure and happy, to being without a home in a matter of minutes. I watched her, totally helpless, as she moved angrily through the house and packed three, four bags, including Ali's bowls, food, clothing, toiletries, and a few expensive things that she wanted to ensure were safe. She collapsed Ali's crate and wedged it under her arm. Then she slipped Ali's leash around his confused head, grabbed her keys, and walked out the door to the elevator. I followed her and heard the click behind me as they locked us out. It was nine forty-five.

She didn't say a word, not until she got to the car and arranged a small blanket in the back for Ali. He jumped in, clueless, happy to be on an adventure, and she called her mother. Shelby had not lived at home for any notable length of time since she was seventeen. She and her mother had a good relationship when there was distance between them. Close up, her mother could be critical, negative, and even degrading to Shelby. I had heard it through the phone many times. But this was it; I had left her with no other option. She asked if she could come home, through hiccups and clenched teeth. Her mother sounded sad for her; I didn't blame her. She told her to come home, that they'd figure it out. Her mother had a five-bedroom house in Ventura County, about forty minutes north of Los Angeles. Shelby jumped in the car and turned it on. I didn't know what to do. I knew if she drove away that I would have no one left. I had fallen

so far out of touch with Justin that I couldn't call him just for help. I couldn't ask for any more help from Rakaa, or Mister Cartoon, or Estevan, or any of them, all of whom had tried to help me. I had run out of help. I stood there, terrified, as she started to back out of the parking lot. Then, she stopped.

"Are you fucking coming or are you going to try to sleep on skid row tonight with the other fucking bums?" She was crying, I mean torrentially. And she was taking digs because, well, I deserved them. I reached for the passenger-side door handle slowly. As I got in, she turned away from me and just said, "How could you do this to me . . . how . . . ?" It dissolved what was left of my heart.

"I . . . I'm so sorry. . . ." It was such a pitiful fucking thing to say, and it fell so far short of what I wanted to convey to her.

"God, I just want to fucking hit you right now. I want to hit you so fucking bad." She was serious. This I could take. This I was used to.

"Do it. Please, do it. If it will make you feel better, go ahead and—"

She cocked back and slapped me twice on my left cheek. I have to say, it shocked me. It wasn't that I didn't really mean for her to do it—I wanted her to—but I kind of didn't think she would. Shelby isn't violent by nature. She's fierce but not violent. This meant she was livid. And it didn't seem to make her feel better; it seemed to make her feel worse.

"Goddamn it, Mark. My fucking mom's house. And I'm not taking you. There's a Motel Six about five minutes from her place; I'll drop you there and you can get yourself a room for the night. We'll figure out long-term plans tomorrow."

"I hope it's a cheap place." I laughed. I was trying so desperately to make light of it. I felt like I had big sailor's knots for guts. I could not unclench my hands from around small bits of fabric on my pants. I felt like I was falling off my little fragment of peace of mind. I wanted a drink.

Shelby went to her mother's house first, which was so much worse for me mentally, and I know now that she did it on purpose. She made me help her unload her stuff and Ali into the small downstairs bedroom. We set up his crate, took him for a short walk (he loved it, as this house was out in the suburbs, so he got to walk on grass instead of asphalt), and then put him in his crate so she could take me to the motel. Her mother was pleasant, not cruel or bitter, but she definitely looked disappointed also. Disappointed for me and by me. It was awful.

Shelby pulled up to the Motel 6. It was a nice one, lots of families playing in the pool outside. The woman behind the desk seemed in tune with how depressing the whole thing was and tried to be comforting. "I have you in a room with a view of the pool!" she said brightly. *Oh great, so I can hear all the happy families laughing and having fun, just enough to remind me of what I don't have and how far from joy I really am.*

We walked to my room. Shelby reached for my hand right before I opened the door and squeezed it. This was fucking terrible. She was without a home, and here she was trying to comfort me. It was too much. I opened the door and set my one bag down on the small desklike table. I flipped on the TV and it was set to Cartoon Network. "Hey, at least I have cartoons!" I said, and tried to crack a smile. Shelby wasn't smiling. In fact, she had started crying again.

"Try to sleep, Mark. Tomorrow we will figure out where you are going to go. I'm sorry. . . . I'm sorry I didn't know. I'm sorry I couldn't help." And she closed the door.

I sat on the bed and stared out the window. I had fucked up absolutely everything, and now I had almost nothing left. She apologized to me. That's the kiss of death right there in a friendship. "I'm sorry, but you're not worth my time"—that's the subtext.

I had the option to go eat, as there were small centers around me with food, and while I didn't have enough to make rent, I had

plenty to buy food. I opted instead to ration the two protein bars I had in my bag. I didn't want to go outside. There were restaurants outside, but there were also liquor stores and bars, two of each, very close by. I knew where I would end up if I opened the door. I had called Matty and talked for a while. But I wasn't safe and I knew it. Hours passed. I lay on my bed just staring at the ceiling. At some point I decided to do some push-ups and crunches inside the room and then took a shower. More time passed. It was approaching midnight. This is what they mean by "white-knuckling it." I was sweating thinking about a drink. I had forgotten that I had Ambien in the bag I packed, relics I had never even touched from many years before. I found them in that hotel room. The idea of getting a drink and taking a fistful of Ambien sounded like the best and worst idea simultaneously. . . . ,

Then there was a knock at the door.

I pulled back the curtain and saw Shelby standing there in sweats and Ugg boots, with puffy eyes and one of my oversized hoodies on. I opened the door.

"Have you even eaten, because you probably haven't, knowing you, and we have food at the house." She wouldn't look at me but she couldn't help herself. I don't know why she showed up, why she refused to just let me go. I deserved it, and she would have been right to do it.

"I ate some protein bars. Didn't really want to go out for food, there's liquor stores and stuff. . . ."

She nodded. "I half expected to come here and find you drunk already."

"Nah—I mean, I thought about it. But that really wouldn't make anything better, would it?" I was trying to convince myself of this as much as I was her when I said it.

She laughed a little. "No, it would not. It would make things worse. And I might have needed to hit you again."

I smiled. "Yeah, that was a good swat, still hurts a little. So did you steal that sweatshirt from me?" I tugged at the sleeve.

"Yeah, it's the least you can give me." She looked up at me and those big eyes filled up. Suddenly she hugged me, sobbing into my shoulder.

"Shelby, I'm so sorry. . . ." I had no idea what to do anymore. No idea.

"I can't bear the idea of you here, just hating yourself all night. You won't sleep. I know you won't. Just come to the house. She already said it's fine. I'll put you on the couch. We'll figure out what to do with my furniture tomorrow." She turned to walk outside.

"I already called a local place; they can move it all and store it within five miles of your mom's, and I have enough money to do that. Plus, you will never have to pay the storage, I can promise you that much. And, Shelby, I'm really really sorry."

She turned and looked at me and half smiled. "It's okay, let's get you out of here."

The most heartbreaking part of that was, she meant it. She had already forgiven me. And to this day I don't know what I did to deserve that, but I am grateful. I am grateful.

chapter seventeen

Learning is not child's play.
We cannot learn without pain.

—ARISTOTLE

Shelby?! Can you please mow the lawn today? Or can one of you do it, please?"

Shelby's mother was hollering down the stairs. I learned quick that her family didn't walk up and talk to each other much. They either yelled or they texted. Her mother had taken full advantage of our being there by handing out chores. Shelby's mother was an interesting woman. She was smart, she was hardworking, and she gave the impression of being a woman who was wholly disappointed in life. She sighed a lot. I mean big, heaving sighs, three to an hour often. The kind you do when you are trying to exhale and let go of being wound up, because she was. She was wound up. She wasn't a bad person, she was just wound up. She and Shelby's dad had divorced over fifteen years ago, and it seemed like she'd just closed up shop since then on ever trusting anyone. She had a touch of bitterness toward men as well, one she didn't hide very well, but that I could understand. Shelby's father cheated on her. The personal relationships between married couples are just that, and who

was I to judge? Plus I knew that it's never black and white. But her mom never got over it. She was still pissed off, and it seemed like she might stay that way forever. It was a shame, because when she actually let go and just decided to be happy, she was pretty awesome. Gail, Shelby's mother, was a small woman with bobbed blond hair and icy blue eyes; she puttered around a lot, and when she had guests there, she perpetually looked for ways to do for them. It was the Southern in her. Born in Texas, she tried to feed you, gave you shelter, and then put you to work. She was one of the more generous folks I'd ever met, but her generosity came with strings; sooner or later you had to give back, and right now, I had to go mow the lawn.

"I'll do it, Gail!" I shouted up. *Right as soon as I finish this conversation I'm having online.*

I had been utilizing social networks more and more to try to see where I could get a fight. I was offered one in Philadelphia, an MMA fight where I would be expected to sell tickets. Shelby forced me to turn it down. "You're better than that. Don't ever accept anything beneath what you are worth. Plus, you are a kickboxer, not an MMA fighter. Do what you love." She was right. But she might have been forcing me into the poorhouse.

After returning to the loft months before, we had found the place ransacked. The building hadn't done a good job of keeping out thieves, and one of the things stolen was Shelby's computer, which had contained loads of pictures. She was heartbroken. I knew who did it, but it wasn't worth pursuing beyond the criminal report filed, and I learned my lesson. I had had just enough money to pay movers to package everything up and move it to storage close to her mother's house. We could have done it ourselves with a rented truck, but I didn't want her to have to watch as everything was carried out. It was already hard on her. After that, I was pretty much broke. I took teaching jobs here and there, pawned some things I had bought when I was a wealthier man, but really what I needed was to fight.

On the weekends we had taken to having late breakfasts with Shelby's father, who lived just a ten-minute drive from her mother with his gentle girlfriend Shayna. Shelby's dad, Steve, was something else. Meeting him made her make more sense. They were almost identical personalities. Her father was a lawyer. A good-guy lawyer, so he wasn't rich. Gentle, empathetic, a creative storytelling force. At five feet eleven with a well-muscled build even in his sixties, he was athletic, almost hyper, and childlike. He talked too much, he laughed too loud, and he made jokes constantly. But he was wonderfully kindhearted, and while I had felt that I needed to win her mother's approval, I felt that her father accepted me right away as not just a friend of his daughter but as part of his family. One day in talking to him I opened up and voiced my desire to fight, not just look for odd jobs. He phrased it perfectly: "You need to fight not just for money, but for yourself. You have unfinished business."

I had met a man online named Dave Walsh, an avid kickboxing fan and keeper of one of the top kickboxing websites. He was a fan of mine, a fan of all kickboxing really, especially from back in the old K-1 days. K-1 was virtually gone now. Its ownership had changed hands, and once Ishii was no longer in charge it just disintegrated slowly. There were few kickboxing promotions out there, as MMA was eclipsing it. The only promotions that were still doing shows and that were worth anything were in Europe. Dave had started asking around. He wanted to see me come back too, and he believed he had found something.

A new promotion had fired up called United Glory. The promotion itself was being put on by the same people who had started the kickboxing gym Golden Glory, which in its heyday had produced two K-1 Grand Prix champions, one of them, Semmy Schilt, having won several times over. Golden Glory was one of several major kickboxing gyms and was notorious in the world of kickboxing, both because of the fierce fighters it produced and also because of

how they treated those fighters. The stories of fighters getting fed to the wolves by Golden Glory were long. They liked to chew American fighters up, use them to promote their own homegrown fighters, who were Dutch. They also had a long history of people running from the promotion post signing. They didn't have a perfect sheen to them, but then again, neither did I. Dave mentioned that this new promotion had expressed interest. Now, with whatever fan base I still had egging them on to put me in the show, I was booked. I signed offline. I had a fight.

I ran to find Shelby. My heart was screaming at me. I found her sitting in her room, looking shocked as I walked in, flushed. "What the hell . . . why are you out of breath? You know, you should mow the lawn, because—"

"I have a fight," I said, overenunciating each word so that I couldn't be misunderstood. Her jaw dropped.

"Where? With who?" she asked, getting up slowly.

"Moscow, in May. With United Glory. It's a kickboxing fight. Against Nikolaj Falin."

Her face fell. "The guy that just went three rounds with Gokhan Saki before losing? Fuck, Mark . . . couldn't you get a build-up fight?"

Gokhan Saki, a man I am proud to call a friend, is to this day one of the highest-ranked kickboxers in the world, and in my eyes he is currently the most talented. Gokhan is a new breed of kickboxer; unlike the monsters of old K-1, he is a small heavyweight, only about six feet tall and two hundred twenty-five pounds. His opponents frequently are five to six inches taller and outweigh him by forty to fifty pounds. Gokhan is fast, lightning fast, with unlimited ability, allowing him to throw kicks from impossible angles. He is tenacious, bullying his opponents and attacking relentlessly. Most of Gokhan's fights end quickly. While he had beaten Nikolaj, it had taken him well into the third round to do it. Nikolaj was a multiple belt holder in various parts of Europe. Fighting out of Germany, he was six feet

two and two hundred thirty pounds with an incredible physique, very hard punches, and a strong chin. This was not an easy fight. This was not a fight I was supposed to win.

I looked at Shelby, who was worried. She's a ride-or-die sidekick, but she's also a realist. Her expression said loud and clear that she felt this was a bad idea. She wasn't going to blow sunshine up my ass and tell me she thought I could win without proper training. Hell, she didn't really think I had much of a chance of winning anyway. I needed to convince her that this was what I needed to do. And I knew how. I had a secret weapon.

"I think I've found a place to train, but we'll be doing a lot of driving. I've tracked down my old friend Rob Kaman, and a boxing coach. They have a gym down near Santa Monica they're working out of, and they said they would work with me. I can't go wrong with Rob, and wait until you see who else I'm going to be training with. . . ." I threw a big grin at her and she went pale.

"*Rob fucking Kaman?* Oh my *God, Mark*! He's . . . a *legend*! You *know him?* Who is the boxing coach? *Who?* You *have to tell me who.* Don't do that to me, Mark. *Who?*"

"Buddy McGirt." Her face went from white to beet red. She was opening her mouth but making no sound. She looked like someone had put her on mute. Finally she gathered herself enough to squeak this out:

"Rob Kaman would have made me feel intimidated enough. But I can't stand before Buddy, Mark. He's . . . He's my hero."

"I know. And now he's going to be my coach. One of them. If he can guide Arturo to a victory, I think he can help me." I'm a smooth motherfucker when I want to be. I wouldn't call what I did manipulation, just a clever delivery of facts. Everything I told her was true; I just waited to tell her in order to get her to support me on the idea of this fight. Now, *now,* she was on board.

I had tracked Rob down a few weeks before. If you search

Rob Kaman's name you will come up with a myriad of listings and descriptions, one of which will repeat frequently: "the greatest kickboxer who ever lived." And that very well might be the truth. I had no contact information for Maurice anymore. The old number was disconnected and I couldn't track him down. He was my first thought, even before I got the fight; I knew I needed a coach. If I couldn't have Mo, Rob was as good a choice as anyone is ever likely to have. The trouble with Rob is pinning him down. Rob is a world traveler at heart. Since he'd retired from fighting he had become a globe-trotter, teaching seminars and attending fights all over. He was a gentler soul now, a far cry from the Dutch fighter he used to be and whom so many were downright afraid of. His leg kicks used to sound like a cannon being fired (actually they still did). Now he was more interested in connecting with his students, really getting their minds clear, making room for the training to sink in. I had set a time to go down to the gym and work with Rob and Buddy, a sort of tryout to see if they would indeed be willing to take me on as their fighter. I was both excited and nervous. I knew I was physically in shape as Shelby had been kicking my ass for months. But I was afraid of how my technique had held up.

On the day I was set to go to the gym, Shelby drove me by way of the Pacific Coast Highway, the beach on our right almost all the way to the gym. It was comforting and gentle, a great contrast to what I was walking into.

We parked the car on a small side street near a strip club that was next to the fight gym. I do not know why, but this happens more than you know. Real gritty fight gyms stationed right next to strip clubs. Shelby didn't know that Buddy would be meeting us first. For as long as I'd known her she had talked about Buddy and Arturo's working relationship as though it were holy. It had set the wheels in motion for her to even try to pursue fight sports, and here she was about to meet one of her biggest heroes—and we were both about to

meet one of the greatest boxing coaches of all time. I had butterflies, and I didn't know who I had them for more.

Shelby ran to a nearby gas station to stock up on protein bars, trail mix, anything that they had, as she knew I was going to be working for a while (I had tryouts back-to-back with each coach) and I would need to eat fast. I wandered in and put my bag down to find Buddy leaning against the ring, his aviators hiding dark eyes. He smiled a big smile and held his hand out. "Mark Miller, is that you?"

"Sir, yessir. It's a pleasure to meet you." I stuck my hand out and he clasped it inside his. Buddy isn't a big man, but his hands are big, and they bear the years of his profession all over them, from being an incredible fighter to being one of the greatest coaches the sport has known. "Well, Mark, let's get you warmed up, get your wraps on, and then we'll get you shadowboxing."

Buddy was walking to the side of the ring to set the timer when Shelby came walking in at a good clip. She didn't see him at first, so she just moved in on me quickly. It wasn't until she was standing right beside me, explaining everything she had in the bag she was carrying, that she saw him sitting in a chair next to the ring, flipping around on his phone. She froze. She knew he was going to be there, and yet she looked more shocked than she would have been had a grizzly bear been perched beside the ring swinging a stopwatch around one claw. I smiled.

"Oh, really quick, Mr. McGirt, this is Shelby. She's my strength and conditioning coach, and my best friend. You'll have to forgive her, she's normally a talkative and outgoing girl, but she's quite possibly your biggest fan in the world and she's a little starstruck right now."

Buddy stepped forward, grinning, and stuck out his hand. "Well, the pleasure is all mine, ma'am. How do you even know who I am? You are too damn young."

Shelby wasn't talking. So I piped up again. "Your work with Arturo changed her life—"

Suddenly she interrupted and rattled off a frighteningly precise retelling of the entire third Gatti–Ward fight. It was comedic and endearing, and so uncool. She followed it up with, "You're my hero, sir." Something I had never heard her say to anyone or about anyone besides her father.

"Well, thank you so much. Now, the real question is"—Buddy pulled his sunglasses down onto his nose and peered at her with narrowed eyes—"where are your gloves?"

Shelby looked confused, as though she didn't understand the question.

"Well, bring 'em next time, because I'll be damned if you are going to just sit by the sidelines and watch." Buddy McGirt had just told Shelby—not offered, *told her*—that he was going to train her.

I finished warming up and Buddy lined me up on a bag. He had me throw specific combinations for about thirty minutes, making small adjustments each time. Buddy reminded me a little bit of Maurice, calm, specific, never critical or cold. I have a habit of criticizing myself loudly when I know I've not done something correctly; Buddy would admonish me and say, "That's my job, now, you're going to take my job from me picking on yourself like that."

After I worked the bag, Buddy switched to mitt work. Buddy moved fast and tight, forcing punches to come short and quick. He forced me to follow him or control the work by cutting angles. He bullied me and got me to spin off throwing hard hooks. Every time my right landed properly, Buddy shouted, *"Now you're cooking with grease!"* The work went on for another thirty minutes. I was tired. Seven or eight rounds on a bag, seven or eight rounds on mitts. Now he wanted me to end on a speed bag. Two rounds' worth. And Rob hadn't even shown up yet.

As my training session with Buddy came to an end, he rattled

off a few things. "You need to work on keeping your hands up, you drop your left when you bring your jab back, and you aren't getting full power out of your hooks. When you come back next time we'll work more on that." Buddy had just agreed to be my boxing coach for the next month and a half. Now I just needed Rob.

Rob came walking in a few minutes later as I was shoveling trail mix into my mouth and chugging water. Rob was a big man. Six foot one but with massive legs and feet. Shelby would later say that his big toes looked like the fists of a small child. He was wearing board shorts and a black T-shirt. His shoulders and hands were wide, massive. He seemed larger than life. For the second time that day, Shelby was sitting on the edge of the ring, starstruck. "Hello, Mr. Kaman," I said, standing and giving him a big hug. Rob and I had known each other for many years. This, however, would be our first time working together.

Rob had me start by warming up shadowboxing. Buddy was sitting in the corner smiling, watching us. He stood and shook Rob's hand. He knew I'd warmed up, but he wasn't going to say anything and I was sure as hell not going to say anything either. I was being forced into deep water on purpose by these guys. This was how they tested people. After shadowboxing, Rob put me on a bag. Low kicks. I was practicing low kicks and low-kick combinations. I did this, I swear to fucking God, for an hour and a half. My shins split, and I lost feeling in the bottoms of my feet. I refused to complain. Then Rob moved to the mitts. Mitt work, throwing combinations, most commonly the right low kick to a jab, then a right hook. Over and over and over. For another hour and a half. In between rounds, Shelby ran in and was pouring a carbohydrate-fortified drink down my throat, trying to keep my sugars high enough to perform. Rob stopped her at one point and stuck his hand out. "I'm Rob, by the way, we haven't met."

Shelby grinned and said, "I know who you are." And shook his

hand vigorously, blushing before going back to trying to keep me hydrated.

After mitt work, Rob had me cool down with shadowboxing. He told me almost the same things that Buddy had, and added, "But we will work on all of this. I will see you tomorrow then? I'm staying in Ventura County, so it takes me a while—"

I cut him off. "Rob, I'm living in Ventura County right now. You're really close to me!"

"Oh, then we can train in the park out in the sunshine during the day and in the afternoon you come here." His thick Dutch accent was softened with age and time. He had just accepted me. I had passed the test. I had coaches.

"Thank you, Rob, thank you, Buddy. I'll see both of you gentlemen tomorrow?" I was standing on rubber legs as Shelby bustled around behind me gathering up my gear and stuffing it into my bag.

"See you tomorrow, Mark. And see you, Miss Shelby." Rob waved and winked as he exited. Buddy stood from his chair and walked over to us.

"You did good today. This was not an easy day." He let out a chuckle.

"Fuck no, it was not. But I love this." I was wiped out. Exhausted. Beat to shit. But I was happy.

"All right, Mr. Miller, I will see you tomorrow. And *you*, young lady, bring your gloves tomorrow, it's you and me." Buddy pointed at Shelby before he grabbed her for a big hug. She blushed deeply and nodded. She picked up both her bag and mine and we headed out the door. As we got to the car she shoved the bags in, arranging the gloves on the backseat so they could partially dry out. She then pulled a bag of almonds and a protein drink out of a bag and shoved them in my face with a palm full of small white pills.

"BCAAs [branch chain amino acids]," she said. "You're going to need them. Your muscles got beat to shit today."

I swallowed the pills and drank half the shake in one gulp. Shelby climbed into the driver's seat and started the car.

"Hey, Shelby, I need a favor."

"Yeah? What's up?" She turned to me quickly.

"Uh, I can't lift my arms to put on my seat belt. . . ."

We both burst out laughing. I was being serious. She reached across and plugged my seat belt in and we started the drive home. About twenty minutes later we were driving by the ocean while the sun was setting and I heard a sniffle. I turned to look at Shelby to see that she was crying.

"What is wrong?" I was trying to sound concerned, because I really was. But I was so tired, I couldn't even make myself sound concerned. I just sounded half-drunk and sort of amused.

Shelby pulled the car suddenly into a gas station and turned it off. She turned to me and wrapped her arms around me in a massive hug. "I stood in a room with three men who have inspired me. Buddy, Rob, and now you. I never would have had this happen if I had never met you. Thank you, Mark. *You* are my hero. I'm so proud of you. And I'm so proud to be a part of your team. Thank you for letting me." She then quickly let go, turned around, started the car, and continued driving.

I may not have had arms that worked to hug back, but I had a heart that said loudly and despite the odds, "We are going to win this fight."

chapter eighteen

Travelers never think that they themselves are the foreigners.
—MASON COOLEY

Up until now, I had been calm. Up until now, I had been busy. For weeks I had trained with Rob and Buddy. Buddy was always calm, funny, cracking jokes. He used to crank the radio up. Some awful pop song had come on the radio once that had a line in it about being a "boomerang." I happened to be on the speed bag keeping time with the rhythm when Buddy decided that my new nickname had to be "Boomerang." So that's what Buddy called me. Rob just called me what everyone else called me. He called me Shark. I spent weeks getting my ass kicked by Rob, having him bloody up my face and bruise my legs. And after every single training session he would sit and tell me everything I did that was good and where I needed to improve. He was calm and wouldn't let me criticize myself, encouraging me to just see where improvement was needed and focus on that. He always talked about my right hand, worked multiple drills to get me to set it up. Up until now, I had felt totally at peace with everything. But it had been a week since I'd seen Buddy or Rob. I had just gotten off the phone with Rob; he had given me his best wishes, told me he knew I would do well, said he was proud of me. I

was standing inside of LAX with Shelby, the only person I had opted to take with me on this long journey to my first fight in six years. Rob could not come with me; neither could Buddy. They had previous obligations. The only other person I trusted enough to bring with me was Shelby. She was working out our luggage and getting us through the lines. I was just following. Up until now, I had been helpful. But now, I was checking out. Now, the fight was incredibly close and imminent, and I was shrinking down into myself, like a star before a supernova. All movement, all words were preserved. I was meant for one thing now.

A few weeks previously I had been sitting at home when Shelby came running in saying that there was mention of me on a blog; a mother of a young man named Jacob was talking about me. I had done an appearance on a few TV shows to talk about my comeback fight, to help promote it, and I guess Jacob's mother, Jenn, and his stepfather, Lonnie, had seen me, heard my story. Jacob was born with a congenital heart defect also. Jacob had already had multiple surgeries. After seeing me on TV, Jenn and Lonnie had felt inspired, felt like I represented a fight against the overall morbid attitude offered to CHD kids. I had gotten in touch with them, spoken on the phone a few times. They had become fast friends. They were hosting a party at their house to watch my fight, and Jacob would be there. Jenn was worried; she cared about me. She was worried about Jacob's watching; what if I got hurt? I told her I would be fine and asked that she have Jacob nearby when I called before I got on the plane.

Shelby pulled me into yet another line. I was plugged into my headphones: Wu-Tang Clan, Gang Starr, House of Pain, Cypress Hill, KRS-One, Dilated Peoples . . . Rakaa had texted me, *Strike fast and true fam, leave no question to the masses about who is the winner. Much love.* I had received a card from Shelby's mom signed, "To my other son, be careful." Shelby's brother, Tristan, a twenty-five-year-old guitar player, had pulled me aside and asked me where a good

place to bet on my fight was. This was his way of telling me that he was willing to put his money behind me, that he believed in me. Shelby's dad had pulled me in for a hug and said to me, "Warriors are never truly themselves unless they have a fight to go to. This time is yours." Ever the poet. Cory and his mom had sent their best. Amy had put my sons on the phone earlier. I told them I loved them. Nothing from Justin. I was antsy. I called Jenn and had her put Jacob on the phone, and I could hear his excitement. He wished me good luck, and I knew he meant it. Still, Justin . . . Where was Justin . . . ?

Suddenly a text popped up. *I want you to know, that while I'm not gay, I am so proud of you, and everything you have done, all the hard work and how far you've come, that I might kiss you when I see you next. And I mean kiss you for real. Like a viking.* There he was. There was Justin.

I wrote back, *I love you brother. I mean that. And thank you.*

His last text to me: *Bring home the victory. I know you will, it already belongs to you.*

Now. Now I could board. Now I could go.

We boarded the first flight. Los Angeles to Chicago. From there we were to fly from Chicago to Helsinki, and then from Helsinki to Moscow. The entire process would take about fifteen hours, give or take, with stops. Shelby had stocked her purse and backpack with nonperishable food, vitamins, and supplements. She was trying to counteract the jet lag that would be inevitable. The only gift I was going to get was that by the time I landed, I wouldn't have to fight until two days later. The jet lag would hit me most likely the day after the fight, by which time I'd be back on the plane heading home. Still, since I was a diabetic, my sugars could go weird when I was forced to travel long distances and cross multiple time zones, and Shelby was trying to make sure I felt as good as I possibly could. As soon as we sat down, she pulled out two different protein bars, a small baggie of almonds, and an apple. She set them all in front of me and said,

"Pick one to eat now." For anyone wondering, this is what it is like if she is working with you. She doesn't ask if you are hungry; she tells you when you are going to eat and what you are going to eat. It isn't an option. You still have choices, but that's really where it ends. She also stuck a sixteen-ounce bottle of water in front of me, one of fourteen she had bought once we had passed through security, and said, "And drink this too. Now." I chose a protein bar and began to absentmindedly shove it into my mouth. I was not hungry, but I knew she was right. It was very early, and while I'd eaten breakfast, I knew it was probably time for me to eat again. Shelby had my meal planning down to a science. She could tell by the way my skin looked if I had cheated and had a high-sodium or high-sugar meal. I finished the bar and she tucked the rest away under her seat, settling in with a water bottle of her own.

"What about you? Aren't you going to eat?" I asked.

"Oh no, I can't risk running out of food. I want to make sure you're eating properly. It doesn't matter if I feel like crap; you're the one who can't afford to. I'll eat whatever hell on a plate they serve once we're airborne."

Los Angeles to Chicago was a breeze. We boarded the second leg of our flight and got settled onto one of Finnair's planes. I highly recommend this airline. It is a huge misconception that fighters get treated like royalty. The promotion barely rolled out enough money to afford me a corner person, and they sure as hell weren't putting any of us fighters in anything above coach, which is a joke. Coach is a possible loss on a fight record, that's how fucking bad it is for a heavyweight kickboxer to fly it for over four hours. I was to be jammed on this particular plane for around eight. Fifteen hours total in coach for the whole travel time. Finnair was surprisingly comfortable, very empty, which meant Shelby and I moved back to take an entire row up all for ourselves, with movie screens and *beautiful* tall, blond stewardesses, one of whom took a liking to me and

kept my water glass full and brought me extra bags of peanuts and pretzels when Shelby wasn't looking. We were on the plane for a few hours when suddenly the captain came on over the intercom: "Hey, folks, uh, our computer isn't working very well, and we don't really want to cross the Atlantic without a fully functional computer, so we are going to emergency-land at JFK in New York and de-board. We shouldn't be too long, and we'll be back up in the air before you know it. We are terribly sorry for the inconvenience."

Before he stopped talking Shelby was already rifling through our papers to check our itinerary. She was worried.

"What is it?" I asked.

"Oh, nothing, it's not a problem. Don't worry about it." She was a terrible fucking liar. The worst.

"*What is it,* Shelby?" I asked more seriously, closing my eyes and feigning melodrama, as though I was thoroughly exhausted with her.

"It's just that . . . our plane change in Helsinki was going to be a tight squeeze. . . . I don't think there is any way we'll make it now. But it's fine, I'm sure there are tons of planes that they can bump us to."

She jinxed us right there.

We landed in New York. I saw the Statue of Liberty through a window as we were descending. I was born there, in Queens, thirty-nine years ago. My dad was from there. We got off the plane and searched for a real meal. Though only about six or seven hours had passed since we boarded in the morning in Los Angeles, it was getting dark here in New York. I took Shelby to a small restaurant inside the airport to buy her a steak dinner. She ordered salmon for both of us. I was slightly disappointed. We spent an hour and a half eating before we were called to reboard the plane.

As we were getting back on I saw Mighty Mo, another American kickboxer who was also fighting on the show, boarding our plane. I

hadn't seen him before. I stopped him and shook his hand. Part of me relaxed a little. Nothing could go wrong the rest of the trip if we were both here. Strength in numbers.

The plane took off and we were on our way to Helsinki. We arrived several hours and a few not-so-terrible plane meals later. Shelby had been shoving her tray in front of me the whole time, picking off the tray what she didn't want me to eat. I'd been getting doubles of meat, salad, and fruit. She'd been living off of dinner rolls and water for hours since the salmon without a single complaint. Pollyanna Sunshine.

We touched down in Helsinki. The airport was beautiful. I mean it, it's worth seeing. Mighty Mo and I searched for an outlet to charge our phones as Shelby went to the nearest desk to ask about what we should do since we had missed our connecting flight . . . by five hours, which I still can't figure out. A smiling blond woman was explaining things to her with an apologetic look on her face. This was unnerving. After writing a few things down on a piece of paper and making several phone calls, the woman shook Shelby's hand and Shelby turned to walk toward us. She was trying to act unfazed. She was, again, a terrible, terrible liar.

"So, here is the deal. We have two choices. We can either stay the night in Helsinki and hop a plane at nine A.M. tomorrow, or we can grab a flight to Frankfurt and then get a connecting flight to Moscow from there. If we choose door number two, we have to run, because that flight leaves in around thirty minutes."

Motherfucker. Frankfurt was the *other direction*. So we had to go *backward* to go forward. My hands were tied. I had to get to Moscow that night.

"Well, we have to run, because I don't know what else to do." I picked up our stuff, and me, Mighty Mo, and Shelby started tearing ass through the airport. A tall redhead, a tall tattooed guy, and a giant Samoan. We did not fit in. We made it onto the plane to Frank-

furt by the skin of our teeth. It had now been fifteen hours or so since we left L.A. You see, the goal had been to sleep on the plane. I hadn't slept yet.

Frankfurt's airport was not so nice. Actually, it was fine, it was just confusing and very, very big. When we got there, once again Shelby was trying to figure out our connecting flight. An American gentleman who had happened to be on the same flights as us had taken a liking to us. His name was Gordon, and thank God for him, because by this time, none of us were making much sense. Mighty Mo and I were underfed, overtired, and cranky. Shelby was trying her best, but she was also running on no sleep and hadn't eaten half as well as we had. Gordon and Shelby decided to approach the connecting gate together, leaving Mo and me to stand off to the side. They walked up to a window for Aeroflot. Gordon was making jokes about Aeroflot before we landed. Aeroflot is called "Aeroflop" by those who travel frequently to Eastern Europe, as it is widely regarded as the worst airline. No sooner did they get to the window than a severe-looking gentleman slammed it shut in their faces. I was starting to get angry. Shelby ran over to a window for a Siberian airline. The woman there looked at her tickets but clearly told her that she couldn't help her. Gordon and Shelby were looking desperate. I shouted, "What the fuck is going on now? What is the goddamn holdup?" People were turning around to stare at me. I was now the ugly American asshole in a German airport. Airport security moved a little closer. Shelby rushed over.

"Please please lower your voice, Mark, we are figuring it out."

Mo was as mad as I was, but instead of voicing it, he was just scanning the area looking for something to break. I was seething.

Gordon and Shelby conversed, and Shelby walked over to the Aeroflot window again and knocked. The same man shrugged and waved her away. Shelby moved to the next window over and started talking to a German woman, who seemed to be helping. Within five

minutes Shelby and Gordon were smiling again and running back to us with tickets in hand.

"Okay. She was able to find us by tracking our luggage. We are on Aeroflot. Now, the only catch is, the plane leaves in twenty-five minutes. So we have to run. Again."

We were now trying to function after about eighteen to nineteen hours without sleep. Running was increasingly difficult. We moved from one line to another, got on a bus, got off a bus. Finally we were at the plane. We boarded, and suddenly I felt like I was on the set of a bad movie. The aircraft was shabby, to say the least. The carpet was coming up in the corners on the floor. The seat cushions were ripped and some had been taped back together. All the magazines in the pockets of the seats in front of us looked like they might have been twelve years old. The flight attendants looked like they were from a sixties movie. The uniforms were bright orange, with pencil skirts, white gloves, and pillbox hats, still sporting the hammer and sickle. This was the strangest airplane I had ever been on. Gordon was already laughing. "So this is why they get the reputation. Oh boy . . ."

The plane had a rickety takeoff and the flight attendants began an in-flight service with a meal. Once they passed it out, Mo, Gordon, Shelby, and I lifted the lids on the meals to find an absolutely unidentifiable meat.

"What is this?" Gordon asked, prodding it with his fork.

"This could be fish or pork. That's how unsure I am of what it is," I said.

"Oh for God's sake." Shelby jammed her fork into the slab of whatever and shoved it in her mouth. She took a few chews and said, "I still don't know. But it's edible. You need to eat."

She shoved the rest of her tray in front of me yet again. I picked at what was left. Afterward I was able to get a fitful thirty-minute nap before awakening to Shelby shoving a fistful of vitamins in my

face. "Take these, your electrolytes are going to be so screwed up, you need to try to fix it, and here, extra vitamin C."

By the time we landed in Moscow it had been thirty-one hours since we left L.A. None of us were doing that well. We already knew that our luggage was probably lost, so we were going to have to deal with that. What we didn't know as we deplaned was that Russia is one of the least visitor-friendly countries in the world. Little backstory: To go to Russia, you cannot just walk in with your passport like you can in Europe. No. To visit Russia you need more than just a passport, you need a visa. This visa must include an invitation from someone within the country (yes, you have to be invited or you aren't allowed to come; those are the rules) and a definite outline of where you will be staying, including the address of your hotel or of the home in which you will be staying and how long you will be there. And you cannot overstay your welcome by even a day; this was really emphasized to us by the folks who took care of our visas. If you do, they arrest you. Then, once you actually get to Russia, instead of just walking through a gate where they say, "Where are you going, how long, cool, have fun," or something like that, they put you through what seems like an interrogation. They make you fill out your mother's maiden name, where your father was born, the city he was born in, etc. etc. When you have been awake for over twenty-four hours, this is not easy. It took us another thirty minutes to get through the gate and into the actual airport. Here's the other thing about Russia that no one will tell you. Russians seem to hate smiling. They are the least smiley people I have ever been around. After so many hours of travel, I was just looking for a smile, some kindness. What I got was a woman who barely even looked me in the face and who spoke no English, shouting at me from the luggage-retrieval desk and motioning for me to walk around a corner, presumably to go get my luggage. Mighty Mo had run out of words at this point. He had procured a luggage cart and was just walking in the direction the woman had

motioned for us to go in, grumbling. Shelby was following him; her body was bent nearly in half carrying both her backpack and my carry-on, which I nearly had to wrench from her to get her to give it up to me. She was trying so hard to take away any pressure, and this whole trip had just fought her. Here at the home stretch, her blood-shot eyes showed the strain. She was tired, hungry, and emotionally worn down. There were no creature comforts here, and she couldn't even get a smile from anyone. Russia is, in a word, cold. And Russians are, in a word, surly. Both of these things were the opposite of Shelby. She was from California and she was as smiley as they come. This place was already very hard on her. As for me, I just wanted one thing to go right.

We said good-bye to Gordon, whose luggage had arrived safely. With Mighty Mo leading the way, we descended into the guts of the airport. We walked for a long time. Finally we reached this door that looked like a door to a submarine, with a crank wheel and a small sign that had been printed out and taped to it that read LUGGAGE RETRIEVAL in red. Mo stopped, looked at us, and said, "Well, has to be it," and knocked.

The door swung open and this man who looked and smelled as though he hadn't showered in the last four months and was missing all but a few teeth beckoned us into a small, severely overheated room. He spoke no English. Not a word. So he just started talking to us in Russian and using pantomimes to communicate. He "asked" us for our passports, and we all obliged. He then took them and walked into a completely different room. I glanced at my phone, which had no service, and started to laugh uncontrollably. I was way, way too overtired, and this was way too ridiculous. I mean, this was how bad horror movies started. Here we were, sitting in some dungeon in the innards of the Moscow airport, while a sweaty and toothless old man wandered off with our only forms of ID. I couldn't stop laughing. Mo had taken to just rambling to no one in particular,

and Shelby was just staring at me, one part amused and three parts scared. We were all losing it.

We sat there for probably an hour and a half. Finally the door opened again and some giant woman, equally as smelly and equally as non-English-speaking, came in and gestured for us to walk into a small side room. There, wrapped in plastic bags, to our utter shock, was our luggage. We all signed for the bags and left.

Now the new issue was, we didn't know if we were going to have a ride to the hotel. It had become apparent that not everyone in Russia spoke English, and all the Russian Shelby and I knew was "please" and "thank you." We wandered to the front of the airport, staying just inside the sliding glass doors. It was now two A.M. in Moscow.

"I see a driver, holy Jesus, thank you, God." Shelby quickened her pace and made for the door. Suddenly I saw him. A tall, impossibly thin albino man with alopecia was standing holding a poster for the United Glory show. He was wearing a long-sleeved silk button-up shirt in a very loud print, tight Wrangler jeans, and cowboy boots. We asked if he was our driver and he answered without a smile, and through a thick Russian accent, "My name is Yuri, and you are very, very late."

I could not make this shit up if I tried. I felt like I was in a fucking Fellini film.

It took Yuri another hour to contact his partners to get us all into one very small sports car. Mighty Mo was seated in the passenger seat up front next to a driver who reeked of vodka and was blasting techno music. Getting in the car with a potentially drunk driver would have been out of the question if I had had my wits about me and thought there might have been an alternate choice. As it was, I just wanted to get to the hotel and go to sleep. In the back Shelby and I were wedged next to one of the co-promoters for the show, a wide-shouldered man wearing a pinstripe suit, also reeking of vodka, and

smoking a very large cigar. Being in Russia, so far, was like being in a twisted cartoon. As we were driving into the city I noticed something very strange: the streets were full of people. No one looked drunk, even if they were. No businesses were open. There were just people walking around everywhere.

The promoter said, "Do you see all of these people here? They are all criminals. Everyone in Russia is a criminal in some way."

This just could not have gotten any weirder.

At the hotel, we checked in very quickly and went to our room. Shelby threw her stuff down on the small chaise lounge in the corner and immediately opened up the room service menu. She ordered me a chicken dinner and a bottle of water and tossed me two of the bottles of water the room had provided us with. She explained to the woman on the phone that she had to pay with American dollars. One hundred sixty-five American dollars. For a chicken dinner. Goddamn it, Russia. I wanted to like you but you were making it very, very hard.

Shelby laid out a series of B-vitamins, zinc, magnesium, and melatonin for me to take.

"I really don't think I need melatonin. I'm pretty sure I'm going to pass the fuck out after eating," I told her.

"That's not the point. You need restful sleep. This will ensure that."

She made herself comfortable on the chaise and quietly said, "Hey, Mark, let's play a game."

"Okay. What game?"

"I'm going to call out a strike, and you are going to call out the counter for it as fast as you can, okay?"

She had been playing this game with me on the plane a little bit. This was how she kept me focused on the fight at hand.

"Jab, right hook."

"Right hook, right low kick." I was seeing this as I said it.

"Jab cross jab."

"Right low kick, block the jab, right hook." The combo I worked with Rob and Buddy over and over . . .

The bed swallowed me whole as I allowed myself to relax. I fell asleep calling out counters, and I dreamed of fighting a fight in slow motion, almost like we were underwater, every one of my openings so clear to me. . . .

chapter nineteen

In a battle all you need to make you fight is a little hot blood and
the knowledge that it is more dangerous to lose than it is to win.
—GEORGE BERNARD SHAW

I was startled awake by my cell phone ringing. I blindly hit the mute
button, rolled over, and glanced at it to get the time. It was
close to noon there in Moscow. I had slept for almost eight hours.
Shelby was already awake, showered, and dressed, and was sitting at
the foot of the bed in all black with knee-high motorcycle boots on
and her bright red lipstick. "You might want to check that, it's gone
off twice," she said, raising an eyebrow.

I grabbed my phone and looked to see who was calling me. It
was one of the promoters for the show. Shit. I muscled myself up,
gathered the sheets around me as I rubbed my eyes, and called him
back.

"Hey, Mark! Did you get the itinerary yesterday when you
checked in?" he asked brightly, his thick Dutch accent making his
words staccato.

"No. I got nothing. I got a room key, that's it. What is the deal
with food, man? I'm starving."

"Oh, well, uh, you should have gotten an itinerary. Breakfast

and dinner is covered, but you are on your own for lunch. Breakfast already happened; you slept through it." He was smiling while he said this, I could hear it. He was being preemptively gentle when he told me this, because he knew I was going to get mad.

I sat up, irritated. "Yeah, well, my planes, plural, were a little delayed. I didn't get in until three A.M. last night." My stomach was starting to burble and whine at me. Shelby's eyes widened with the panic of a nutrition coach who was trying desperately to keep her athlete fed. She began to rifle through all her bags, searching for anything to give me.

"Oh wow. Well, we can figure it out today at the press conference. You are due at weigh-ins."

Suddenly I felt very rushed and frustrated. "*When?* When are the weigh-ins?"

"Well, uh, they start in twenty minutes."

I hung up the phone without waiting for further explanation. Typical fucking ragtag promotion; the right hand didn't know what the left hand was doing. Don't get me wrong, they had the talent on this card, but there was just no order and no organization to anything. I sprang out of bed and sprinted to get ready. I couldn't even fucking shower. I had wanted to shower, shave, and get really prepared before this godforsaken weigh-in was to take place and before I had to go stand on a scale in my underwear in front of everyone. Now I got to do none of that. I threw on a pair of jeans, a shirt, my Thai amulets that were blessed for me by Buddhist monks when I fought in Thailand, a wooden-bead *mala,* and a necklace with three small silver disks on it that read HARRY, HELEN AND COLIN that Shelby had given me for Christmas. I'm not a religious man per se, but I know my ghosts are fiercer than most, and so I chose to try to keep them appeased. I grabbed a beanie and threw it on my head. Shelby was fishing around for whatever food she could find. One last protein bar and a green apple that was from the fruit bowl at the front

of the hotel. I ate both quickly and we ran downstairs to the press conference.

The Ritz-Carlton Moscow was a gilded jewel of a hotel, but the elevators were utterly confusing and seemed to run from floor to floor on some unseen schedule that had absolutely nothing to do with the numbers being punched in. As with many things in Moscow, form preceded function. We were delayed descending to the press conference room. By the time we arrived, I was an anxious mess. From the corner of my eye I could see Nikolaj's red Mohawk across the crowd, patterns shaved into the side of his head. He looked like an angry rooster. Many of the fighters I admired were fighting on this card. Errol Zimmerman, who would go on to become a friend of mine. Artur Kyshenko, a smaller but incredibly tough Ukrainian fighter. Chalid Arrab, who wasn't fighting but was just there to watch, and whom Shelby had a terrific crush on. Gokhan Saki, another man who would go on to become a friend; Zabit Samedov, one of the most interestingly dressed men in all of kickboxing with his Hawaiian shirts and neon board shorts and dress shoes; Siyar Bahadurzada; Brice Guidon; Nieky Holzken. All men I admired. This card was stacked with talent. I'd be lying if I told you I wasn't a little intimidated. When they called my name I rose, approached the scale, stripped, and stepped up. I had lost weight in transit—I knew this before I even shed my clothes—and as my shirt hit the floor Shelby sighed with irritation. I am what Shelby called a "hard gainer." It means I have a very fast metabolism and I lose weight and size quickly. She refused to go the easy route and just stack fat on me; she wanted my speed to remain, but it meant that I was never going to be as big as so many of these guys. I weighed 207. I could hear Shelby grumble from across the room. She'd had me level at 220. The travel had just caused me to go too catabolic, which means I'd burned up muscle mass for fuel. I'd lost muscle, water, and electrolytes. Nikolaj stepped on the scale:

229. Had I kept my weight up, we'd have been almost even weight-wise; as it was, he had me by a little, not that I cared. His physique was much more beach body. He was thick, well muscled, and tan. I was taller but leaner. We both stepped forward for the stare-down photo. Nikolaj looked straight into my eyes and tried to snarl and growl. This was so silly to me; what was the point? I used a phrase I heard Phil Davis once say in regard to a guy mean-mugging him before a fight: "I signed the same contract you did, I promise I'm going to fight you, you don't need to encourage me!" Then I grinned brightly.

Nikolaj's tough-guy image faded momentarily as he told me that his English was not very good. We shook hands and went back to our seats. As the rest of the weigh-ins proceeded, I was getting hungrier, and my sugar was dropping lower.

I approached the promoters once the press conference was done and asked once again about meals. Apparently breakfast was at nine A.M. in the dining hall, and dinner was at six. There was no other food being served. None. They had covered two meals for a boatload of heavyweights, all of whom were used to eating six times or more a day. The Dutch promoter I had spoken to on the phone was trying to pass this off as normal to me. Suddenly Shelby burst out, "You know he's a type one diabetic, right?! So if he doesn't get any fucking food he could go into a coma. So what are you going to do for him? Because this is ridiculous." Her cheeks were flushed and she was tugging on her hair, which was set into two long red braids, covered on top by a black knit cap.

The promoter got a semi-worried look on his face and assured us that he would work something out. I could have laid money down on the fact that he wasn't going to do anything. Instead, he forgot about us and I just waited until dinner, sucking on glucose tablets in the meantime. Dinner was delicious: salmon, vegetables, and a small piece of honey cake, which I didn't eat. It was the first real meal

I'd had in days. Our waiter at dinner was a young Mongolian man who actually smiled at us. It was such a relief and a comfort to see a smile. Mighty Mo sat with us, and I was overjoyed to see his trainer, William "the Bull" Sriyapai, with him. Willie and I had known each other for a long time, and I asked him to corner me for my fight, as Shelby suggested that he would make a better cornerman than her. Shelby was a supporter and an incredible strength trainer, but she didn't pretend to know the sport better than an actual fighter. Willie accepted with a big smile and over dinner we made some plans to go walk around Red Square the next day, do a little sightseeing in the afternoon before the evening of the fight. Then we went back up to the room. Shelby flipped on FashionTV, and we both passed out watching runways before eight P.M.

The next morning at breakfast Shelby had devised a simple plan. Breakfast was a buffet, so she kept revisiting it for whole fruit, small tubs of yogurt, bottles of water, muffins, crackers, anything that would keep without too much refrigeration for at least a day. She would bring plates full of the stuff to the table and casually scoop it all into her lap, which was covered by a napkin. She then wrapped the napkin up and stuffed it into her massive purse. Then she would stand and grab another napkin as she walked to the buffet again. She did this three or four times before finally settling down to have her actual breakfast. When we got up to leave she had an incredibly nice Alexander McQueen purse brimming so full of fruit and pastries she could barely close it. "Russia is turning me into a thief," she joked.

The food she procured at breakfast became lunch, and a few other meals. We would have ventured to a restaurant, but not knowing the language and hearing horror stories of $800 meals nearby kept us away. Make no mistake, Moscow is very, very expensive. Plus, this way we could better control what I was eating, and being that this was now the day of the fight, we needed to be absolutely careful.

One bad piece of meat could ruin the entire thing. After breakfast we changed into some comfortable clothes and walked out the front of the hotel to Red Square, which was two blocks away. At the front of the hotel, outside the metal detectors (yes, there were metal detectors in front of the Ritz-Carlton), a famous techno DJ was signing autographs and people were crowded around him. We squeezed through the bundle of people and walked on. At some point I turned, feeling like I was being followed, to see that half of the crowd had started following us, taking pictures of me as I walked. I found out later why. Apparently my face was on a massive billboard somewhere in Moscow. I never got to see it.

Willie, Shelby, and I wandered around, taking pictures of St. Basil's and the Kremlin, and even got to see a portion of the military marching in formation. At the opening of Red Square is a small chapel for people to pray in, no bigger than a closet, called the Iveron Chapel, which has been there since 1669 and housed the icon of Panagia Portaitissa, the keeper of the gate. The story about the chapel is that customarily, everyone heading for Red Square or the Kremlin visits the chapel to pay homage at the shrine before entering the gate. The only poor I saw in Moscow I saw here, clustered around this small chapel. Outside of the chapel stood a Russian Orthodox priest in his traditional garb, collecting alms in a small cup and offering blessings. I approached him and placed a few coins in his cup, and he gave me a blessing. I said before I am not a religious man, and that is true, but I also believe that doing that would have made my mother happy. She never saw this chapel, she never saw the homeland of her faith, and here I stood. I may have gotten the blessings for her, if blessings indeed work that way. That may have been my whole purpose for doing it, but it made me feel comforted, like she was there somehow, like I had completed a task I hadn't known was mine until then.

After walking a bit and taking some pictures, we ventured back

to the hotel, where we ate a little and I slept. I awoke a few hours before I had to board the bus to take me to the venue. Shelby was already mostly dressed, and I nearly fell over when I saw her. Knowing Willie would be cornering me, she had opted for fancier dress than the tracksuit she would have worn in the corner. In a tight black pencil skirt, a white high-necked blouse, a steel-boned corset shrinking her already small waist to a cartoonish size, a black pillbox hat with a veil, red lips, cat eyes, and staggeringly high black heels that had naturally shed shark teeth encrusted around the heel, she looked like some sort of comic book villainess.

"Jesus, do you have daggers hidden in your garters?" I asked.

She laughed. "No, just glucose tablets. I'm still working with your run-down old ass, not James Bond, not yet."

I smiled. "So why so fancy? You know we're just going to sit at this venue for hours before I fight, right? You don't have to do all this. Be comfortable."

Her expression got frosty. "This is one of the most important fights of your life. I'm not dressing like some sad asshole. You deserve to have the people with you dress to the nines. You know what Deion said—you look good, you feel good; you feel good, you play good; and if you play good . . ."

She trailed off and I finished it: "They pay good. Deion Sanders, my favorite quote. Stealing my lines. Again."

She meant it too. She would go on to suffer in that steel-boned corset, her waist at a mere twenty-two inches max, all night, only loosening it on the bus ride back, simply because she wanted to represent right.

"Fine. If you're going to dress like that, though, you're at least walking me out to the ring. Otherwise that's just a waste of a perfectly superb outfit."

I got into the shower and steamed for a while. The shower in the Ritz-Carlton was the best part of the room. I could have invited ten

of my friends over to hang out inside it with me, had I ten friends in Moscow who would have wanted to do that. I shaved my head, lathered up, and got out. Some guys don't shower before fights on purpose; not me. In fact, before fights are the few times I will shave my head down to the skin, simply to make it easier for stitches to be put in if I suffer cuts. I think it's revolting, the idea of not showering, and I have pride in who I am. If I have to use body funk to get leverage in a fight, I shouldn't be fighting. My heart was feeling slower, calmer, and so was I. I got dressed and we headed downstairs for the bus, but not before I handed Shelby all of my blessed Thai amulets and my necklace with my family's names on it. She put them on her own neck, every single one, and followed me out, taking tiny steps in those gruesome-looking stilettos.

Once at the venue, we were divided into rooms. One room held one group of fighters, the other room held the opponents of those fighters. Red corner and blue corner. I walked into my room with Shelby close behind to see Andre Mannaart, an old legendary Dutch fighter turned trainer. I had known Andre for years. Andre was incredible, positive, a tough trainer but very good. He was there cornering his fighter Brice Guidon, a massive French heavyweight who was facing Gokhan Saki. I grabbed Andre in a hug.

"I haven't seen you for so long, Mr. Shark! I am glad to see you. Robbie told me that he was working with you! He said that you were looking good!" Andre's bright eyes were shining; his presence made me feel even more relaxed.

"Yeah! I am so glad I got to train with Rob. Hey, Andre, when am I going to get one of those shirts, man? You know I've been a fan for forever, when do I qualify?"

I was referring to Andre's Mejiro Gym shirt. I was in awe of the old Dutch kickboxing gyms Mejiro, Chakuriki, and Vos. So many titans had come out of those. So many kings. Andre smiled and patted me on the shoulder. "We'll see, Mark, we shall see."

I sat in the corner with Shelby, who was now playing video games on her phone. She was nervous and trying very hard not to show it. She was distracting herself but fidgeting and clearly emotionally reactive. As we had filed into the room one of the co-promoters of the event had touched her shoulder and said, "It's just really good that he's fighting again, you know?" It seemed like a nice enough thing to say, but with the tone it was said in, it was obvious what was being implied. No one expected me to win, and this person was trying to offer a bright side to Shelby, who they figured would be carrying my broken body back to the hotel later that night. My sweet friend didn't react so kindly to it. Shelby was behind me when it happened, and while they had tried to be quiet, I had heard the whole thing. I also heard when she yanked her arm away and said, "It's also going to be fucking awesome when he wins. PS: pity is so fucking unattractive."

A TV crew was moving between the rooms doing interviews. The man holding the microphone was Samuel Pagal from Eurosport TV. He was an impeccably dressed French journalist, in braids and custom-fitted leather pants with a bright scarf draped around his neck and a bomber jacket on. He tipped up his sunglasses and approached me.

"Man, and here I thought I was the best-looking guy in the room," I said, smiling, as I shook his hand.

"Mark it is, yes? So, Mark, we know your nickname is 'Fightshark,' but why that nickname?"

He held the mic out and I leaned in, the memory of when my nickname was first spoken suddenly so fresh in my mind.

"I was in my early twenties, and after a sparring session where I had been particularly brutal, my trainer told me that I was like a shark in the water when it smells blood. If I know you're hurt, I come after you. I'm the Fightshark."

Samuel was grinning. "I love it, Mark, I love it." He asked me

a few more questions about my heart and then wished me well, but not before commenting on Shelby's outfit, which she loved.

After a little while, Willie came in, and I sat to have my hands taped. It felt good, calming. I hadn't had tape on in so long, but here it felt familiar. Like putting on an old, comfortable pair of jeans. Willie was serene, even-toned, relaxing as he talked to me, went over the game plan. Once my hands were finished I waited to get my gloves so I could warm up. Shelby turned to me and said, "Let's play the game, Mark."

We went back and forth quietly. She gave me a strike, and I rattled off the counter, trying to get my mind to disappear into the answers so they came faster than I could even recognize. I was immersing myself in the patterns that come naturally to a fighter. I started thinking in terms of what I wanted to set up, what my strengths were. The gloves were brought in, bright blue ones. Willie started rubbing them and manipulating them to soften them up before he put them on and taped me in. I warmed up on the pads with Willie for a bit before he worked with Mighty Mo. Shelby watched close by, taking quick breaths as she tried to calm her obvious nerves. I was not nervous now. I was so calm, in fact, that I felt like I could take a nap. I had missed this, longed for this. I was excited, but more so, I was happy. The time came; I was up soon, so a few people came to retrieve me and take me to the back of the catwalk.

There was only one catwalk to walk out on. This meant that I would be going down the same walkway as my opponent, either before or after him. Nikolaj stood a few feet from me. His trainer, a massive man with a shaved head, was grabbing ahold of Nikolaj's shoulders and pressing his forehead against Nikolaj's. He was muttering something, something aggressive sounding, in another language, and every so often Nikolaj let out a series of impossibly loud screams. The second time he did it, Shelby, whose nerves were eat-

ing her up, turned to him and loudly went, "Are you kidding me?!" Willie and I burst out laughing.

I was to walk first. The announcer shouted my name, and I set foot onto the walkway into a cascade of spotlight. Twenty feet away was the ring. The ring, my home. The place where I had worked through so many personal and emotional battles, the place where I had unshackled so many demons and brought them out to play, hurling them at my willing opponents. The place where everything shrank down to simple, quick decisions, and for minutes the world was so uncomplicated and lovely. The place that had been my church, my sanctuary, my theme park, my playground, my purgatory, and the nest from which my smoldering carcass would hopefully rise again from its ash. This was where we as fighters went to grind out our pain, to survive. To truly be alive. I had only minutes to go. The helicopter that had crashed and taken out so many had spared the ones closest to it, held them safe somehow against its metal bosom as it careened into others and crushed them. My whole life had felt like I was in the helicopter, and I had been inside it. I had come this far. I had rebuilt my little army with better soldiers than I was born into having. I had my three boys, Shelby, her family, Justin, Matty, Mikee, Rakaa, Paul, Cory, Jacob, everyone. They were waiting, they were watching, they had sent their best hopes to follow me and the score I was settling into this ring. My feet were moving as though through water, without my being connected to them, it felt like. I was floating. My heart was thundering like a war drum. I reached the ring and turned to climb inside; I saw Shelby step off the catwalk and Willie go to the corner. From here until the bell, it was now up to me, and me alone.

Guide me now. Be with me.

Nikolaj walked down the catwalk, screaming and snarling. He stepped into the ring and went straight to his corner, his coach firing him up more and more, pulling on his shoulders as Nikolaj stamped

and pawed at the ground like an angry ox. I pulled my shoulders back and stretched my jaw. I didn't need manufactured motivation. I had the real thing. That's what everything had been up until now. Encouragement, training. The bell sounded, and the referee immediately called for a pause as a small water bottle somehow rolled into the ring. Our pace was awkwardly halted as they retrieved it, and I glanced up to see Shelby in the crowd. She was leaning against a pillar next to a cluster of VIP tables. Her hands were pressed to her mouth and she was completely frozen. She knew the weight of this fight. She might as well have been tied to me.

The referee waved us on, and we began.

Nikolaj approached me; his cover was good. Having big muscles is a plus because one can hide behind them. I threw an inside low kick at him, and though he checked it, he didn't like it. Then he decided to bully me . . . he started trying to walk me down. I threw my jab. . . . And I saw it. . . .

Nikolaj had walked right into it. As my jab was retracting, the entire world slowed, and I saw it. He was countering with a left hook, leaving the left side of his face completely vulnerable.

Left hook. Shelby's voice, Buddy's drills . . .

Right hook.

I slipped his left hook, and I threw it. My fist connected, and I knew by the feel, by the sound. Nikolaj crumpled to the floor.

I was almost too shocked to return to my corner, but Willie was screaming at me to come back so the ref could start the count. It wasn't a full knockout, not yet. Nikolaj might still rise to his feet. I went to my corner. The ref counted, and Nikolaj rose on rubbery legs before staggering backward into the ropes. He was muttering to the ref, something I couldn't hear, and suddenly, the ref waved it off.

I had won. By knockout. In nine seconds.

Willie ran to me. He lifted me up, giggling. *"You did it, Mark! You did it!"*

I could not stop shaking. I hadn't shaken before the fight, yet now, I was trembling like a leaf in a storm.

I clasped Nikolaj's glove in mine and he was kind in defeat. Later he asked me how long it had been since my heart surgery. I told him four years. He shook his head and smiled. "You hit very hard," he said, his face bearing the swelling and bruise from the punch.

As I was stepping out of the ring Shelby came, on tiny quick steps in her heels, and grabbed me in a massive hug. She was crying. "I am so proud of you, so proud." I had to let go of her hug fast; I didn't want to lose it. Not here.

As I made my way back to the room, I saw Andre, and he walked up to me. "I spoke to Robbie on the phone, he said to give you a big hug and a kiss. I won't kiss you, but here . . ."

Andre pulled the Mejiro shirt off his own back and handed it to me before grabbing me in a massive hug. "You have earned this, Mark. You have earned this."

The entire night, wealthy Russian businessmen offered to buy me champagne and caviar. I declined politely, but Shelby partook. She fell asleep on the bus on the way back to the hotel, her pillbox hat slightly crooked and her red lipstick smeared. We went up to the hotel room, and she disappeared into the bathroom, reappearing only twenty minutes later in sweats with no makeup on. In minutes, she was asleep on the chaise.

I got in the shower, thinking about everything that had brought me here. My self-doubt, my anger, my inability to climb out of my own self-imposed cage. Then the eventual letting go of every weight I bore that told me what I was supposed to be and the accepting of who I am. My friends, who would not let me drown. My kids. My boys . . .

I came out of the shower and sent Justin a text message. I wouldn't hear back from him until I was back in the States, but I told him I loved him.

Before I climbed into bed, I sat beside Shelby and placed one hand on her shoulder. As she was sleeping, I told her thank you. I told her thank you for everything. She would never know what she did for me. She would never know how close I was to giving up.

And then, in bed, I slept, the deepest sleep I had known in a long, long time.

chapter twenty

Every saint has a past, and every sinner has a future.
—OSCAR WILDE

This homecoming was the best I had ever received. Shelby's mother picked us up from the airport and was wearing the biggest and brightest smile I had ever seen. When we got back to Shelby's house, her brother, Tristan, grinned at me and said, "Told you I should've bet money on that fight, you would have made me a rich man." Her father had us over to his house a few days later, where he had invited friends and coworkers over to brag about my fight. Matty and I talked a few times, and Mikee called to tell me how proud he was of me. I felt like a fighter again. My kids called and said they missed me, so I took a portion of my win money and booked a flight home. I hadn't seen them in way too long.

Pennsylvania still was full of ghosts, but I felt a little better, a little stronger, about being there. I didn't feel so defeated or lost. I took my children out to meals, bought them some new clothes, and generally did things that I hadn't in past years been as able to do. After a few days I decided I felt strong enough to finally do something I hadn't done yet. I wanted to visit my parents. I was ready.

I sent Shelby a message and asked her to be near her Skype. I wanted to show her something. . . .

I climbed into the car I had rented and rolled down the window. It was starting to rain, and fat droplets flew through the window onto my arm and the side of my face. A spring storm was coming. I was more nervous to do this than I had been for my fight. I hadn't done much to address my feelings about my family since they had died. I had wept torrents in the recent months, but I hadn't really felt that I had said good-bye or found closure. In truth I don't think I had addressed my feelings about my family since before they died. I had been able to mourn in small spurts when something would trigger a memory, but I had not yet found a way to completely release all of that pain I had in me about their being gone and about the way I had grown up. I had lingered in anger for so long, avoiding tapping into any feelings of real sorrow. I was pissed off that my family had died, one after the other, that they had left me to handle all of their business. I was pissed off that I'd never had the life I wanted with them, the childhood I had read about or seen in friends of mine. Fathers who carried their sons on their shoulders like I do with mine now, or mothers who cuddled and kissed their babies. I was pissed that my brother hadn't wanted to live enough to get clean, that he had jumped the emotional ship so early on that I missed out on having someone to talk to when all hell was breaking loose in the house. I was pissed that he had died after I had told him to, as if to spite me, and left me there to miss him and hate myself. I was pissed that he had said the things he had, that there were elements of truth to his final corrosive words, even if they were generated specifically to hurt me. I hadn't been able to visit my parents; he was right about that. Because it was too hard to take. The finality of it all. Once you accept that a person is truly gone, there is nothing left to do but grieve, since the conversation is ended. There is no more to work out, no score left to settle, no more talks. It's just you,

left by yourself, with a fucking bag of issues that you've accumulated over the years. Time to sift through the bag. Time to take out the garbage.

I pulled onto the long street that led right up to their burial plots. I lingered in the car for a bit; maybe I was preparing myself. The National's "Fake Empire" blared through the speakers, a song I had played over and over again to punish myself. I think I was saying good-bye to that too, this imprisoning of myself in misery. I wanted to live in the light. I wanted to be happy.

"Let's not try to figure out everything at once, it's hard to keep track of you falling through the sky, we're half awake in our fake empire, we're half awake in our fake empire. . . ."

Deep breaths, deep breaths.

Final good-byes don't always happen at the moment a person leaves you. You'll know when you have said your final good-bye. You'll feel it. It resonates in your body, this hollowness, this echo of "no more." It's a concept that people can't process with any quickness. We aren't built to deal with it in one fell swoop. Instead it grows like kudzu slowly over you, and before you know it you're suffocating under this thick, heavy mass of undeniable loss that you have to deal with. All the *never agains* swirl through your head like angry hornets. Never again will I . . . eat German chocolate cake with my mom, work on the house with my dad, or play a song for my brother, receive or send a Christmas card, birthday card, hear a voice, laugh at a joke, fight with, laugh with, break bread with, never again will I have a chance to see if it could be better. . . . Never again . . .

I had been holding back all of these feelings, this complex tangle inside, and every time I felt like leaking some of it out, I could feel its vastness following, not allowing for it to be broken apart, and the magnitude of that grief threatened to buckle me. I was never ready to let it through, to just invest in being a man who had buried

his family. Even now, when I talk about it, it feels like I am speaking of someone else, still keeping all of that preserved pain at arm's length, maintaining enough distance to not get pummeled by it, to not get swept into that dark and tempestuous sea of loss.

The rain was coming down now. It was comforting, and I felt my hurt was camouflaged by the gray sheets washing over me. Some voice inside said, "Just leave, go back, change your clothes, get an umbrella, come back tomorrow." I tuned it out. Your mind will always try to convince you to avoid discomfort, to run from pain, and wait for the "opportune time." The truth is, that time doesn't exist. There will never be perfect conditions to deal with anything that hurts or scares you. It's like a fight in a ring. If you want to find excuses to back out of facing it, you will. There are always a myriad of them lingering around, and it can be harder to dig up the motivation to keep going rather than to give up or hang back. You have to set your jaw and just move forward, no matter what. You have to swing out onto that rope of uncertainty and hope for the best. Walking into the ring was never this hard, but it gave me the strength to know how to just put one foot in front of the other, until I stood facing them. Side by side, Harry and Helen Miller. My parents.

I knelt down and pulled a few weeds that had grown thick surrounding their headstones. There were flowers on my father's grave; I will never know who brought them. I had words trying to fall into order in my throat. When you talk to a person in a coma, you can speak knowing that maybe they will hear you. At this grave site my voice sounded so unconvinced, so strange. I don't know who I was talking to; possibly to myself.

"Hi. I, um. I haven't been here because I was, uh, real fucked up for a while. And, I . . . I didn't know what else I had to say to you guys. You left me with a lot of shit to sift through—could have done better on that, Dad."

I forced a laugh. My fingers were running through the grass,

searching for something to hold on to, wanting something to hold on to me.

"So I guess, I wanted to say that I love you guys. . . . I think I do. And I wanted to say thank you, for, trying. . . . Thank you for trying. I am grateful for my life. . . ."

With that, the dam that had held back years of bitter anger and hurt melted enough to create a crack, and all of those tears I hadn't cried yet came roaring through. Honesty has a way of placing you directly in the middle of whatever emotion you've been protecting yourself from. I buckled in half, my palms resting on those granite stones, air pulling into my lungs almost too slowly for me to breathe. The sobs were violent, and embarrassing, even though no one was around.

This was the first time I had been able to cry in front of my parents since I was a baby, and this time I was crying because I actually missed them.

"I'm so sorry, guys, I'm so sorry. . . ."

I must have said this a million times. I don't know what I was saying it for. Maybe I was sorry that I couldn't have made things better for them or that I couldn't have helped them to be happier. Maybe I was sorry that I had hated them for so long and blamed them for my unhappiness. Maybe I was sorry that they weren't there to see me growing out of the parameters they had set for me and into something bigger, something stronger.

After an hour or two I reached a point of calm, and I called Shelby on Skype. She answered, and I made sure to point the phone away from my face. She had seen me cry more than anyone ever had, but I still wasn't comfortable with it.

"Hey, kid. How are you?" I had the camera pitched slightly over my shoulder. She could see the rain coming down on the hills behind me. I'm sure she could hear the cracks in my voice, but she didn't let on.

"Heya. Where are you, dude? How's the Pit treating you?" I could see her eyes searching around, trying to figure out my surroundings.

"I'm okay, weather sucks. But hey, I want you to meet some people. . . ."

I turned the camera toward my parents' graves.

"Shelby, this is Harry and Helen Miller. Guys, this is Shelby."

She was quiet for a minute, and then she spoke softly.

"Hi. Nice to meet you. Thank you for making my best friend. . . . I'm proud of you, buddy. Good to see you finally did this."

She smiled through the camera. I thanked her and got off the phone quickly.

The ride back was quiet. Passing bars I had gotten drunk in and fields I had played in. The schools I had attended, and the small gyms where I had learned the beginnings of my craft. This town had raised me collectively. I had been born to a set of parents, but I had been cared for and nurtured by many. My coaches became my parents. My training partners my brothers and sisters. I had been raised by Steelers, by Pirates, by fighters and athletes. I learned to walk on fields and concrete floors. I took my licks at home, but I learned to give back here.

Justin sent me a message as I drove home: *Did you see your folks?*

I responded, *Yes I did. Shelby met them too. I'm sorry you never got to.*

Justin, in true Justin fashion, had this to say: *I already met the best part of them. You. Get home safe. And come visit sometime. I think you could actually be in Austin and not totally fuck shit up now. Love you.*

I had tracked Maurice down not long before. We were talking again, and I would start training with him once more several months later. My tribe was reconnecting.

As I pulled up to the front of the house where my kids lived, I saw Ronan, one of my twins, burst through the door. Saw his crooked

little smile and heard his husky voice bellowing, *"Daddy!"* Ronan's twin, Paddy, followed, a quieter version of him, more reserved. Ben came after. Already tall and quirky, Ben reminded me of me. I had done so much wrong in my life, but somehow I had been gifted with wonderful children, children I couldn't have been more proud of. Children I couldn't say enough good things about. They were perfect in their individuality. They were smarter than me, and they would grow to be bigger and better than I ever was.

What you are born with is just that. Your beginnings, nothing more. You have no choice in that matter. It's how you deal with it that makes you who you are. Everyone has demons; everyone has shit they have to shovel through. You find your ring, you pick your fights, and you work through it. You don't back down from something because it scares you, you only back down when you know that winning isn't worth the sacrifice at hand. You learn to love with your whole heart, and it will scare the holy shit out of you. And you learn to forgive, because hanging on to a grudge is a futile thing and born of weakness.

I was born in the city of steel, and I was cut from a mold that told the world that I would be weak, that I would be fragile. Physical obstacles and cruelty afforded me what seemed like one path, and it led to anger and self-destruction. Instead I found a way out, but I had to cut that path for myself and I had to eliminate all of the bullshit excuses. And I had to learn that you don't always win, but you do always get a lesson, if you are open to it. Sharks hunt for survival. Fighters aren't that different. Each battle is something settled, some pain we can't express that we get to muddle through. If you are lucky in your life, you'll find your ring, your place to go to work that shit out. If you're lucky, you'll be able to forgive the people who hurt you the most, to quit hanging on to every excuse you afford yourself rather than actually facing the truth, which is that the bitterness poisons you worse than the initial pain. If you are lucky, you'll fail

enough to love your success. The balance is what makes us genuine in life, what makes us real. I am a father, and I am a son. I am a fighter and a survivor. I am all of the above and more. No one is ever one thing only, unless it's by choice. Sharks never swim backward; they can't, and neither can I, not anymore. The past is an anchor with *suffering* written on the rope. I don't live there now. I am cutting myself free. And while I might not have everything figured out, I am slowly getting there, and I can say that I know who I am and I'm not perfect, but I am as resilient as the steel that was once made here, and I am a fighter, in every sense of the word. We all are.